l'odyssée de jim dine

estampes 1985–2006
a survey of printed works 1985–2006

l'odyssée de

jim dine

steidl

Cet ouvrage a été publié à l'occasion de l'exposition
L'Odyssée de Jim Dine. Estampes 1985–2006,
organisée au Musée des Beaux-Arts de Caen du 16 mars au 11 juin 2007.

Commissariat : Caroline Joubert, conservateur au Musée des Beaux-Arts de Caen.

MUSÉE DES BEAUX-ARTS DE CAEN
Direction : Patrick Ramade, conservateur en chef
Administration : Isabelle Reux, assistée de Ghislaine Lenogue
Communication : Anne Bernardo
Régie des œuvres : Magali Bourbon
Service des publics : Sarah Gillois, assistée de Guylaine Geffroy, Claude Lebigre et Marjolaine Lempérière
Photographie : Martine Seyve, assistée de Patricia Touzard
Montage de l'exposition : Yves Boitard, Gérard Hamel, Christophe Marguerite et Gilbert Marie.

L'exposition présentée à Caen n'aurait pu avoir lieu sans l'extrême générosité des prêteurs :
The Pace Edition, New York
The Alan Cristea Gallery, Londres
et sans le concours de Michael Woolworth, Paris.

L'exposition à Caen a pu être mise en œuvre grâce au soutien de la Ville de Caen,
en particulier de :
Brigitte Le Brethon, maire de Caen, député du Calvados
Éric Eydoux, adjoint au maire de Caen, chargé du développement culturel.

Elle a bénéficié de l'appui du Conseil régional de Basse-Normandie,
en particulier de Philippe Duron, président du Conseil régional de Basse-Normandie.

sommaire/contents

l'odyssée de jim dine

La distance prise avec le Pop Art, mouvement dont il est un des pionniers et auquel il est inévitablement rattaché, n'a pas empêché Jim Dine de rester fidèle à ses intentions premières. Bien au contraire, son propos s'est renforcé au fil du temps tandis que son engagement demeurait intact. Après une entrée fulgurante sur la scène new-yorkaise à la fin des années 1950, marquée notamment par le radicalisme des quatre performances qu'il organisa en 1960, Jim Dine a poursuivi un voyage artistique d'une parfaite cohérence, pratiquant simultanément la peinture, le dessin, la sculpture et la gravure, sans oublier de notables incursions dans les domaines de la poésie et de la photographie.

Bien qu'il n'ait jamais établi aucune hiérarchie entre ces différents moyens d'expression, l'estampe reste sans doute le médium auquel il s'est consacré le plus assidûment. Depuis en effet presque cinquante ans, Jim Dine n'a de cesse de produire des images imprimées suivant des méthodes qui, au regard des pratiques traditionnelles, paraissent bien peu orthodoxes. Créer une estampe, ce n'est pas seulement pour lui graver une plaque, choisir les encres et le papier, suivre le processus de fabrication jusqu'au bon à tirer. C'est aussi dessiner, peindre, assembler, inventer des associations inédites; c'est convoquer toutes les ressources possibles pour parvenir au résultat escompté ; c'est aussi exploiter au mieux les talents et les idées des imprimeurs avec lesquels il travaille.

De fait, en Europe comme aux États-Unis, Jim Dine accoste bien des rivages, mettant à profit chacune de ses étapes pour explorer de nouveaux territoires. Entre 1985 et 2006, son nomadisme l'a conduit notamment auprès de Toby Michel à Los Angeles et de Robert Townsend à Georgetown (Massachusetts), chez Aldo Crommelynck à Paris et Niels Borch Jensen à Copenhague, les collaborations les plus productives étant pour cette même période celles apportées par Kurt Zein à Vienne, par Donald Saff à Tampa (Graphicstudio, University of South Florida), par l'équipe du Spring Street Workshop à New York et plus récemment par l'atelier parisien de Michael Woolworth.

D'une officine à l'autre, les enjeux se déplacent et dans cette continuelle remise en question des moyens il entre une part de défi. La collaboration avec l'imprimeur est évidemment fondée sur la complicité, avec ce que cela suppose d'acceptation et de consentement, mais aussi sur une émulation nécessaire et bien comprise. Provoquer, bousculer les règles établies, susciter, faire exister dans l'urgence d'une passion partagée : l'art de la gravure a souvent engendré de tels rapports et Jim Dine, comme nombre d'artistes, aime ces ambiances d'ateliers, où l'on se frotte à d'autres habitudes, à d'autres expériences. Chaque collaboration apporte ainsi sa part d'imprévus et de bonnes surprises, dont il faut tirer avantage.

Lithographie, pointe sèche, eau-forte et aquatinte, carborundum, linogravure et xylographie, Jim Dine s'est approprié toutes les techniques de l'estampe auxquelles il ajoutera en 1994, sous l'impulsion de Kurt Zein, la gravure sur carton. Plus impres-

sionnante que la syntaxe elle-même est la manière dont il en use. De nombreuses estampes sont en effet le fruit d'un travail complexe, à l'exemple de *The Foreign Plowman*, l'une des plus ambitieuses images imprimées de l'artiste. Composée de cinq feuilles, cette estampe résulte de la combinaison d'eaux-fortes sur fer, encrées à la poupée, de bois traités en héliorelief et de rehauts à l'acrylique. Par la forme choisie du polyptyque, par sa monumentalité et par son sujet – où le mort saisit le vif, où féminin et masculin s'opposent, où s'entrecroisent culture et nature –, cette œuvre se rattache à la grande tradition picturale européenne plutôt qu'à la production graphique mécanisée du Pop Art. Elle relève aussi de la technique du collage et présente un cas typique de réemploi des planches gravées : le squelette et la tête d'écorché de la première feuille, le motif inférieur de la deuxième feuille et l'un des arbres du panneau central proviennent de *Youth and the Maiden*, un triptyque de 1988, tandis que les autres têtes ont permis l'impression de *The Mead of Poetry*, une suite de trois images datées également de 1988.[1]

Toute plaque est ainsi susceptible d'être exploitée de différentes façons, d'être corrigée, reformulée, transformée, bien des années après avoir été gravée : l'arbre noir de *The Foreign Plowman* sera associé à un cœur pour donner naissance à *Lakeside et Noon* (1998) ; les cuivres de *The Garrity Necklace* (1986) et de *Rise Up, Solitude!* (1985) imprimés sur une même feuille engendreront *Woman on Fire in Vienna* (1993). Les exemples de réutilisation du matériel gravé sont à vrai dire légion, et cette réutilisation est non seulement fréquente mais elle est aussi clairement revendiquée par l'artiste. L'œuvre ne naît pas de rien, elle ne surgit pas du néant ; bien au contraire, elle se nourrit de sa propre généalogie, d'une histoire que l'on peut reconstituer, et c'est en vérité cette histoire de l'œuvre qui passionne Jim Dine : montrer d'où vient l'image en donnant le sentiment que rien n'est jamais achevé, que tout peut advenir.

La méthode adoptée par Jim Dine laisse aussi volontiers place au hasard. L'inattendu est pris en compte, assimilé, absorbé, excluant par là même toute notion d'accident malheureux. La gravure *The Pro Consul* tire ainsi son effet particulier du craquèlement de la préparation épaisse posée sur la surface de l'un des trois cartons ayant servi à son impression. Comme s'il avait été gercé sous l'action du froid, le cœur profondément lézardé exprime la désolation et la tristesse. Le caractère spectral de *Ghost Robe* n'est pas dû à un incident survenu pendant le temps de la réalisation mais à une opération fort simple : tandis qu'il procédait au tirage de *The Colorful Venus and Neptune*,[2] Jim Dine eut l'idée d'imprimer deux fois le bois comportant le motif de la robe de chambre, bois encré à la poupée avec quinze couleurs différentes. La feuille posée sur la planche au second passage a recueilli le reste de l'encre pour produire cette image fantomatique à la polychromie atténuée. Le même bois encré en bleu et combiné à la technique du carborundum produira *The Blue Carborundum Robe*, une œuvre en revanche vigoureuse et contrastée, possédant sa propre identité.

Le mélange des procédés, la manipulation des plaques, leurs divers assemblages, le choix d'un support d'impression particulier – une toile pour *Raven on Cloth*, du feutre pour *Felt Skull* ou encore de précieux papiers Japon – tout concourt à élargir considérablement l'éventail des possibles. Malgré ces innovations qui bien souvent ressemblent à des prouesses, Jim Dine éprouve encore le besoin de rehausser de peinture ses estampes, coloriant le plus souvent les épreuves après tirage (*Hand Painted Afrika* ou *Grease, Bone and Color* en constituent de bonnes illustrations), intervenant parfois à un stade intermédiaire comme l'atteste le rouge incandescent de *Woman on Fire in Vienna* appliqué manuellement entre l'impression des deux plaques.

Si ces additions font de chaque épreuve une pièce unique, on ne saurait y voir une simple stratégie de valorisation. Peu intéressé par le principe d'une édition uniforme et par la multiplication en grand nombre d'une même image, Jim Dine aime cette possibilité d'introduire des variantes. Mais surtout, poussé par une nécessité intérieure, il a le désir constant d'enrichir les textures, de les rendre tactiles, de laisser apparentes les traces de la main. Ce sont des raisons semblables qui l'ont conduit à adopter des matériaux inusités comme le carton ainsi que des outils capables d'attaquer férocement les plaques, des pointes et des roulettes électriques pour le cuivre, des tronçonneuses ou autres scies mécaniques pour le bois.

Il suffit d'avoir vu travailler Jim Dine une fois pour comprendre toute l'énergie et l'ardeur qu'il déploie à chaque création. Ce qui le distingue de la plupart des artistes réunis sous l'étiquette du Pop Art est son aversion pour l'image plate, manufacturée et inexpressive et, par opposition, son goût marqué pour des surfaces d'une grande subtilité. Dès lors, l'évidence ne vient pas seulement de la qualité des images, de leur extraordinaire présence physique, mais aussi d'une subjectivité qui s'affirme clairement et se traduit, notamment, par le geste visible et l'aspect fait main.

À cet égard, *Double Pacific Gift* – une monumentale estampe de 1985 dont le titre fait référence aux objets trouvés sur les plages du Pacifique –, apparaît comme une profession de foi. Réalisé à Los Angeles, à une époque où Dine suivait une psychothérapie avec un analyste jungien, le diptyque présente deux mains largement ouvertes, l'une taillée dans le linoléum, l'autre obtenue grâce à une contre-épreuve de la linogravure reportée sur aluminium et traitée en lithographie. Jouant du phénomène d'inversion propre à l'estampe, l'œuvre témoigne de la dextérité mentale de l'artiste en même temps qu'elle célèbre son agilité manuelle, considérée comme un don. La main a de toute évidence pour Dine un pouvoir de transmission et une relation au divin clairement affirmés déjà dans son édition illustrée de l'*Apocalypse*, publiée en 1982.[3]

D'autres motifs ont pris une place considérable au point de devenir indissociables de l'œuvre et du nom de Jim Dine, en premier lieu le cœur de la Saint-Valentin emprunté à l'imagerie populaire vers la fin des années soixante et toujours au répertoire de l'artiste cinquante ans plus tard. Forme élémentaire aux contours bien délimités, il se prête à toutes sortes de combinaisons et

d'interprétations. Cet emblème de l'amour peut subir un infléchissement spirituel lorsqu'il est associé, dans *The Garrity Necklace,* aux symboles chrétiens de la croix, du crâne et du poisson. Expression d'un profond abattement dans *The Pro Consul,* d'une sérénité teintée de mélancolie dans *Noon* ou d'une exubérance joyeuse dans *Hand Painted Afrika,* il est souvent le réceptacle d'émotions très diverses ou parfois, comme beaucoup de motifs choisis, un simple prétexte à peindre.

Jim Dine a une nette prédilection pour les sujets dont il peut disposer à sa guise, à la fois neutres et flexibles, préférant à tout autre agencement formel les représentations frontales et centrées sur des fonds peu différenciés. Aussi banal que le cœur, et comme lui immédiatement reconnaissable, le peignoir répond à toutes ces exigences, ce qui lui a permis de s'imposer durablement. Tiré d'une publicité vue dans le *New York Times,* le motif rencontre d'emblée la subjectivité de l'artiste et devient un thème familier dans sa peinture à partir de 1964. Dans la lithographie *Eleven Part Self-Portrait (Red Pony),*[4] datée de 1965, comme dans *Ghost Robe,* bois gravé de 1992, le peignoir emplit l'espace pour dessiner en creux un autoportrait. Signalant une absence autant qu'une présence, la formule bien établie de l'autoportrait sans tête ni corps resurgit ainsi périodiquement, permettant le retour sur soi et l'enregistrement des états de conscience, suggérés par les couleurs (le rouge de *Red Sitting with Me* par exemple) et par les traces de la main. Le désir d'introspection s'accomplira dans un registre plus intime et sur un mode plus classique, celui de l'artiste fixant les traits et les expressions de son visage reflétés par le miroir. Faisant suite à de nombreux autoportraits dessinés ou gravés, le portfolio des *55 Portraits* publié en 1995 décline cinquante-cinq eaux-fortes dont quatre sont imprimées en blanc sur fond noir. Dix d'entre elles ont été obtenues à partir d'une seule plaque tandis que les quarante-cinq autres, résultant de la conjugaison des premières, offrent des images brouillées, l'altération du visage liée à l'acuité du regard révélant d'une autre manière la difficulté à se connaître soi-même.

À la fin des années soixante-dix, c'est au tour de la Vénus de Milo de prendre rang parmi les figures emblématiques de l'artiste. Partant d'un moulage reproduisant la célèbre sculpture hellénistique, Jim Dine prête à sa Vénus une apparence à la fois fruste et conquérante ; il la décapite et simplifie sa silhouette, remplaçant le galbe harmonieux par des contours incisifs. Ainsi reconfigurée, cette icône de la féminité sera souvent employée seule ou en contrepoint de l'image masculine du peignoir. Avec *Two Old Bathers,* Dine propose cependant une vision plus nuancée de l'idéal féminin. Incarnant la beauté intemporelle et parée des couleurs de l'arc-en-ciel, la Vénus est flanquée d'un nu traité en noir et blanc, un corps vieilli également sans tête ni jambes, représentant l'emprise du temps sur la chair. S'il y a dans cette confrontation autre chose qu'une simple opposition formelle, il faut se garder toutefois de chercher derrière chaque peinture ou chaque estampe une signification précise. Comme autrefois la palette du peintre et les outils de l'artisan, qui furent les sujets favoris de Dine dans les années soixante, le cœur, le peignoir et la

Vénus obéissent aux règles de la production sérielle, la répétition des motifs trouvant sa justification dans leur réinvention ainsi que dans la variété des techniques et des formats utilisés.

Le renouvellement de la thématique, perceptible surtout depuis 1985, va contrecarrer, sans l'effacer, ce qu'il y a d'obsessionnel dans l'œuvre de Jim Dine. Les motifs botaniques se multiplient pour satisfaire à la fois son goût pour les plantes et l'impérieux besoin de dessiner d'après nature. On croise aussi beaucoup d'estampes représentant des têtes égyptiennes, des figures de Tanagra ou d'autres sculptures gréco-romaines,[5] autant de sujets permettant à Dine d'objectiver son rapport à l'art du passé et à la culture muséale. Le crâne, dont il n'ignore pas le caractère polysémique, appartient d'une certaine façon à cette catégorie en tant que traditionnel accessoire d'atelier et objet de vanité. Pour autant, le crâne vu de profil de *Grease, Bone and Color* et de *The Side View*, emprunté au fameux traité d'anatomie publié en 1858 par Henry Gray,[6] n'est pas pour Jim Dine une image symbolique de la mort. Dans un entretien de 1986,[7] il explique que lors d'une conversation avec un ami à propos du phénomène médiumnique, le crâne lui était apparu comme un véhicule permettant de communiquer avec l'au-delà ; après quoi il devint, comme le cœur ou le peignoir, un autre portrait de lui-même, une structure visuelle dans laquelle il pouvait se projeter.

La quête de sens, depuis longtemps sous-jacente aux œuvres, et la recherche d'archétypes capables de l'exprimer, favorisée par une longue pratique de l'analyse jungienne, se poursuivront dans les années quatre-vingt-dix à travers les mythes, les fables et la vision onirique. La chouette et la corneille qui peuplent plusieurs estampes des années 1994 et 1995, en particulier *White Owl* et *Raven on Cloth*, sortent ainsi tout droit de l'inconscient de l'artiste. Quoi qu'il en soit de leur signification ambiguë, les deux oiseaux sont venus visiter Dine en rêve, après une amère expérience de la solitude faite pendant un hiver berlinois, froid et ascétique.[8] Ils côtoient quelques uns des motifs chers à l'artiste – parmi lesquels un autoportrait, une tête de mort, un arbre et le nu de *Two Old Bathers* – dans une suite baptisée *Winter Dream*, impressionnante fantasmagorie nocturne composée de douze planches, imprimées en noir sur un papier buvard gris. Le choix de la technique n'est pas anodin. La taille brutale des bois contribue largement à créer l'atmosphère cauchemardesque de cette série.

En 1994 pour le triptyque *The Historical Untersberg*, Jim Dine expérimente la gravure sur carton, un procédé mis au point par l'imprimeur viennois Kurt Zein et qu'il allait reprendre l'année suivante pour *White Owl (For Alan)*. La nature fibreuse du carton permet de restituer l'effet produit par un dessin au fusain, tout en donnant une grande profondeur aux images. Répétée sur trois panneaux, la silhouette massive de l'Untersberg évoque une légende selon laquelle Frédéric Barberousse est enterré vivant dans la montagne, attendant le jour du Jugement Dernier pour sa délivrance.[9] De gauche à droite, l'oiseau de mauvais augure, la barbe rouge de l'empereur et le nom du pic se détachent sur un fond minéral, dans une lumière toujours plus argentée. Singulier dans

l'art de Jim Dine, ce triptyque ne fait pas seulement allusion à l'immortalité et à la transformation alchimique, il est par la grandeur de son paysage un écho à la tradition germanique du sublime.

L'intérêt que l'artiste porte à Pinocchio depuis quelques années enrichit l'œuvre d'une référence supplémentaire tout en confortant son caractère résolument autobiographique. Découvrant Pinocchio à l'âge de six ans peu après la sortie du dessin animé de Walt Disney en 1940, Jim Dine s'est, comme tous les enfants du monde un peu menteurs et un peu désobéissants, identifié au personnage ; sans doute a-t-il craint de voir son nez s'allonger et ses oreilles se transformer. Ce processus d'identification est encore à l'œuvre bien des années plus tard, non seulement parce que Dine se souvient de l'enfant qu'il a été mais aussi parce qu'il voit dans Geppetto, le père créateur du pantin, un double de lui-même. Pinocchio fait irruption dans l'œuvre de Dine en 1997, quand il vient rejoindre la chouette et le corbeau empaillés mais aussi la collection de crânes et d'autres jouets qui constituent alors le bric-à-brac de l'atelier. Plusieurs héliogravures et images digitales en témoignent, en particulier l'une datée de 1999, *Me, Dangling,* montrant de manière significative un petit Pinocchio et son ombre se superposer au visage de l'artiste.[10]

Dès lors, le pantin va hanter un grand nombre de ses œuvres parmi lesquelles beaucoup d'estampes de grand format. Tantôt agité et hilare, tantôt maladroit et inerte, Pinocchio y apparaît certes plus tout à fait comme un morceau de bois, mais pas encore non plus comme un enfant, plutôt comme une figure en cours d'achèvement, pleine de défauts et perfectible. L'intérêt de Dine pour Pinocchio réside dans la transformation d'un matériau brut en créature humaine, dans la métamorphose d'une marionnette mal dégrossie en petit garçon sage, ce qui n'a pu s'accomplir qu'au prix d'une succession d'épreuves. L'histoire est ainsi pour lui, avant toute autre interprétation symbolique ou morale, une évidente métaphore de la création. Geppetto a façonné Pinocchio à force de labeur, d'attention patiente et de temps. De la même façon, l'artiste crée son œuvre. Et si Dine fait aussi référence à l'alchimiste, capable de changer une matière vile en or, c'est sans doute pour y ajouter ce soupçon de magie nécessaire à toute opération de création.

Tout récemment Jim Dine a réalisé une suite de lithographies en couleurs qui a sans nul doute renforcé sa familiarité avec le conte. Prenant appui sur le texte original que l'Italien Carlo Collodi, l'inventeur du personnage, publia en 1883 sous le titre *Les Aventures de Pinocchio* (en italien *Le Avventure di Pinocchio*), il a composé trente-six images, imprimées et réunies dans un coffret de bois par Michael Woolworth et son équipe. Les lithographies intègrent et illustrent les en-têtes des trente-six chapitres de l'ouvrage de Collodi. C'est dire que les phrases font ici vraiment partie de l'image. Reproduites avec des polices et des tailles de caractères différentes, elles entourent les personnages ou se glissent parmi eux. Lorsqu'elles sont répétées plusieurs fois, les lettres viennent se chevaucher et courent sur la feuille dans une sorte de frénésie déréglée. Parfois les mots rehaussent plus sim-

plement l'image. Ainsi en est-il de cette inscription solennelle qui annonce la mort de la fée aux cheveux bleus sur un fond de pierre lithographique évoquant la dalle d'une tombe. Il n'y a pas à proprement parler de scènes représentées dans cette suite de lithographies, l'élément narratif étant essentiellement donné par le texte combiné à un personnage ou à un motif seul, plus rarement à deux ou à trois personnages. Si certains d'entre eux s'inspirent de l'imagerie populaire, d'autres appartenaient déjà au vocabulaire de l'artiste. Il a ainsi réutilisé la tête du Pinocchio de *Pure Woodcut* pour quatre images de la série et l'un de ses autoportraits pour incarner Geppetto. Jamais dans son travail d'illustration, Dine n'avait associé texte et motif avec autant de liberté et d'invention, qualités que l'on retrouve dans les choix de typographie et de mise en page du livre d'édition courante qui reproduit l'ensemble complet des lithographies.[11] Une telle aventure éditoriale est à la hauteur de son enjeu intellectuel : interroger l'énigme de la création en s'appropriant le mythe, suivre les péripéties de l'histoire pour dire les hésitations et les doutes de l'artiste.

Dans l'œuvre imprimé de Jim Dine, l'approche technique peut varier sans contrainte, le geste se déployer et le leitmotiv se distribuer en de multiples versions, toujours en tirant parti de la surabondance de sens. Ainsi s'affirme, avec intensité et vitalité, un art servi par le décalage et la réinvention des formes comme par la recherche d'une iconographie originale. Une odyssée capable à partir d'une expérience personnelle d'approfondir notre compréhension de l'humain.

Caroline Joubert

1 Elizabeth Carpenter, *Jim Dine Prints 1985-2000 : A Catalogue Raisonné*, Minneapolis, The Minneapolis Institute of Arts, 2002, n° 21, 24-27.

2 *Ibid.*, n° 49.

3 *The Apocalypse : The Revelation of Saint John the Divine,* San Francisco, Arion Press, 1982, avec vingt-neuf bois gravés de Jim Dine.

4 Susan Tallman, *The Contemporary Print from Pre-Pop to Postmodern*, Londres, Thames and Hudson, 1996, p. 48.

5 Voir en particulier le livre et le portfolio *Glyptotek*, New York, Pace Editions, Londres, Waddington Graphics, 1988, illustrés respectivement de quarante et quatorze « glaciés transférés » de Jim Dine reproduisant des sculptures conservées à la Glyptothek de Munich.

6 *Gray's Anatomy : Descriptive and Surgical*, publié en Grande-Bretagne en 1858, deuxième édition 1860.

7 Entretien qu'il a eu en juillet 1986 avec Marco Livingstone, publié dans le catalogue *Jim Dine : Rise Up, Solitude ! Prints 1985-86,* Londres, Waddington Graphics, 1986, p. 10-11.

8 Voir le texte de Jim Dine dans *Jim Dine : Birds*, Göttingen, Steidl, 2001.

9 Jim Dine a pu observer à loisir le massif montagneux de l'Untersberg lorsqu'il enseigna à l'International Summer Academy de Salzbourg en 1993 et 1994.

10 *Jim Dine. The Photographs, so far*, 4 vol., Göttingen, Steidl, 2003, avec la participation du Davison Art Center, Wesleyan University, Middletown, Connecticut et de la Maison européenne de la Photographie, Paris, vol. 2, *Digital Prints*, p. 123.

11 Paru sous le titre *Pinocchio,* Göttingen, Steidl, 2006, avec le texte de Carlo Collodi traduit en anglais par M. A. Murray.

l'odyssée de jim dine

Although Jim Dine first came to prominence as a Pop artist and is considered a pioneer of the movement, he later distanced himself from Pop Art to forge a very personal artistic path. This did not prevent him, however, from remaining faithful to his early intentions – on the contrary, they intensified over time. After making his entrance on the New York scene in the late 1950s, he was rapidly recognized as an exceptional young artist, due in particular to four revolutionary performance pieces presented in 1960. Since then, while he has simultaneously produced paintings, drawings, sculptures, prints, poems and photographs, his artistic voyage has remained utterly coherent.

While he never established any hierarchy among these various means of expression, he has always been most devoted to printmaking. For nearly five decades, Jim Dine has never stopped making prints, using inventive techniques that seem unorthodox when compared with traditional methods. For him, printmaking goes far beyond making his image on a plate, selecting ink or paper and overseeing the process until the artist's proof; it means drawing, painting, shaping, building, mixing materials and methods, discovering new combinations – using all the resources available to him, and making the most of the talents and ideas of the printers he collaborates with.

Like a nomad, Jim Dine travels frequently throughout Europe and the United States, with each journey leading him to explore new artistic territories. From 1985 to 2006, for instance, his wanderings led him to work with a variety of master printers: Toby Michel in Los Angeles and Robert Townsend in Georgetown (Massachusetts), from Aldo Crommelynck in Paris, to Niels Borch Jensen in Copenhagen. The most prolific collaborations during this period occurred with Kurt Zein in Vienna, Donald Saff in Tampa (Graphicstudio, University of South Florida), Pace Editions in New York and, more recently, with Michael Woolworth in Paris.

Since approaches to risk taking and problem solving obviously vary greatly from one atelier to another, Jim Dine finds himself continually confronting new challenges. Collaboration with a printer is based on complicity, acceptance, and compromise, even emulation – challenging and provoking and probing one another, turning established rules upside down in the quest for a shared passion. Like many artists, Jim Dine loves the workshop atmosphere, where each new collaboration leads to investigating unconventional techniques, bringing together unforeseen, often surprising effects in ways that can be endlessly altered and transformed.

Lithography, drypoint, etching, aquatint, carborundum printing, linogravure and xylography – Jim Dine has appropriated all these printing techniques, even adding cardboard intaglio at the urging of Kurt Zein in 1994. In his prints, syntax itself is less important than how it is used. Many incorporate several complex processes, as in *The Foreign Plowman*, one of the artist's most

ambitious. Printed on five separate sheets of paper, it brings together etching on metal à la poupée, woodcut and hand painting in acrylic. The print's pentitych format, its monumentality, its subject matter – in which the dead interact with the living, female and male are juxtaposed, and culture and nature are interwoven – links it more to the great European pictorial tradition than to the mechanical, illustrative nature of Pop Art. *The Foreign Plowman* also incorporates collage as well as one of Dine's typical working habits: recycling plates. This occurs, for instance, with the skeleton and profile sketch on the first image; the lower portion of the second image; and one of the trees on the central panel, also used in *Youth and the Maiden,* a 1988 triptych. Other images of heads can also be seen in *The Mead of Poetry*, a series of three prints also dated 1988.[1]

In the printmaking process, plates can be exploited in multiple ways, corrected, reinvented, transformed, even several years after they were first employed: The black tree in *The Foreign Plowman*, when combined with the image of a heart, gave rise to *Lakeside at Noon* (1998); copper plates from *The Garrity Necklace* (1986) and *Rise Up, Solitude!* (1985), printed on the same sheet of paper, generated *Woman on Fire in Vienna* (1993). Examples of recycling previously printed material are abundant, in fact, and the practice is not only frequent but also clearly championed by the artist. His prints were not born of nothing, nor have they emerged from nothing. On the contrary, they were nourished by their own genealogy, a history one can recreate; in fact, it is this history, these traces that Jim Dine feels passionate about, about showing where an image comes from by creating the feeling that nothing is ever really finished, that anything can happen.

Dine's methods also intentionally invite randomness and accidents. The unexpected is taken into account, assimilated, and incorporated, eliminating any notion of "unfortunate" mistakes. The cracking effect in the print *The Pro Consul,* visible on the thick ground applied to the surface, comes from one of the three pieces of cardboard used for printing. As if chapped from the cold, the cracked heart expresses desolation and sadness.

The ethereal nature of *Ghost Robe* is an idea that emerged during the printing process, an extremely simple one: while pulling *The Colorful Venus and Neptune,*[2] Jim Dine tried printing twice in a row the wooden board on which he had made the bathrobe image – a woodcut inked with fifteen different colors. The paper placed on the wood during the second printing received the remaining ink, producing a "ghost" image in pale tones. Then, the same piece of wood, when inked up with blue and combined with a carborundum technique, led to *The Blue Carborundum Robe* – vigorous, full of strong contrasts, this print has a powerful, completely different identity.

The blending of various techniques, the handling of the plate, the diverse compositional arrangements, the surface chosen for a particular print – fabric for *Raven on Cloth,* felt for *Felt Skull,* delicate Japanese papers – all these can significantly widen the

range of possibilities. In addition to these elements, which he uses in a virtuoso manner, Jim Dine often hand paints his prints, most often adding color once the proofs are finished (as in *Hand Painted Afrika* or *Grease, Bone and Color*) or at other times, intervening during an intermediate stage, as with the glowing red of *Woman on Fire in Vienna*, applied manually during an interval between printing the two plates.

These additions make each proof a unique artwork. Jim Dine remains uninterested in the idea of a uniform edition, or in multiplying the same image in great numbers. What excites him is the possibility of introducing alternatives and more strongly, the omnipresent drive to enhance a texture, to make a surface feel more tactile, to leave the traces of his hand clearly visible. For this reason, he adopts such unusual surfaces as cardboard, or tools with which he can "attack" a plate; a needle or rocker for copper, a chainsaw or jigsaw for wood.

After seeing Jim Dine at work just once, one immediately feels all the energy and passion he exudes with each creation. What distinguishes him from most artists under the Pop Art label is his aversion to images that are flat, mechanical, detached; and conversely, his obvious preference for surfaces that look subtle and expressive. This can be observed not only in the images' quality and their extraordinary physical presence, but also in the subjectivity he expresses, especially with their handmade look and the powerful presence of his gesture.

One example of this, *Double Pacific Gift* – a monumental 1985 print whose title refers to objects found on beaches on the Pacific coast – seems to be an admission of faith. Made in Los Angeles at a time when Dine was in Jungian psychoanalysis, this diptych presents two wide-open hands, one made with a linoleum cut, the other with a linogravure counter-proof made on metal and printed in lithography. Playing on the phenomenon of inversion specific to the print, the work both testifies to the artist's mental dexterity while it celebrates his virtuoso agility. Obviously, the hand, for Dine, has the power of transmission and represents a relationship with divinity, already present in his illustrated edition of *The Apocalypse,* which was published into 1982.[3]

Other motifs have become inseparable from Jim Dine's name and work, especially the archetypal Valentine's Day heart, which he borrowed from popular imagery in the late 1960s and which then reappeared in his repertoire throughout the next five decades. A basic shape with sharply defined contours, the heart lends itself to all sorts of combinations and interpretations. This symbol of love undergoes spiritual reorientation, for instance, in *The Garrity Necklace,* where it is linked with Christian symbols: cross, skull and fish. An expression of despondency in *The Pro Consul,* of melancholy tinged with serenity in *Noon* or of joyful exuberance in *Hand Painted Afrika,* it is often a receptacle for diverse emotions; and at times, like many of his chosen motifs, it can simply offer a pretext for painting itself.

Jim Dine has a clear predilection for subjects he can use as he wishes. They are neutral and adaptable, often used in a frontal composition, placed centrally on a plain, solid-colored background. Banal and immediately recognizable, like the heart, his bathrobe, which meets all these criteria, is another subject that has lasted in his work. Originally inspired by an advertisement in *The New York Times,* the image promptly became a familiar theme in his painting starting in 1964. In the 1965 lithograph *Eleven Part Self-Portrait (Red Pony),*[4] and in *Ghost Robe,* a 1992 woodcut, the bathrobe fills the space with a hollow self-portrait. Suggesting both absence and presence, the well-established version of a self-portrait, with neither head nor body, periodically re-appears, allowing him to return to himself and to record states of consciousnesses, expressed through color (red in *Red Sitting with Me,* for example) and hand prints. The desire for introspection is achieved in a more intimate, traditional manner when he depicts his own features and expressions seen in the mirror. Having made numerous self-portraits in drawings or prints, he published the *55 Portraits* portfolio in 1995, a collection of 55 etchings, four of which are printed in white ink on a black background. Ten were obtained based on one single plate, while the 45 others, which result from the conjugation of the first group, are rather jumbled images – a face shifting, in which the artist's sharp gaze reveals the difficulty of truly knowing oneself.

By the late 1970s, it was Venus de Milo's turn to take her place among the artist's emblematic subjects. Starting from a cast of the celebrated Hellenistic sculpture, Jim Dine made his Venus an appearance at once rough and glorious; he decapitated the figure and simplified the silhouette, replacing the harmonious curves with incisive contours. Thus remodeled, this feminine icon was often depicted alone or in counterpoint to the male bathrobe. In *Two Old Bathers,* however, Dine proposes a more restrained vision of the female ideal. Incarnating timeless beauty and wearing the colors of the rainbow, Venus is flanked by another black-and-white nude, an aging body, also headless and without legs, symbolizing the effects of time on the flesh. Although this juxtaposition clearly evokes more than a simple, formal contrast, one must not seek too much literal meaning in each painting or print. Like the painter's palette and craftsman's tools, favorite subjects for Dine throughout the 1960s, the heart, bathrobe and Venus, obey the rules of serial production; his repetition of them can simply be justified by the way he reinvents them, as well as in the variety of techniques and formats he uses.

The appearance of other subjects, especially since 1985, slowed – without eliminating – the obsessive quality in Jim Dine's work. Botanical motifs could be seen frequently, satisfying his love of plants and his passion for drawing from nature. There are also numerous prints of Egyptian heads, Tanagra figures or other Greco-roman sculptures,[5] subjects that allowed Dine to concretize his relationship to historic art and the culture of museums. The skull also belongs to this category, both as a traditional

studio accessory and as an aspect of the Vanitas tradition. The skull, depicted in profile in *Grease, Bone and Color* and in *The Side View* in reference to the famous anatomy book published by Henry Gray in 1858,[6] is not, for Jim Dine, a symbol of death. In a 1986 interview,[7] during a conversation about the phenomenon of mediums, he explains that the skull had seemed to him a vehicle for communicating with the afterlife, and later, like the heart or bathrobe, became another self-portrait, a visual form into which he projected himself.

The constant search for meaning, and for archetypes able to express it, helped along by his extensive involvement with Jungian analysis, continued in the '90s with images of myths, fables and a dreamlike vision. The owl and crow, which inhabit several prints from 1994 and 1995, in particular *White Owl* and *Raven on Cloth*, come straight out of the artist's unconscious. Although their significance may seem uncertain, the two birds often visited Dine in his dreams, after a bitter experience with loneliness during a cold, severe winter spent in Berlin.[8] They touch on some of the artist's favorite motifs – among them, a self-portrait, a death head, a tree and the nude from *Two Old Bathers* – in a suite entitled *Winter Dream,* an impressive nighttime phantasmagoria made up of twelve woodcuts, printed in black on gray blotter paper. His choice of technique is not insignificant: the size of the wood contributes greatly to the series' nightmarish mood.

In 1994, in the triptych *The Historical Untersberg,* Jim Dine tested cardboard intaglio, a process perfected by Viennese printer Kurt Zein, and then took it up again the following year in *White Owl (For Alan).* The fibrous nature of the cardboard recreates the feeling of the original charcoal drawing and also gives the image great depth. Seen on three panels, the massive silhouette of Mount Untersberg refers to a legend in which Frederick Barbarossa "the Red-bearded" is buried alive inside the mountain, waiting for Judgment Day to be released.[9] From left to right, the ominous-looking bird, the emperor's red beard and the mountain's name, detached from the rocky background, are bathed in an increasingly silvery light. Singular in Jim Dine's art, this triptych refers not only to immortality and alchemical transformation but, thanks to the landscape's scale, also evokes the Germanic notion of the sublime.

Over the past several years, the artist has added another reference to his work: that of Pinocchio, which perpetuates his work's autobiographical character. At the age of six, when he discovered Pinocchio, shortly after the release of Walt Disney's animated film in 1940, Jim Dine, like children everywhere, was a bit dishonest, a bit disobedient, and he identified with the character; undoubtedly, he feared seeing his nose grow and his ears transformed. His identification remains in the works on Pinocchio many years later, not only because Dine remembers the child he had been, but also because he sees Geppetto, the puppet's creator and father, as a double for himself. Pinocchio first appeared in Dine's work in 1997, joining the stuffed owl, the

crow and the collection of skulls, toys, odds and ends in his studio. Several heliogravures and digital prints prove the puppet's importance, such as *Me, Dangling,* from 1999, in which a small Pinocchio and its shadow are superimposed on the artist's face.[10]

Consequently, the puppet haunted a great number of his works, among them many large-scale prints. Sometimes agitated and hilarious, sometimes awkward and inert, in the prints, Pinocchio certainly seems neither a piece of wood nor a child, rather like a figure just coming into existence, flawed and vulnerable.

Dine's interest in Pinocchio lies in the transformation of raw material into a human creature, in the transformation of a rough-hewn puppet into a good little boy, which could be only achieved through a succession of challenges, tests. Clearly, for him, the story represents a metaphor for creation, beyond any other symbolic or moral interpretation. Geppetto created Pinocchio with hard work, patience, attention and time, just as an artist creates a work of art. Dine also refers to the alchemist's ability to transform inferior matter into gold, undoubtedly to add the little bit of magic necessary for any creation.

Recently, Jim Dine created a succession of color lithographs that deepened his relationship to the tale. Referring to the original text by Carlo Collodi, the Italian who invented the character, published in 1883 with the title "The Adventures of Pinocchio" (in Italian, "Le Avventure di Pinocchio"), he created 36 images printed by Michael Woolworth and his team of collaborators, who also built a special wooden box containing the entire series. The lithographs not only illustrate but also literally integrate subtitles from each of the 36 chapters in Collodi's book, with the words becoming part of the image itself. In different typefaces and diverse sizes, the words surround his illustrations or are woven through them. At times, the words simply enhance the image. At others, certain letters, repeated several times, intersect, overlap or jump around the image in a kind of chaotic frenzy.

For instance, one print depicts a solemn inscription that announces the death of the blue-haired fairy. The phrase is applied on the image of a lithographic stone, which resembles a tombstone. Dine's lithographic series contains no strictly literal scenes to speak of; the narrative element is expressed primarily by the text, combined with a character or a single motif, or, more rarely two or three characters. Some use popular imagery as a starting point; others already belonged to the artist's vocabulary. For example, he recycled the Pinocchio head used in *Pure Woodcut* for four different images in the series; and one of his self-portraits to incarnate Geppetto. Never in his illustrations has Dine associated text and image with such creative freedom and imagination – qualities also found in the treatment of typography and layout of the current edition of the book, which includes the complete lithographic series.[11] The innovation in this artistic endeavor is equaled by the intellectual challenge it proposes: questioning the mystery of creation by appropriating a myth, and by following the various adventures presented in the story – that is, the artist's own hesitations and doubts.

Jim Dine's technical approach to printmaking is open-ended, limitless, inexhaustible; his gesture, generous and changeable, expresses heightened emotion; different versions of his leitmotif appear and reappear. With their intensity and vitality, his prints take their power from this perpetual shifting and reinvention of forms, this relentless search for unique iconography. Although rooted in personal knowledge, his artistic odyssey also deepens our understanding of the human experience.

Caroline Joubert

1 Elizabeth Carpenter, *Jim Dine Prints 1985-2000: A Catalogue Raisonné,* Minneapolis, The Minneapolis Institute of Arts, 2002, n° 21, pp. 24-27.

2 Ibid., n° 49.

3 *The Apocalypse: The Revelation of Saint John the Divine,* San Francisco, Arion Press, 1982, with 29 woodblock prints by Jim Dine.

4 Susan Tallman, *The Contemporary Print from Pre-Pop to Postmodern,* London, Thames and Hudson, 1996, p. 4.

5 See, in particular, the book and portfolio *Glyptotek,* New York, Pace Editions, London, Waddington Graphics, 1988, illustrated respectively with 40 and 14 "glaciés transfers" by Jim Dine reproducing sculptures in the collection of the Glyptothek in Munich.

6 *Gray's Anatomy: Descriptive and Surgical,* published in Great Britain in 1858, second edition 1860.

7 Interview held in July 1986 with Marco Livingstone, published in the catalogue *Jim Dine: Rise Up, Solitude! Prints 1985-86,* London, Waddington Graphics, 1986, p. 10-11.

8 *Jim Dine: Birds,* Göttingen, Steidl, 2001.

9 Jim Dine was able to observe the mountainous mass of Untersberg while teaching at the International Summer Academy in Salzburg from 1993 to 1994.

10 *Jim Dine. The Photographs, So Far,* 4 vol., Göttingen, Steidl, 2003, co-edition with Davison Art Center, Wesleyan University, Middletown, Connecticut, and the Maison européenne de la Photographie, Paris, Vol. 2, *Digital Prints,* p. 123.

11 Published under the title *Pinocchio,* Göttingen, Steidl, 2006, text by Carlo Collodi, English translation by M. A. Murray.

Caroline Joubert : On trouve toujours votre nom associé au Pop Art. Or, quand on vous interroge sur ce sujet, vous parlez d'un malentendu. Pourriez-vous revenir un peu sur les débuts de votre carrière d'artiste ?

Jim Dine : En 1960-61, pour la première fois aux États-Unis, des artistes très jeunes accédaient à la reconnaissance et à la célébrité. J'étais le plus jeune, j'avais vingt-trois ou vingt-quatre ans, Oldenburg en avait presque trente. Je connaissais des artistes plus âgés comme Lichtenstein, Rosenquist et Warhol qui étaient de véritables artistes Pop puisqu'ils traitaient de la culture populaire. Leurs œuvres venaient de la culture de masse. J'utilisais beaucoup d'objets communs réels dans la composition de mes tableaux. Mais mon travail provenait de mon propre vocabulaire, celui que j'inventais en incluant des objets usuels; quand j'utilisais dans une œuvre un outil comme un marteau, j'utilisais un vrai marteau, et puis parfois je dessinais le même marteau à côté, comme une sorte de tautologie, mais c'était tout. Ou bien quand j'utilisais un chapeau ou une cravate, c'était simplement ça, une image singulière, comme un signe en pleine figure. Alors, on pouvait dire que mon travail venait de la culture populaire, mais contrairement à Warhol et à Lichtenstein dont les sujets venaient du monde extérieur, moi je peignais mon monde intérieur, en utilisant cependant des objets du quotidien. Je n'ai pas d'objection à être catalogué artiste Pop, ce n'est simplement pas tout à fait exact.

CJ : Vous poursuivez une voie singulière, résolument individualiste, empruntant pour vous exprimer plusieurs médiums, de la peinture et la sculpture jusqu'à la photographie et au livre d'artiste. Établissez-vous une hiérarchie entre ces différents médiums ?

JD : Non, ils sont pour moi tous au même niveau.

CJ : Et quelle est la place tenue par l'estampe parmi ces formes d'expression ?

JD : Je suis né pour faire des estampes. Je crois cela. Je peux penser à l'envers. En général, je sais à quoi va ressembler une image. La base de tout mon travail d'impression vient de mon respect et de mon amour du dessin, c'est le fondement de mes estampes. Il est vrai que j'aime mélanger plusieurs techniques parce que l'approche devient ainsi plus picturale. Particulièrement ces derniers temps, en travaillant avec Michael Woolworth, j'ai le sentiment que la lithographie est plus proche de la peinture que du dessin. Néanmoins au départ, tout vient du dessin.

CJ : Vous faites des estampes depuis 1960 environ. À ce jour combien d'estampes avez-vous réalisé ?

JD : J'ai dû en faire près de mille deux cents. Elles ne sont pas toutes bonnes naturellement, mais elles existent.

CJ : Vous souvenez-vous de votre première estampe et ce qui à l'époque vous a incité à la produire ? Vous deviez alors avoir une vingtaine d'années ?

JD : Non, je crée des images imprimées depuis que je suis petit garçon, en gravant le bois et en imprimant avec une cuillère.

CJ : Avez-vous conservé certaines d'entre elles ?

JD : Non, la plus ancienne que j'ai conservée est une suite de lithographies intitulée *Car Crash*, de 1960 je pense.

CJ : Pourquoi est-il important pour vous de continuer à produire des estampes ?

JD : Je fais des estampes parce que j'aime ça. Si je devais faire une édition d'une seule image, je serais ravi de la faire. Mais parce que c'est une estampe, je peux en faire plus, et financièrement c'est plutôt bon pour moi. Comme ma production d'estampes est importante et qu'elle est soumise aux lois de l'offre et de la demande, je ne fais pas d'estampes qui puissent être considérées comme rares. Certaines planches se vendent et d'autres pas, et cela n'a rien à voir avec la qualité. Il y a des estampes effrayantes, certaines sont décoratives, d'autres sont des images familières.

CJ : Avec l'arrivée massive de nouvelles technologies dans le champ de l'art, l'estampe et son mode de production artisanal peuvent paraître un peu désuets ? Pensez-vous toujours important d'imprimer des images sur du papier comme à l'époque de Dürer ?

JD : Oui, c'est mon plaisir. Mon plaisir est de faire des choses avec mes mains. J'utilise mes mains pour faire des estampes, pour tailler le bois ou pour graver le métal ; c'est la même chose que peindre ou dessiner.

CJ : Comment voyez-vous l'avenir de l'estampe ? Les artistes auront-ils, selon vous, toujours envie d'utiliser ce médium ?

JD : Je n'en ai pas vraiment d'idée. Cela ne semble pas en prendre le chemin ; je ne pense pas que les jeunes artistes se soucient de savoir comment leur image est imprimée pourvu qu'ils obtiennent une image. Ça, pour moi, c'est de la reproduction, pas une estampe. Pour moi, une estampe, c'est quelque chose que l'on fait avec ses mains. Je suis très vieux jeux. Et je suis très âgé.

CJ : Pourquoi le thème des outils est-il si présent dans votre œuvre ? Est-ce pour rappeler que toutes formes d'art passent d'abord par une dimension technique ? Ou bien cette présence témoigne-t-elle avant tout d'une démarche plus conceptuelle ou plus autobiographique ?

JD : Ils sont autobiographiques. J'ai pensé représenter les outils que j'emploie pour dessiner ou graver. Toute ma vie, j'ai eu une relation de proximité avec les outils manuels. J'ai donc parlé de ce que je connaissais.

CJ : Le cœur, le peignoir, le crâne, la Vénus, le corbeau et le hibou, pour ne citer que les principaux motifs iconiques et récurrents dans votre œuvre, ont-ils également une résonance autobiographique ?

JD : Je ne les emploierais pas s'ils n'étaient pas des métaphores personnelles, des métaphores de tout ce qui est enfoui dans mon inconscient. Tout ce que je fais est ainsi autobiographique.

CJ : Vous faites volontiers référence à des thèmes très classiques comme l'autoportrait ou la vanité que l'on trouvait par exem-

ple chez les artistes allemands de la Renaissance. Il y a, en revanche, dans votre œuvre peu ou pas d'allusions au monde moderne ? Ce qui donne une dimension intemporelle à votre œuvre. Êtes-vous d'accord ?

JD : J'utilise beaucoup de ces choses pour créer un lien avec mes prédécesseurs, pour conserver une sorte de continuité. Par exemple, quand je dessinais la nuit à la Glyptothek de Munich, c'était une sorte de méditation sur l'artiste anonyme qui avait fait la sculpture. Des mains tendues par-dessus la mer, comme un pont.

CJ : Il y a des motifs qui appartiennent à la tradition comme ceux que vous venez de citer et d'autres qui proviennent des rêves, par exemple les sombres images de la suite *Winter Dream*.

JD : Oui. Certaines choses que j'utilise sont des choses que j'ai trouvées, des « objets trouvés », comme le peignoir qui vient d'une illustration. Ou le cœur qui vient de la culture vernaculaire. Il appartient au vocabulaire du monde visuel. *Winter Dream* vient d'un rêve, de l'inconscient, du rêve que j'ai appelé Winter. Je le raconte dans le livre *Birds*. Le rêve y est décrit.

CJ : Qu'est-ce qui vous séduit tant dans la figure de Pinocchio ? Est-ce son caractère moitié objet, moitié humain ? Ou est-ce parce qu'il est si maladroit et gauche ?

JD : Ce qui m'a conduit à lui est que je suis allé voir le film de Walt Disney quand j'étais un petit garçon et ce fut une expérience traumatisante. J'étais un garçon menteur et, dans l'histoire comme dans le livre de Collodi, les méchants petits garçons sont punis. Ce petit garçon reste pour moi un personnage extrêmement touchant et je veux le célébrer, prendre soin de lui.

CJ : La réalisation des illustrations pour les *Aventures de Pinocchio* vous a rendu le texte de Collodi plus familier. L'histoire a une portée symbolique, il s'agit d'un pantin de bois qui accède à la condition d'enfant; elle a aussi une dimension morale, l'enfant menteur et égoïste promet à la fin, après un dur parcours initiatique, d'être sage; on peut également y voir une apologie de la liberté et de la désobéissance. Avec laquelle de ces interprétations vous sentez-vous le plus proche ? Sans doute votre attachement à Pinocchio relève-t-il d'un processus d'identification, identification au pantin, mais aussi à son créateur Geppetto ?

JD : C'est plus important que tout cela. J'ai passé beaucoup de temps avec cette histoire, en particulier les deux ou trois dernières années. Je l'ai examinée de plus près. C'est clairement une métaphore de la création artistique. On donne à Geppetto un bâton qui parle. Il le taille pour en faire une figure de garçon. Le pantin de bois traverse un « enfer » pour devenir une personne réelle. C'est ainsi que « l'art » se fait. C'est également une idée alchimique, transformer de la merde en or.

CJ : C'est aussi une histoire très visuelle avec plein d'animaux et de personnages. Il me semble que c'est la première fois que vous faites vraiment œuvre d'illustrateur. Le rapport de l'image et du texte, avec un travail très intéressant sur la typographie, est particulièrement novateur et impressionnant.

JD : Non. Presque tous les livres sur lesquels j'ai travaillé sont ainsi. Ici, le texte épouse de plus près les motifs. J'ai découpé le texte et puis je l'ai rassemblé. C'était peut-être moins explicite auparavant.

CJ : Parmi les procédés très variés que vous utilisez, certains ont-ils votre préférence ? Êtes-vous conduit par la nécessité d'explorer toujours de nouvelles ressources, sans limitation, y compris l'image numérique et la photocopie par exemple ?

JD : J'emploie tout ce qui marche; malgré tout je ne serais pas très content d'utiliser la photocopie. J'ai besoin de m'exprimer, donc tout ce qui permet de m'exprimer, je le prends. Je suis devenu plus sûr de moi et plus confiant en mes mains au fil du temps. Je suis moins attiré par la précision et plus intéressé par l'expression et l'émotion, par conséquent si les outils que j'emploie peuvent permettre d'exprimer cela, c'est tout ce qu'il me faut. Si c'est un bâton ou mon doigt ou n'importe quoi d'autre, c'est bon.

CJ : Vous avez travaillé avec un bon nombre de professionnels de l'estampe aux États-Unis et en Europe.

JD : Mis à part Michael Woolworth et Aldo Crommelynck à Paris, et Kurt Zein à Vienne, j'ai travaillé avec plusieurs graveurs d'une génération plus jeune que la mienne, qui ont tous été formés par Aldo Crommelynck après son arrivée à New York à l'atelier de Pace Editions. Il a formé trois ou quatre personnes avec lesquels je travaille chaque jour quand je suis à New York. Ils ont une personnalité bien à eux dans leur façon d'imprimer; ils ne sont pas des machines; ils sont très différents d'un pressier français formé en France. Les gens avec qui Aldo travaillait à Paris étaient des imprimeurs habitués aux grands tirages, ils étaient très précis parce que lui-même insistait beaucoup là-dessus. Aldo maintenait le niveau qu'on lui avait enseigné. Il imprimait d'une façon remarquable, précise et propre. Je préfère parfois l'erreur à la précision, mais ceci étant dit, tout ce que je sais de la gravure je l'ai appris en travaillant avec Aldo, et bien souvent j'ai appris parce que je n'aimais pas la manière dont il procédait. Sa personnalité est si différente de la mienne! Mais comme nous sommes de très bons amis, il ne m'en tient pas rigueur.

CJ : Votre pratique de la gravure a quelque chose de très impulsif, de très spontané. Faites-vous des croquis préparatoires ?

JD : Non jamais. Tout est fait directement sur la plaque. Je n'ai jamais fait une étude préparatoire pour quoi que ce soit.

CJ : Pensez-vous à ce que vous allez faire avant, la nuit qui précède ?

JD : Si un rêve est apparu qui m'intéresse, je peux être amené à le formuler en estampe. Souvent, je commence à graver après avoir longuement mûri l'image en dessin ou en peinture, mais pas toujours. Quelquefois l'image apparaît en gravant.

CJ : Comment réagissez-vous quand, et j'imagine que cela arrive encore après toutes ces années de pratique, vous n'êtes pas satisfait du résultat ? Vous arrive-t-il de détruire des plaques, d'abandonner complètement un travail commencé ?

JD : Non, je fais en sorte que ça marche. J'ai le sentiment que si une œuvre ne fonctionne pas et qu'elle est mauvaise, et c'est

souvent le cas, il faut la corriger. Cela apporte de l'eau à mon moulin. C'est aussi l'histoire de ces repentirs qui donne une valeur à l'image. J'aime montrer l'histoire, montrer les traces de repentir.

CJ : À regarder les estampes reproduites dans cet ouvrage, on ne peut qu'être frappé par la variété des techniques que vous utilisez et par les combinaisons étranges, inédites, auxquelles vous vous livrez ?

JD : Je fais ce qui est nécessaire. Maintenant, après avoir fait tant d'estampes, j'ai accumulé pas mal de tours dans mon sac. J'utilise ceux qui paraissent nécessaires, tout ce qu'il faut pour que ça marche.

CJ : Beaucoup d'estampes sont retravaillées après impression, rehaussées de couleurs par exemple.

JD : Je le fais depuis fort longtemps.

CJ : Parlez-moi un peu de votre méthode pour produire des lithographies en couleurs. Est-ce différent de l'eau-forte ?

JD : La gravure est plus proche de la sculpture. Il s'agit d'inciser une plaque de métal avec une pointe ou de l'acide, ou de l'é-rafler avec un outil électrique, telle une ponceuse de voiture qui produit un grisé instantané sur le cuivre. En lithographie, vous dessinez ou vous peignez sur une plaque ou une pierre parfaitement plane et cela reste après essentiellement en surface. Les quatre dernières années, j'ai travaillé avec Michael Woolworth dans son atelier à Paris pour imprimer des lithographies. Le cadeau qu'il ma fait, en plus de ses nombreuses idées sur les possibilités de la litho en général, est une technique qui consiste à faire un dessin, une peinture ou un collage sur un support transparent, lequel peut être ensuite transféré par report lumière sur une plaque sensible. Je n'aurai jamais pu déconstruire le texte dans les lithographies de Pinocchio sans cette méthode. Sa compréhension de ma manière de travailler et sa maîtrise technique m'ont aidé à trouver de nouvelles idées pour aborder le pantin en bois de Collodi. Ce que je viens de décrire ici est l'exemple parfait d'une harmonieuse collaboration entre un artiste et un imprimeur pour produire, je l'espère, de l'art.

CJ : Vous avez tendance depuis dix ou quinze ans à faire de petites éditions.

JD : J'ai réalisé des tirages importants dans les années soixante-dix quand tout le monde en faisait, mais je me suis vite rendu compte que je n'allais jamais m'arrêter d'imprimer, que je produirai des estampes tant que je serai en vie et qu'il serait ridicule de créer des éditions à soixante-quinze ou cent exemplaires en continuant de produire ainsi. Elles finiraient par croupir dans des garde-meuble, faute de pouvoir s'en débarrasser. C'est aussi à cause de mes interventions manuelles. Au-delà de dix ou douze exemplaires, ça devient d'un ennui mortel.

CJ : Pourriez-vous me citer à brûle-pourpoint une gravure ou un graveur du passé qui vous aurait particulièrement marqué ?

JD : Rembrandt, Edvard Munch et Giorgio Morandi. Ils m'inspirent. Je pense à eux tout le temps.

CJ : Pourquoi utilisez-vous de si grands formats ? Morandi, par exemple, n'a réalisé que de petites gravures.

JD : C'est souvent à cause des dimensions de la presse. J'ai fait des petits formats, mais j'ai une préférence pour les très grands formats. Avec la photographie, je fais aussi des grands tirages. Je le fais naturellement.

CJ : Et dans les cinquante dernières années, pourriez-vous citer quelque chose qui vous ait marqué dans le domaine de l'estampe ?

JD : Bien entendu, toute la production démoniaque d'estampes de Picasso me bouleverse. Ces dernières années, je me suis concentré sur les estampes que je faisais. Ceci dit, j'ai beaucoup aimé le travail d'un lithographe français à Los Angeles qui imprimait pour Dubuffet dans les années cinquante. J'ai vu des choses qu'il avait imprimées avec Sam Francis chez Gemini d'une grande beauté, où l'encre reposait à la surface du papier. C'était très fort et lumineux.

CJ : Est-il vrai que vous vous définissez vous-même comme un « print junkie » ?

JD : Un junkie pour moi, c'est quelqu'un d'accro. Je préfère paraphraser Hokusai et dire que je suis un « vieux garçon fou d'estampe ». C'est pour cela que je suis à Paris. Je suis chaque jour avec Michael Woolworth et, quand je suis à New York, je travaille tous les jours avec mes taille-douciers, parce que je crois que si l'on cultive régulièrement son jardin, on finit par obtenir quelque chose.

Cet entretien, commencé le 16 mai 2005, s'est poursuivi le 30 octobre 2006 à Paris.

Caroline Joubert: We always seem to find your name associated with Pop Art, but when asked about it, you say there seems to be some kind of misunderstanding about you and Pop. Can you talk about the beginning of your life as an artist?

Jim Dine: At the time 1960–61, it was the first moment in America when there were artists who became known and famous so young. I was the youngest, I was 23–24, Oldenberg was nearly 30. I knew artists who were older, like Lichtenstein, Rosenquist and Warhol, and who were true Pop artists because they dealt with popular culture. Their work came from the mass-produced culture. I used many common objects in their real states to make a picture. But my work came from my own invented vocabulary, which happened to include common objects; that is, when I used a tool like a hammer in the work, I used a real one, and then I would maybe draw the same hammer next to it, like a kind of tautology, but that was it. Or when I used a hat or a tie, it was just that, a singular image, like the sign in your face. So you could say that my work came from the popular culture, but unlike Warhol and Lichtenstein whose subjects were the outside world, I painted about my interior life, albeit, using things from everyday life. I don't object to being called a Pop artist, it's just not accurate.

CJ: You've always pursued a singular, individualistic path, using several different mediums along the way, painting, sculpture, photography, all the way to artist's books. Do you establish any hierarchy between mediums?

JD: No, for me it's all the same.

CJ: What role does printmaking play in these different forms of expression?

JD: I was born to print. I believe that. I can think in reverse. I usually know what an image is going to look like. The basis of all my printmaking is my respect and love of drawing, and this is the bones of my printmaking life. I like mixing up the mediums because then it becomes more painterly. Particularly these days, because I'm working with Michael Woolworth and I'm feeling lithography is more related to painting than drawing. But in the end, it all comes down to drawing.

CJ: You've been making prints since around 1960. Do you have any idea how many prints you've made altogether?

JD: I think it's close to 1,200. They're not all good, naturally, but they exist.

CJ: Do you remember the first print you made? Wasn't it when you were in your twenties?

JD: No, I've made prints since I was a boy, making woodcuts and printing with a spoon.

CJ: Do you still have any of those?

JD: No, the earliest print I own is a suite of lithographs called *Car Crash*, I think from 1960.

CJ: Why is it important for you to continue producing you graphic work?

JD: I make prints because I love to print. If I only made an edition of one, I would be happy to make it. But because it's a print,

I can do more, and financially it's been very good to me, but since I make so many prints and since business has so many rules of supply and demand I am not making prints that can be considered rare. Some sell and some don't, and it has nothing to do with quality. Some of the prints scare you, and some are decorative, or some have familiar images.

CJ: With the arrival of new technologies in the art world, printmaking, with its artisanal way of making images, can sometimes appear old-fashioned or out of touch. Do you find it's still important to print images on paper the same way it was done in the time of Dürer?

JD: Yes, that's my pleasure; my pleasure is to make things with my hands. I use my hands to print. I use my hands to cut the wood or to make the intaglio, because it's the same thing as painting and drawing for me.

CJ: Do you imagine a future in the print world? Will artists, in your opinion, still need to go to that medium?

JD: I've no idea, it doesn't look like it so much, and I don't think young artists care so much how something is printed as long as they get the image. That to me was always reproduction, not a print, so for me a print is something made with your hands. I'm very old-fashioned. And I'm very old.

CJ: Can you talk about the presence of tools in your work? Do you use them to show that different forms of art always pass through a technical dimension? Are they witnessing a more conceptual way of working? Are they autobiographical?

JD: They're autobiographical. I thought I would depict the tools I use to draw or etch with. I've had a lifelong relationship with tools of the hand. And therefore I spoke about what I know.

CJ: Your iconic images – the heart, the robe, the skull, the Venus, the raven, the owl – these are recurrent in your work. Do they have an autobiographical meaning for you as well?

JD: I wouldn't use them if they weren't personal metaphors for whatever lies deep in my unconscious, and therefore everything I make is autobiographical.

CJ: You refer quite often to self-portrait or *vanitas*: classical references that one finds in the German Renaissance. On the other hand, one finds in your work few references to the modern world, which gives a certain timeless dimension to your prints. Would you agree?

JD: I use a lot of things to make a link with my forbearers in art, to keep a kind of continuity with these people going. For instance, when I was at the Glyptothek in Munich, drawing at night, it was a kind of meditation on the anonymous sculptor who had carved the sculpture. Hands across the sea, like a bridge.

CJ: Some motifs belong to a certain tradition, then, like those cited above from the Glyptothek, and others from your dreams, such as the dark ones from the suite *Winter Dream*…

JD: Yes. Some things that I use come from things I have found, *objets trouvés*, like the bathrobe; it comes from an illustration. Or the heart, it's in the vernacular. It's in the vocabulary of the visual world. *Winter Dream* comes out of a dream, out of the unconscious, from the dream called Winter. I tell it in the books *Birds*. The dream is there.

CJ: What seduced you so much about the Pinocchio figure? Is it that he's half doll, half human, that he's so very awkward and clumsy?

JD: What drives me is when I was a small boy, I saw the Walt Disney movie, and it was a very frightening experience. I was a liar as a boy, and in the story and in the Collodi book, bad little boys are punished. This little boy remains a very touching personage for me and I like to celebrate him and take care of him.

CJ: The production of the illustrations for *Pinocchio* made Collodi's text more familiar to you. The story has a symbolic impact, it talks about a wooden puppet who acquires the state of a boy; it also has a moralistic dimension, the self-centered and lying child promises close to the end after a hard voyage of initiation, to be good; one can also see the apology of freedom and disobedience. With which of these interpretations do you feel closest? One imagines your attachment to the Pinocchio character comes from some personal identification, identification with the puppet but also with its creator, Geppetto.

JD: It's bigger than that. I've spent so much time with the story the last two or three years. I've examined it closely. It's clearly a metaphor for making art. Geppetto is given a talking stick. He carves it into the figure of a boy. The wooden boy goes through "hell" to be born as a person. This is how "art" is made. It's also an alchemical idea, transforming shit into gold.

CJ: It is also a very visual story with many characters and animals. It seems to be it's the first time you really have gone into an illustrating process. The rapport of image and text, an intense typographical point of view, is innovative and impressive.

JD: No. Almost all the books I've made are like that. The text is closer to the motifs here. I've cut the text and reassembled it. It may have been less specific before.

CJ: Amongst the large variety of techniques you have used, do you have any special preference? Are you driven by the necessity to always explore new approaches through these techniques without limitations, even digital or photocopy, for example?

JD: I'd use anything that worked but I wouldn't be so happy to use a photocopy. I'm driven to express myself so whatever it takes to express myself I would use. I've become more sure and more confident with my hand through the years. I'm less interested in accuracy and more interested in expression and emotion, and if the tools I use can express that, then that's all it takes. If it's a stick or my finger or whatever, I don't care.

CJ: You've worked with a large number of printmakers in the States and in Europe.

JD: Besides Michael Woolworth and Aldo Crommelynck in Paris, and Kurt Zein in Vienna, I've worked with many etchers a generation younger than myself, all trained by Aldo Crommelynck after he came to New York and set up shop at Pace Editions. He trained three or four people I still print with every day when I am in New York. And they're quite personal in the way they print, they're not machines; they're different from French printers. The people Aldo had working for him in Paris were edition printers, they knocked it out and were accurate, because Aldo insisted on accuracy. Aldo held to a standard that he was taught. He printed in a very beautiful, clean way. Sometimes I even prefer mistakes over accuracy, but saying that, everything I know in etching I learned by working with Aldo, and many times I learned it because I didn't like the way he did it. His personality is so different from mine and we are such good friends that he didn't mind.

CJ: Your approach to printmaking comes across as something impulsive, very spontaneous. Do you make any preparatory sketches?

JD: No, never. It's all done on the plate. I've never made a sketch for anything.

CJ: Do you think about it beforehand, the night before?

JD: If I have a dream that I want to talk about, I will bring it to printing. Sometimes I may have explored the image in drawing or painting, but not always. Sometimes, printmaking gives me the image.

CJ: What do you do, and I imagine it still happens despite years of practice, when you're not satisfied with a result? Do you sometimes destroy plates, or throw out ongoing work?

JD: No, I make it work. I feel if I put it down and it's bad, and often it is, it has to be corrected. It's grist for my mill, it's fodder. It's also the history of one's tracks. It is valuable in the image for me. I like showing the history, showing the tracks.

CJ: Looking at the prints reproduced in this catalogue, one is struck by the variety of techniques you use and by sometimes odd combinations, unheard of approaches.

JD: I do what's necessary. At this point, after all the prints I've done, I have quite a bag of techniques I carry with me. So I use what's necessary – whatever it takes.

CJ: For example, several prints are worked on after the final printing by handcoloring.

JD: I've been doing that forever.

CJ: Talk about your method for making a colored image in lithography, is it different from etching?

JD: Etching is more like sculpture. It's about incising into the metal plate with a needle or acid, or abrading the metal with an electric tool (such as an automobile grinder that can produce an instant grey on copper). In lithography you draw or paint on a

perfectly flat plate or stone and it stays essentially on top forever. In the past four years, I've worked with Michael Woolworth at his atelier in Paris printing lithographs. The gift he has given me, besides his expansive ideas about what litho can do in general, is the technique of drawing or painting or collaging on a transparent material that light can go through and exposing it into the plate. I would not have been able to deconstruct the text in the Pinocchio lithos without this method. His openness to my way of working wedded to his own technical expertise has helped me give birth to my new ideas about Collodi's wooden boy. What I've just described is a perfect example of the artist and the printer collaboration in harmony to produce hopefully – art.

CJ: You have a tendency for the past ten or fifteen years to make small editions…

JD: I made large edition in the '70s, when people were making large editions, but I realized I was not going to stop printing, I was going to print as long as I'm alive, and it would be ridiculous to make editions of 75 or 100 if I'm making all the prints I'm making because they'll just sit in warehouses somewhere, you couldn't get rid of them, and also because of all the hand coloring. It's very boring to go beyond ten or twelve.

CJ: Are there references from the past that are illuminating for you and drive you?

JD: The references come from artists like Rembrandt and Edvard Munch and Giorgio Morandi. They inspire me. I have thought about them all my life.

CJ: You use such very large formats. Why? Morandi for instance only made small prints.

JD: Often because of the size of the press, I've made some small prints, but what I really like is a big print. In photography too, I make big prints. It's what I do naturally.

CJ: In the last 50 years, is there something that inspires you in printmaking?

JD: Of course Picasso's demonic full print production thrills me. In recent years, I've concentrated on the prints I've made. I have loved a French lithographer who worked in Los Angeles who printed with Dubuffet in the '50s, I saw things he printed with Sam Francis at Gemini that were beautiful, where the ink sat on top of the paper. That was very strong and luminous.

CJ: You define yourself as a print junkie. Is that true?

JD: A junkie in my definition is an addict. I prefer to paraphrase Hokusai, and say I'm an "old boy crazy about printing." That's why when I'm in Paris I'm everyday with Michael Woolworth and when I'm in New York, I print every day with my etchers because I figure if you tend to your garden, you're going to get something to grow.

This interview took place on 16 May 2005, and 30 October 2006 in Paris.

estampes

prints

Ghost
ROBE ⸺

after an other robe print
was inked & printed a blank
sheet was put on the block
and printed again with out
inking just using what ink
was left on wood surface.
a ghost of an image......

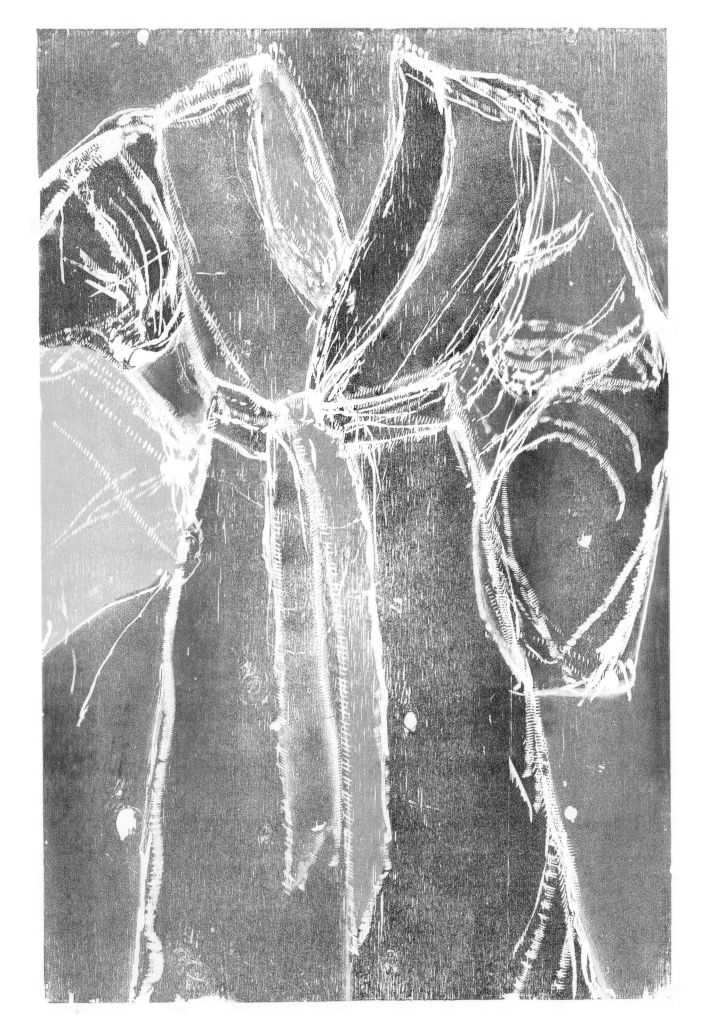

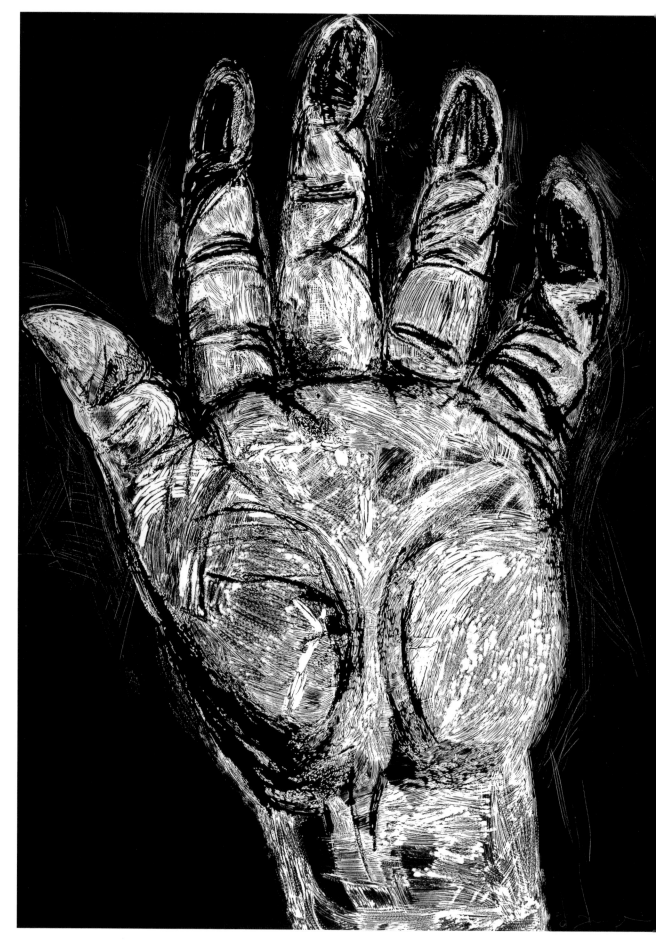

Double Pacific 9

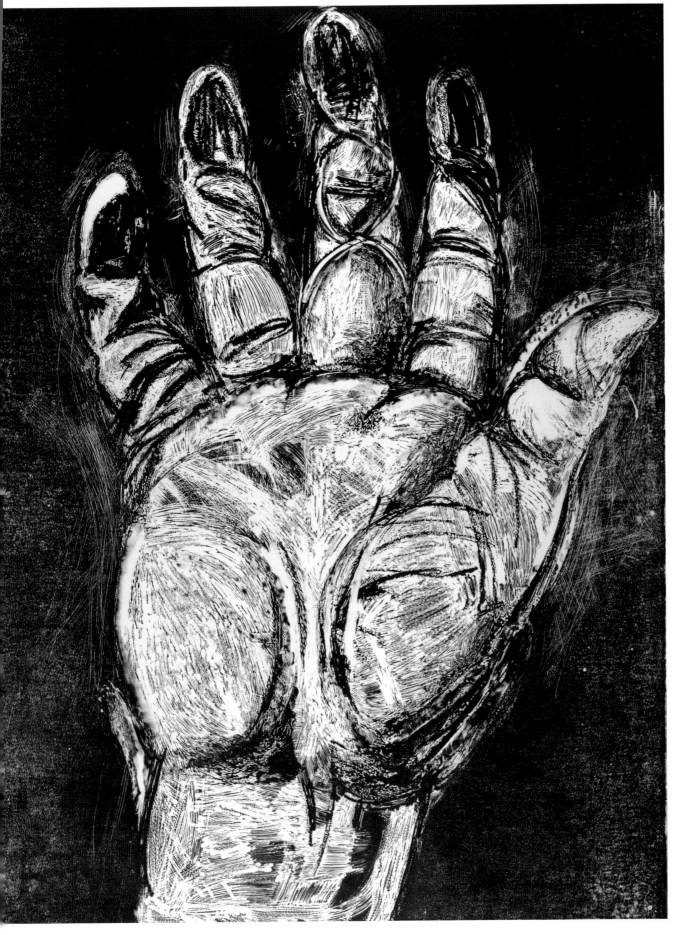

ift

1985)

2 Sheets butted together!

Self in the Ocean
1991

heart is
hand painted
by me

printed in
copenhagen

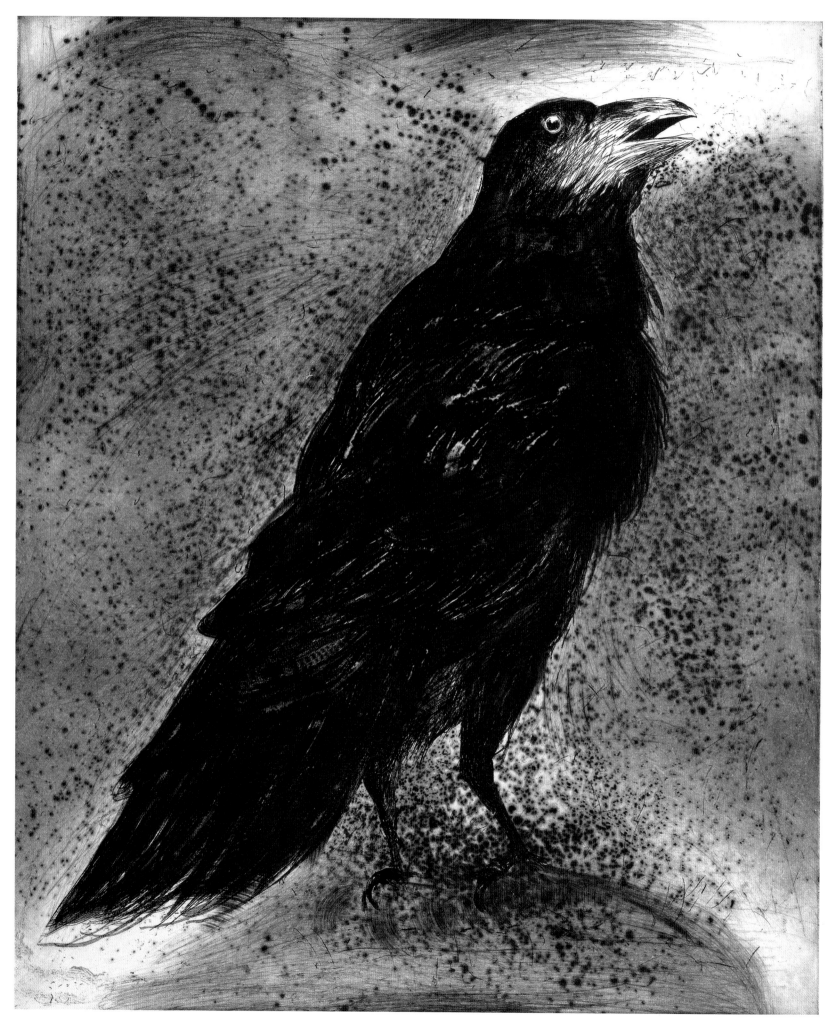

RAVEN ON CLOTH

(Etching printed on cotton canvas)

1994

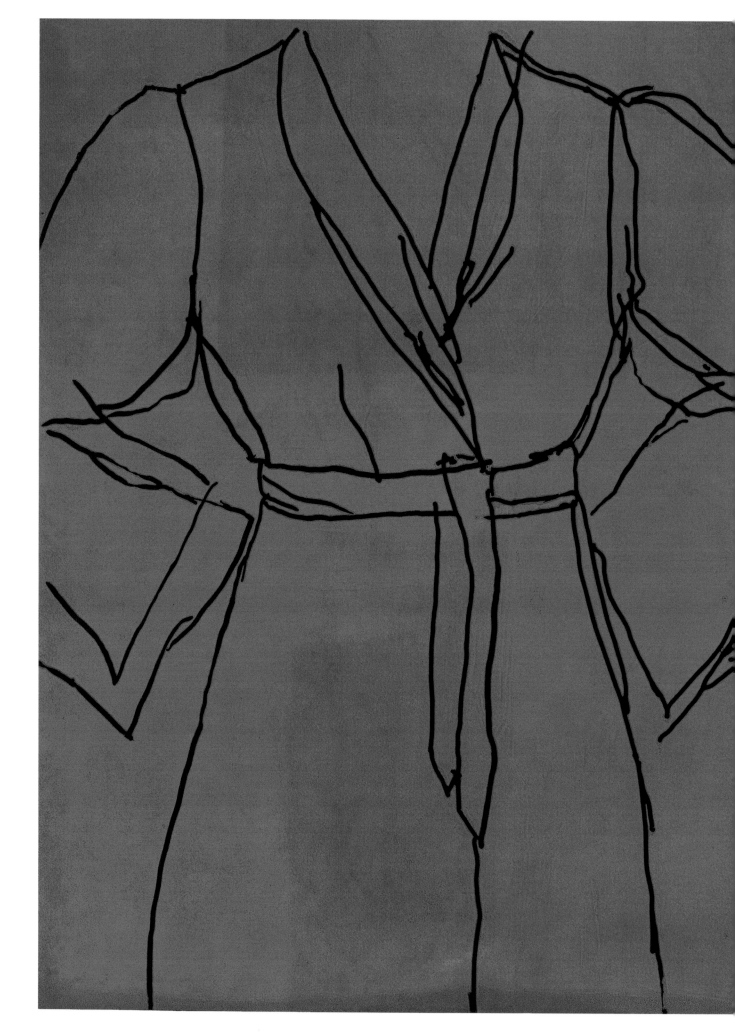

DEXTER & GUS

The SIDE VIEW

from 1986

(copper plate is 105,4 × 98,7

44

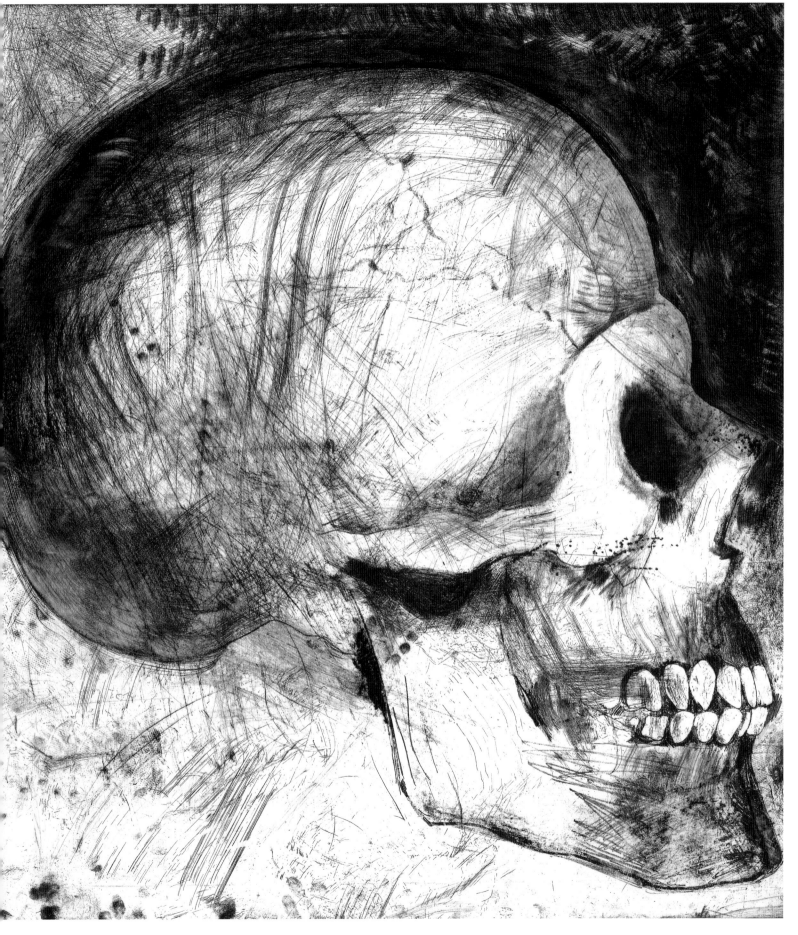

Litho, wood cut (chain saw!) +

"Pinocchio in a Card" 2006

"SAKUSA"
(3rd Version)

title is the name of this piece; its printed over

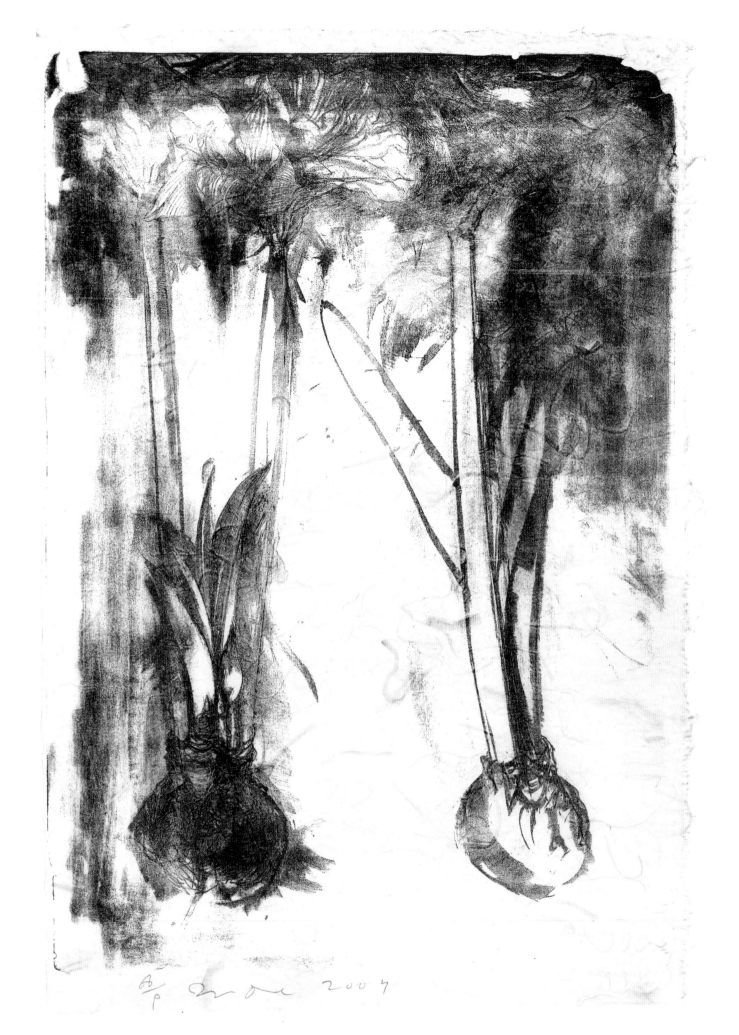

A/P 芝雪 2007

49

The Blue Carborundum Robe

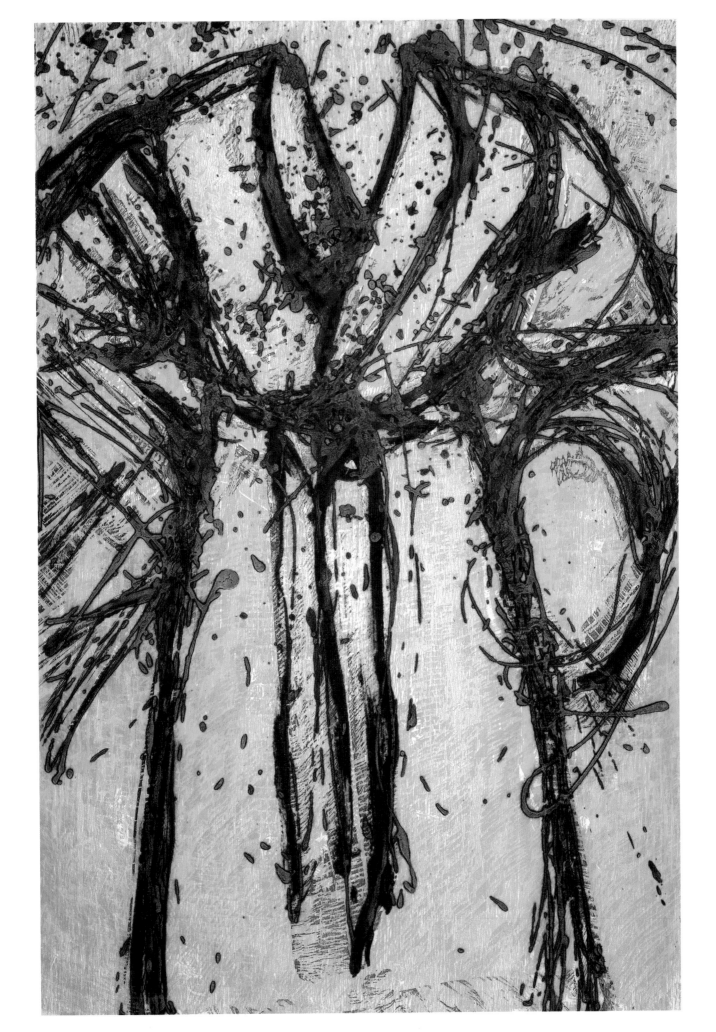

Sun's might glow, 2000

Lithograph
printed in Chicago
at Landfall Press

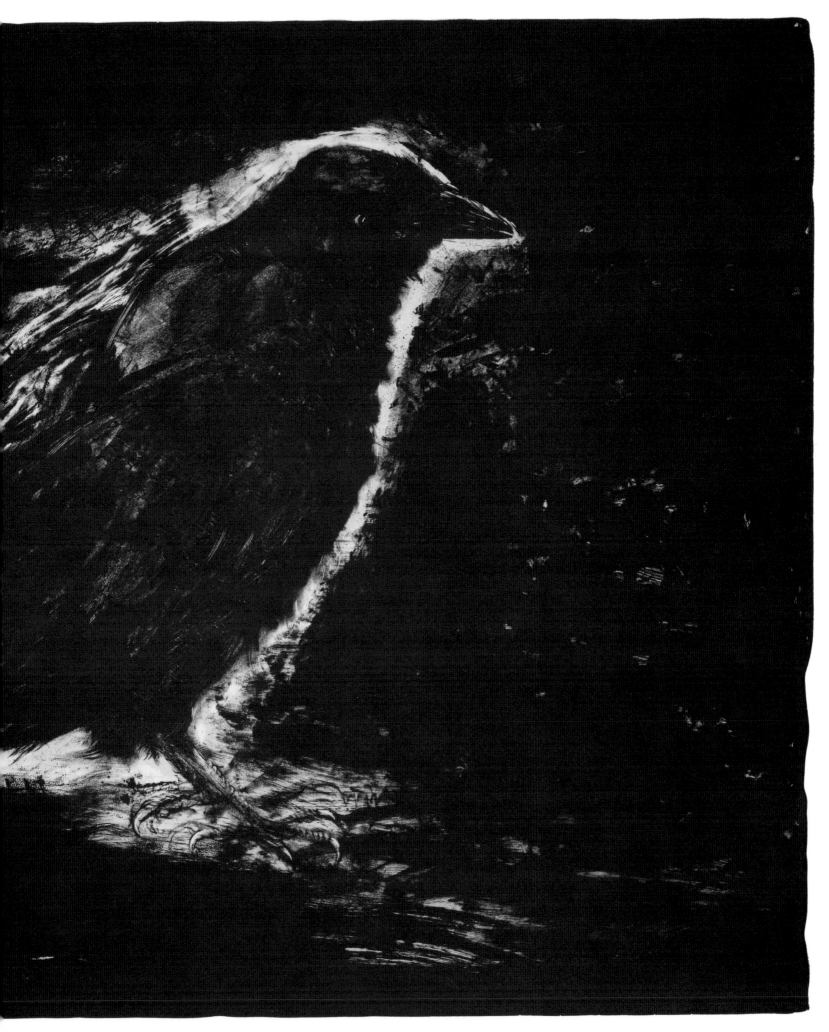

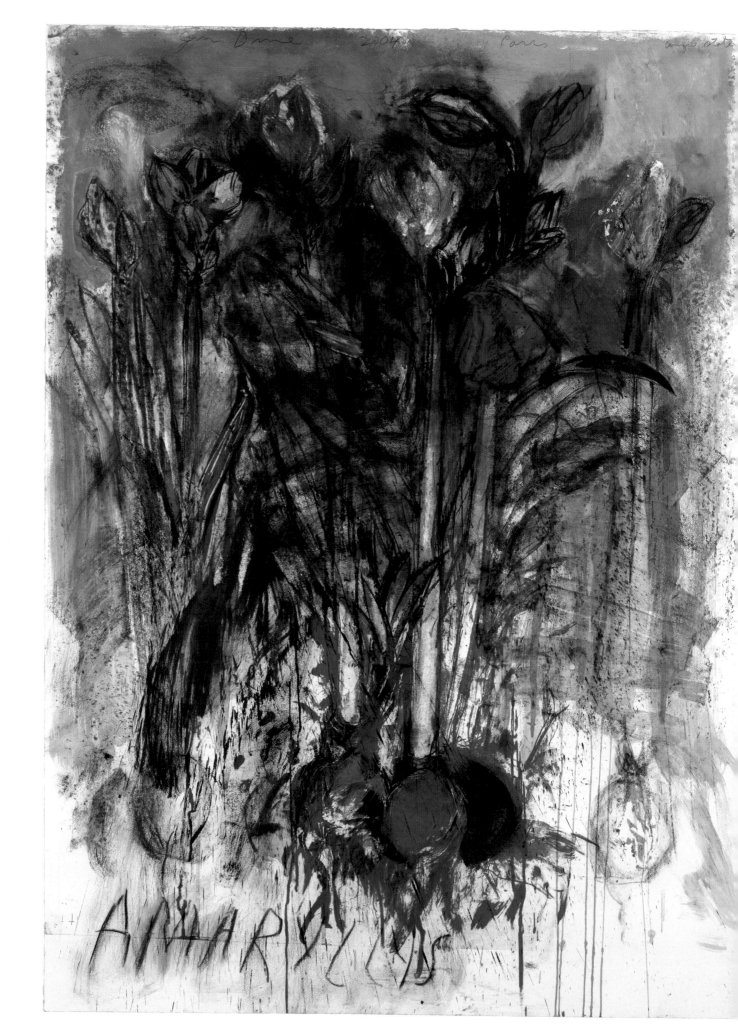

PARIS IX

alot of Hand painting
Lithograph with Mono type
over it.

WHITE Fi.

THE RED ONE !

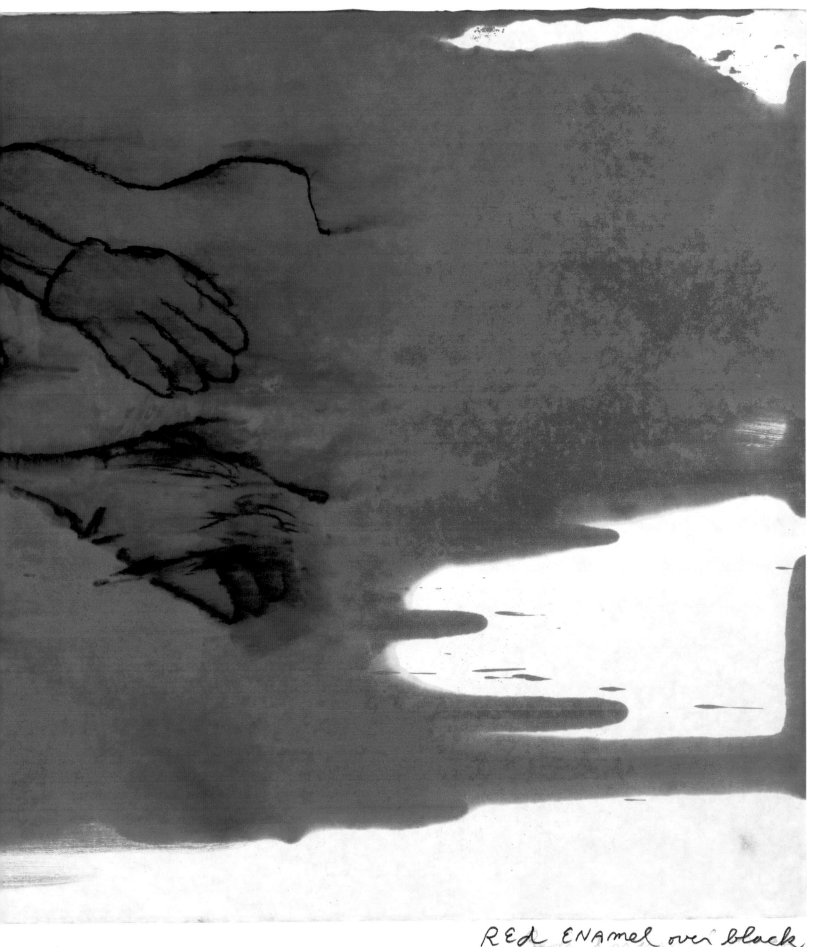

2006

RED ENAMEL over black
ink on Japanese paper,
made in Paris

7 colour pass dream

Seven colour pass
dream 2006

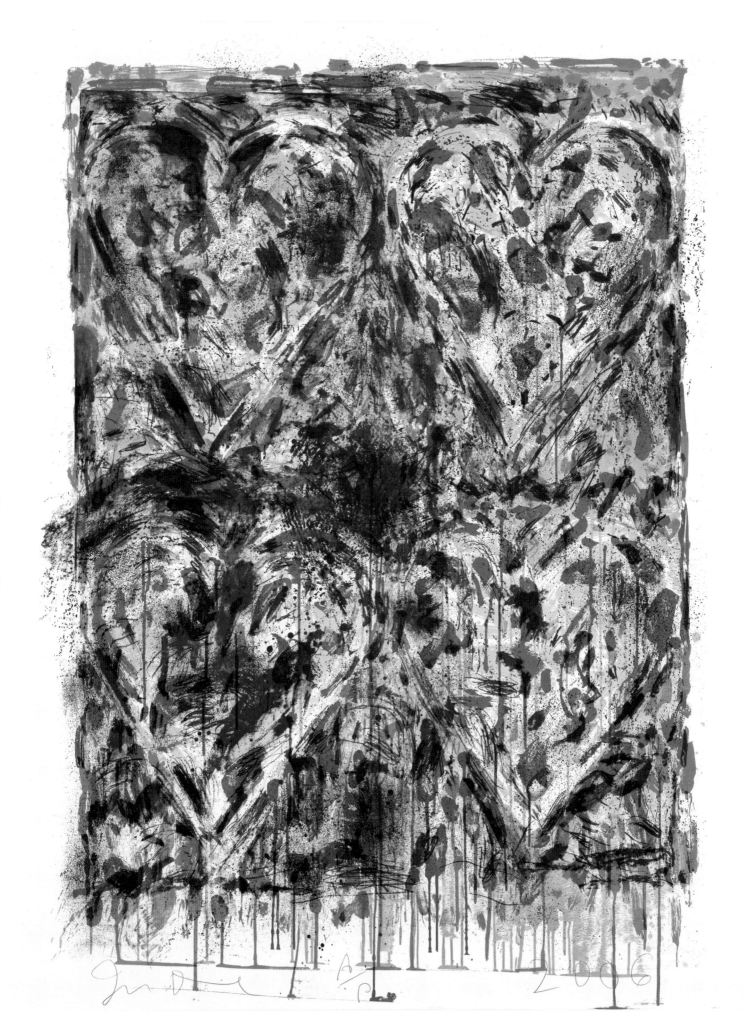

Jim Dine A.P. 2006

61

2 OLD BATHERS

hand painting on the cut out copper venus that was the central figure for the etching "RISE UP SOLITUDE" from years ago

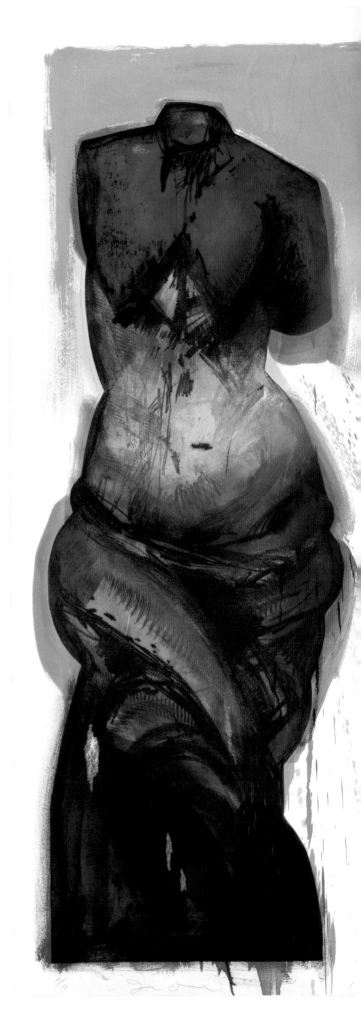

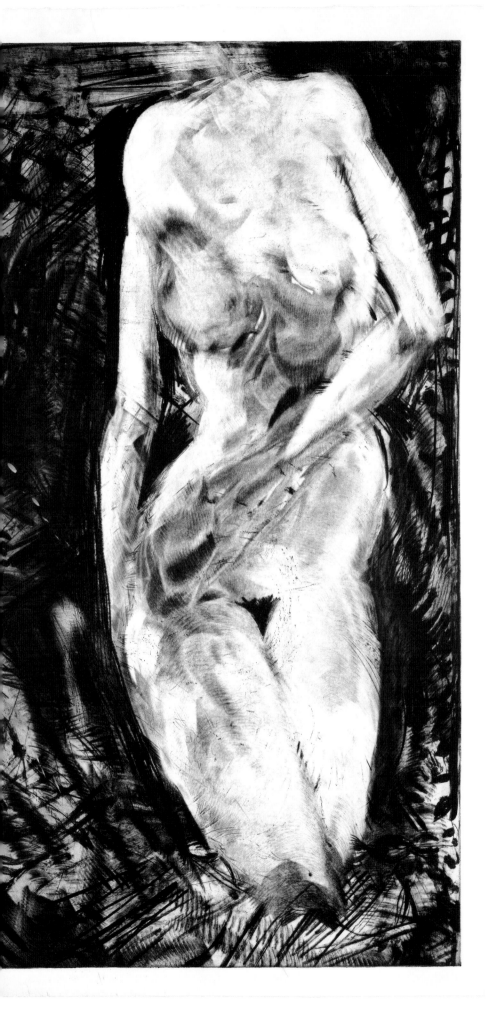

The dear "thin
madame" drawn
with an automobile
body grinder at
Kurt Zein's in
Vienna in 1993

63

Big Winter Breathing →

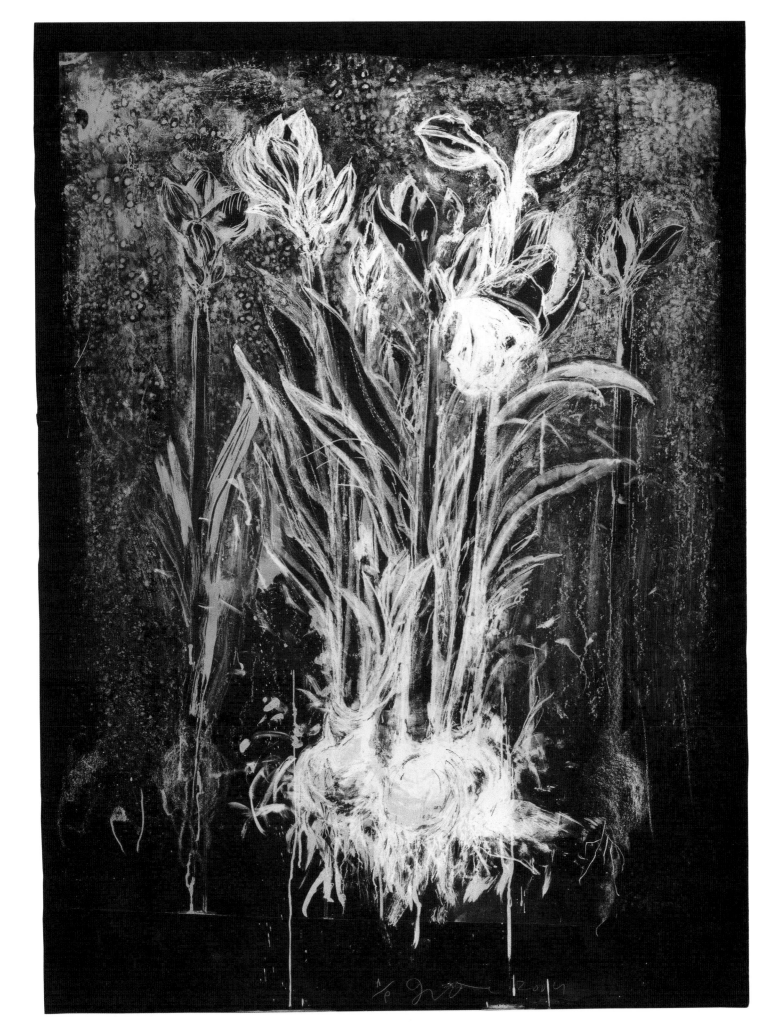

felt skull

woodcut on papermaking felt
printed by Julia D'amario & Ruth Lingen
in New York City 1994

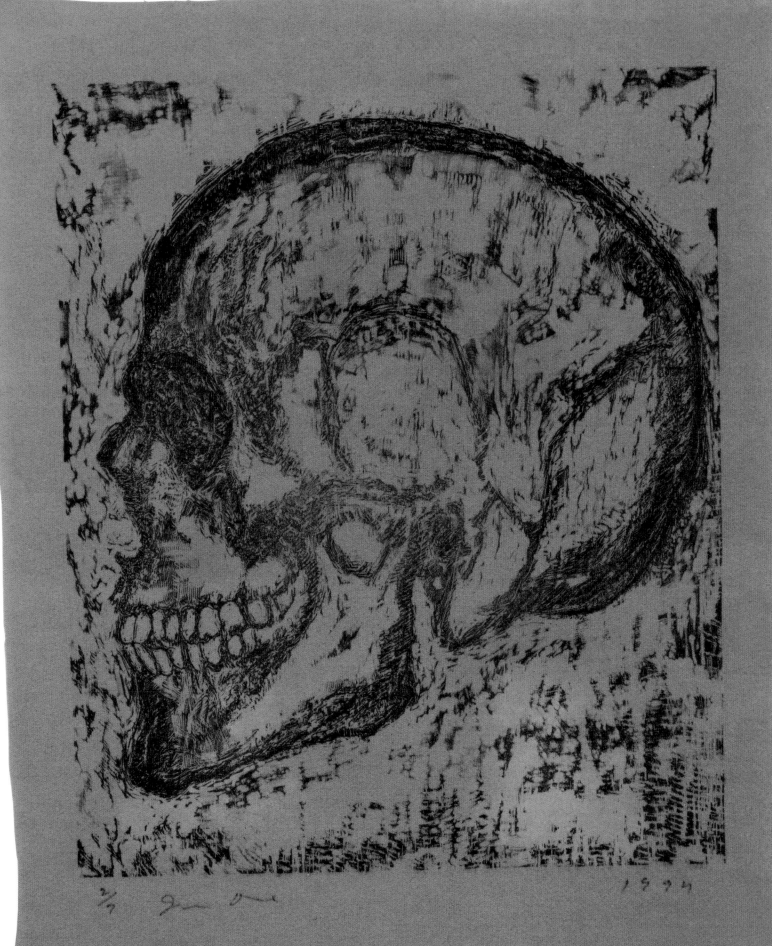

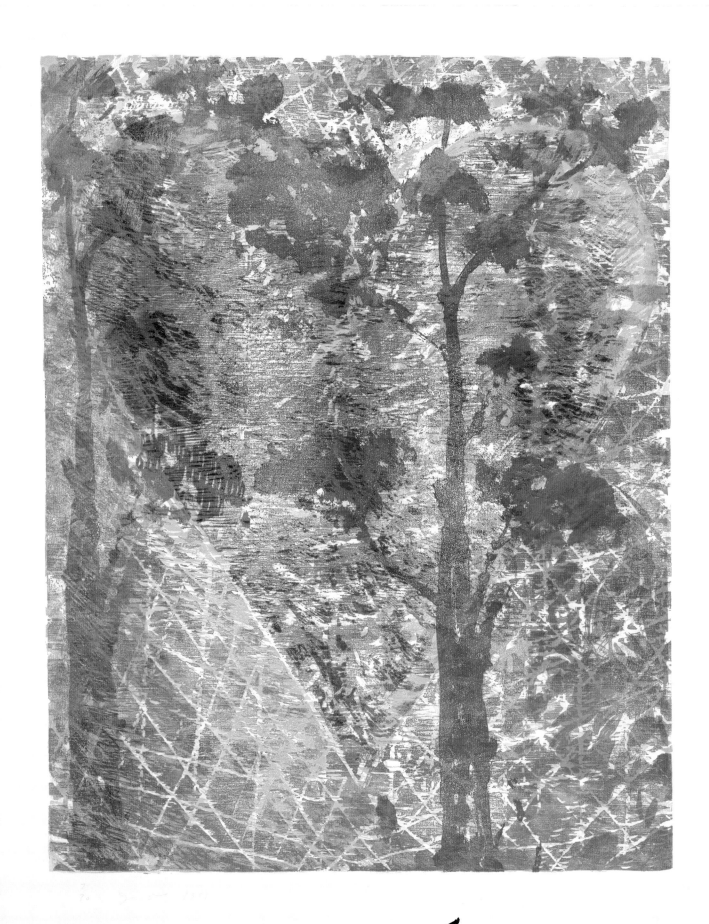

Tree from 'The foreign Plowman' "used again!

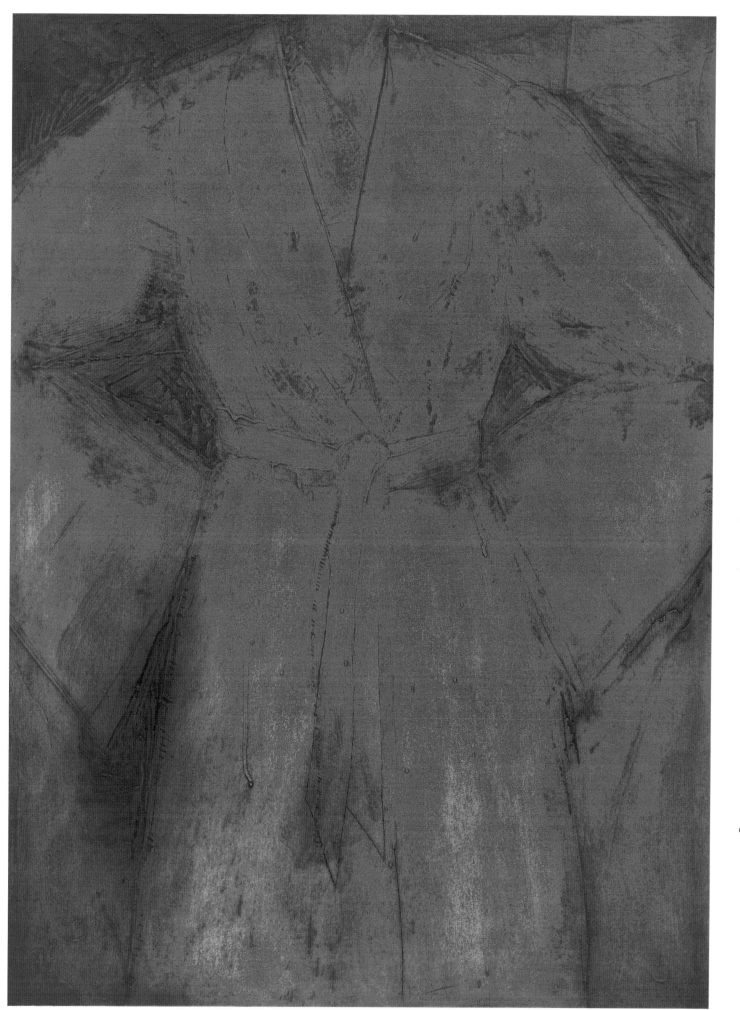

Red sitting with me — Bill HALL & Giulia D'innury in NYC

69

"Pure Woodcut"

Background is cut with a
Chain saw. the "Boy" is cut with a
rotary carver

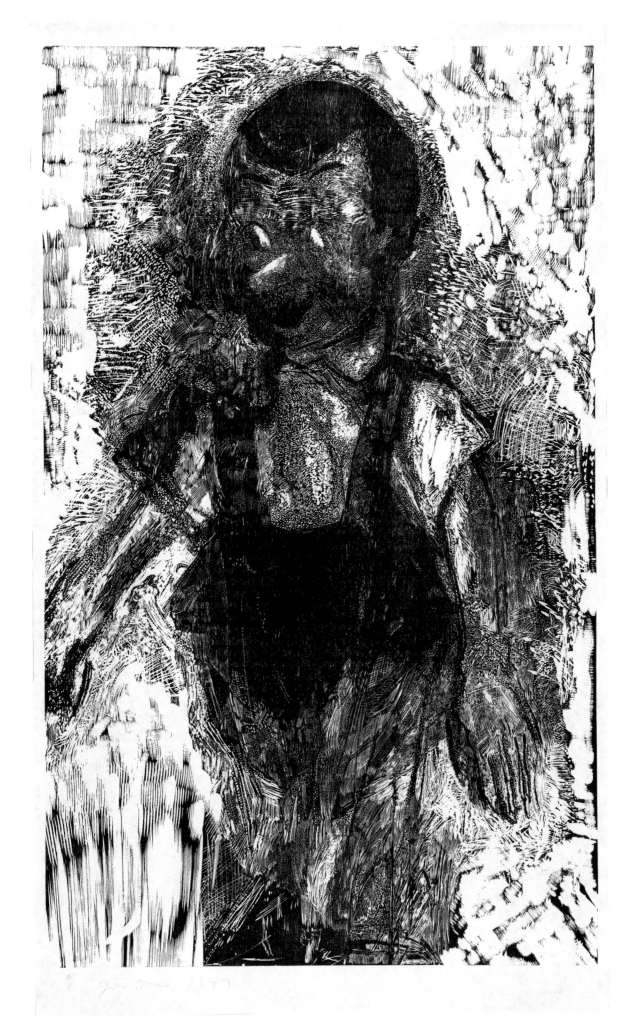

71

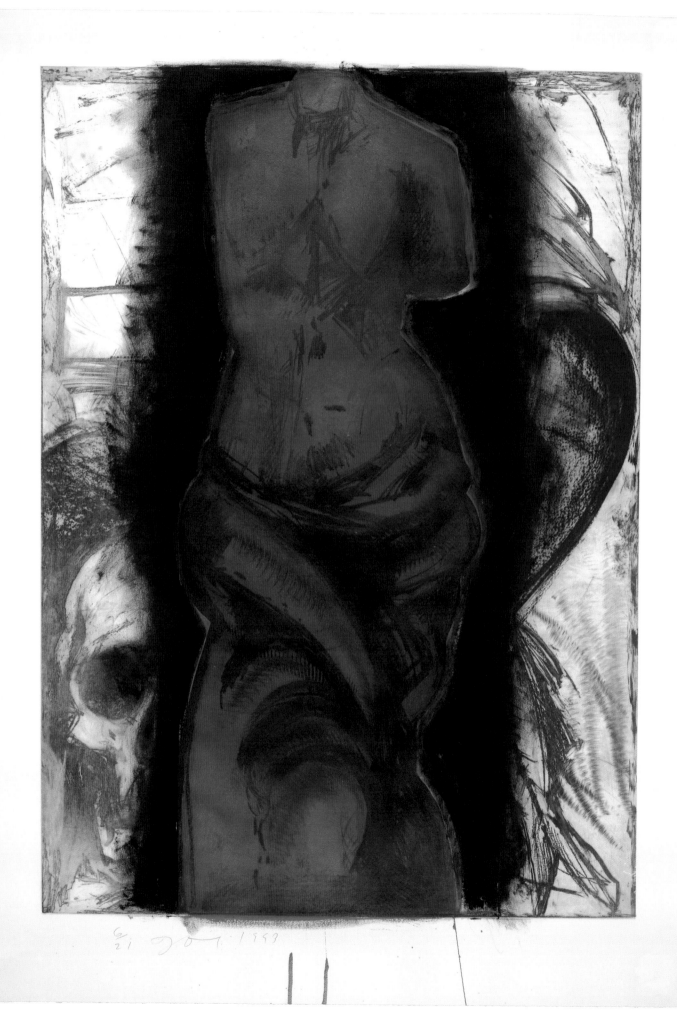

WOMAN ON FIRE
IN VIENNA

Same Venus plate used
as 2 old Bathers, but
lots of heavy red
enamel painted on first
then the plate was
inked darkly and printed
over the Red (FIRE)

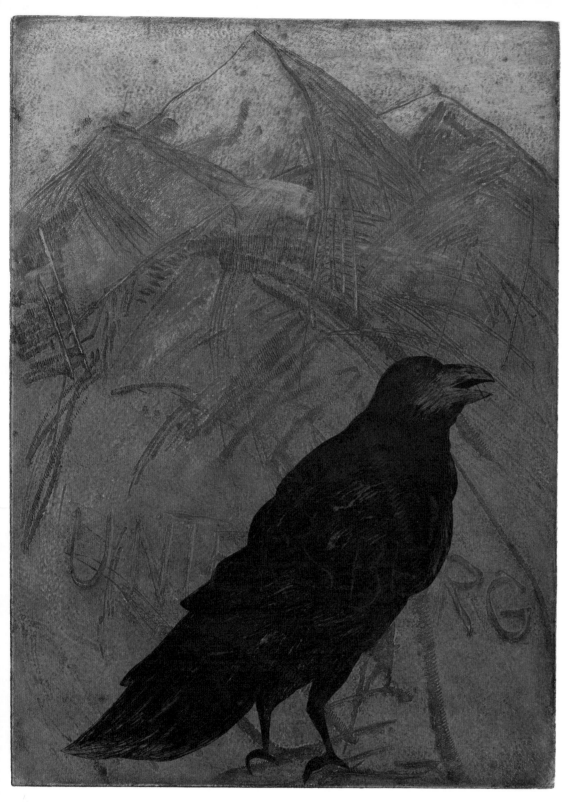

THE HISTORICAL

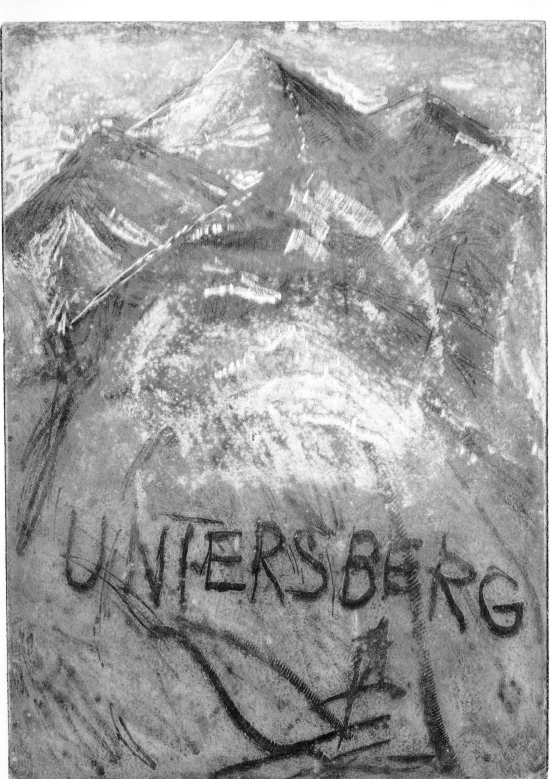

UNTERSBERG

The Pro Consul

is a perfect example of card board intaglio that Kurt Zein & I first printed with in Vienna in the 80's. I've used a lot of acrylic filler & medium to build the surface and I've dried the medium _fast_ to achieve the cracks in the surface.

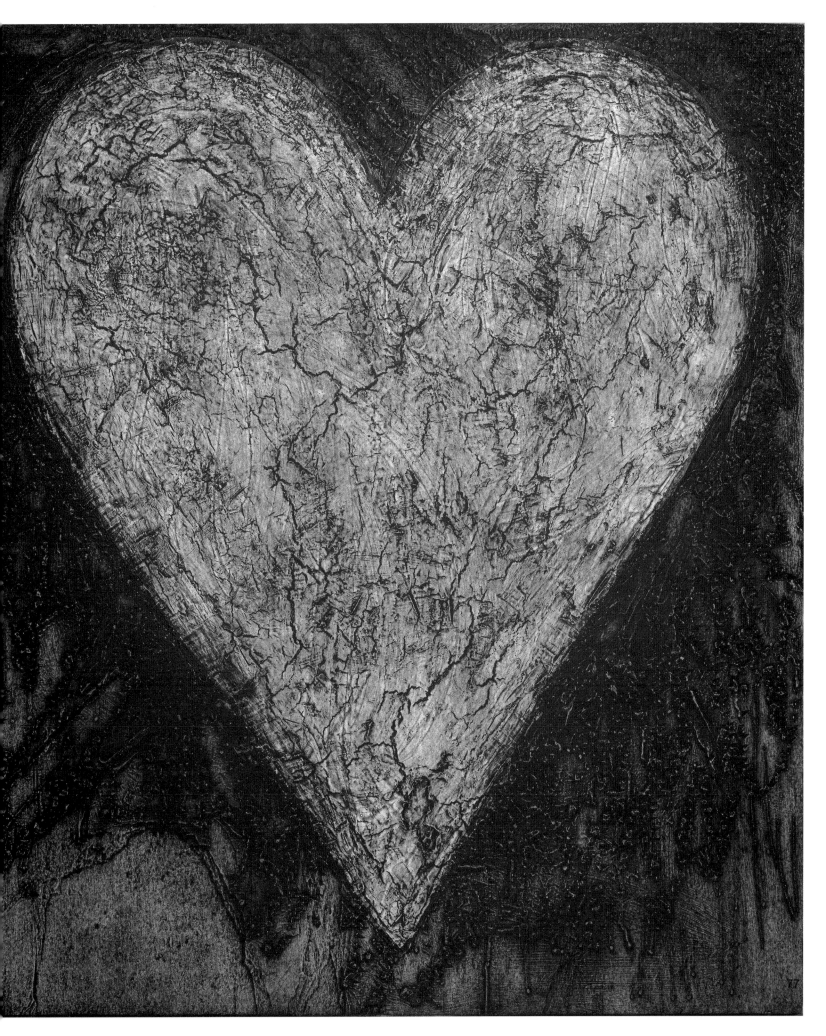

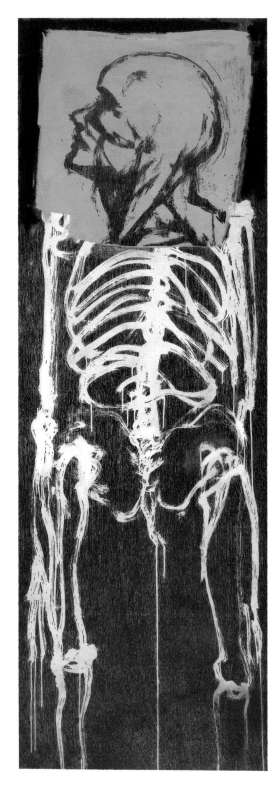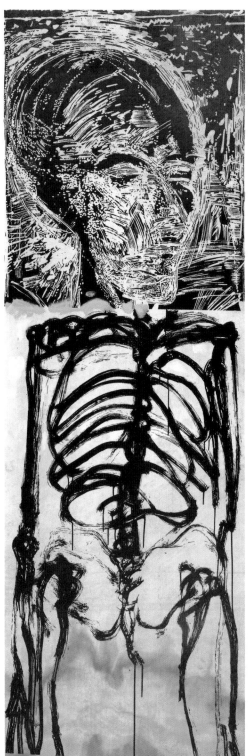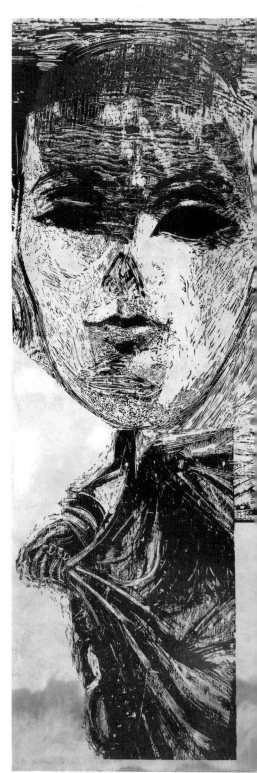

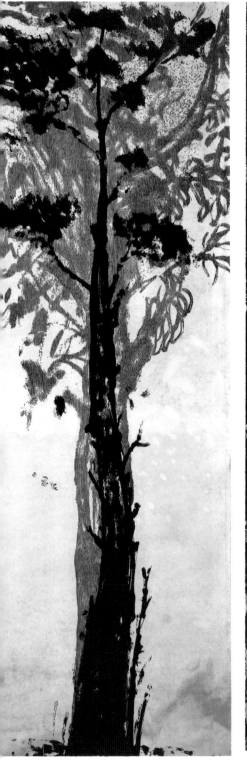

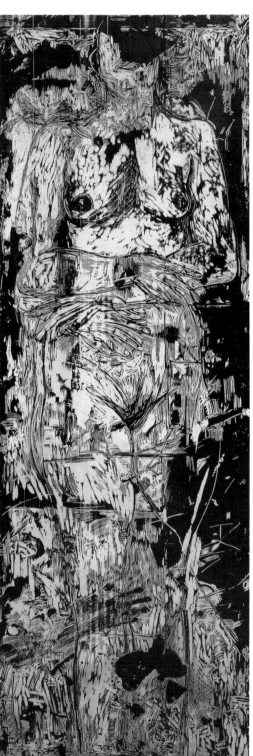

The Foreign Planswoman 1988

printed by Don saff in florida.
& first thought of it as a folding
screen.

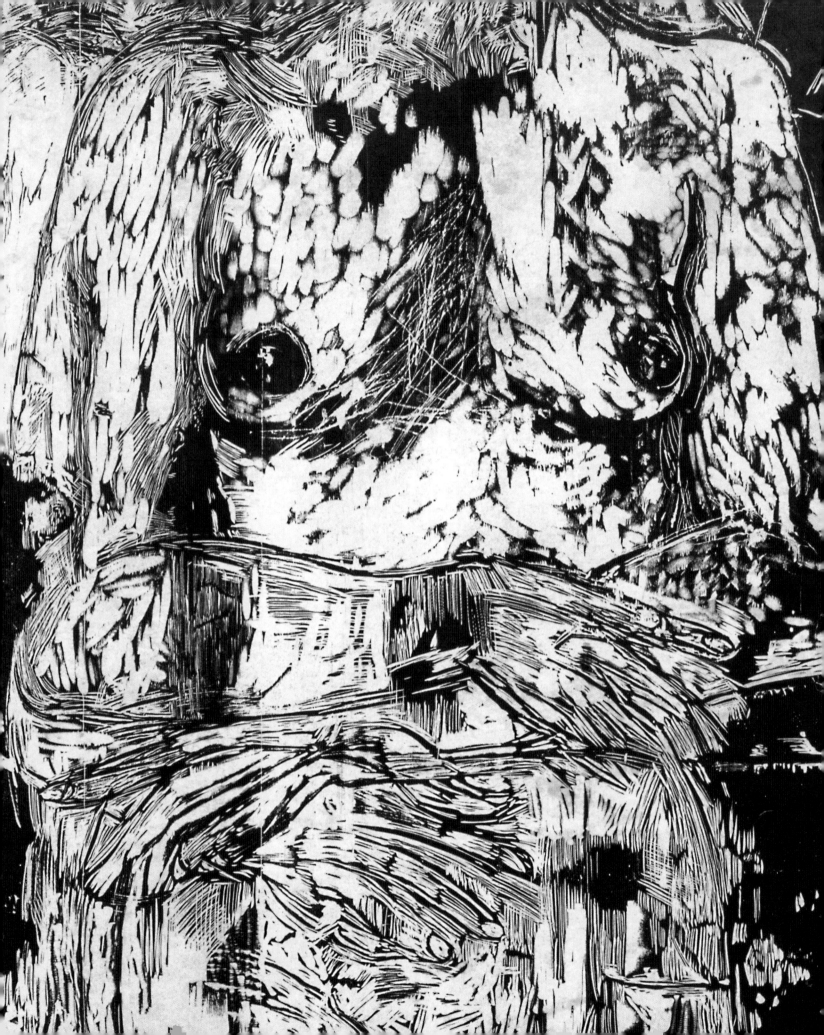

DETail
of Last panel
of F. P.

White
Owl
1995

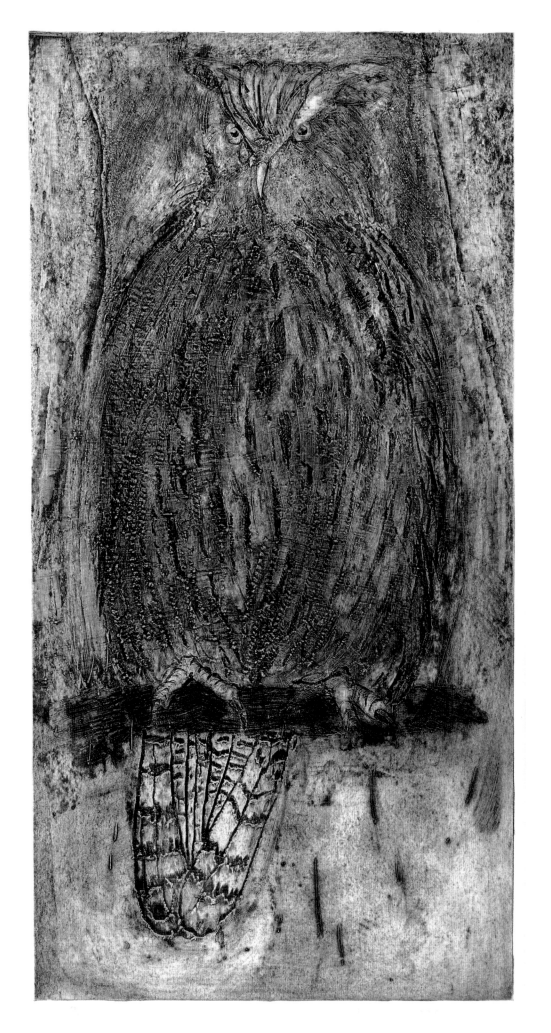

"Sepia with
Coconut"

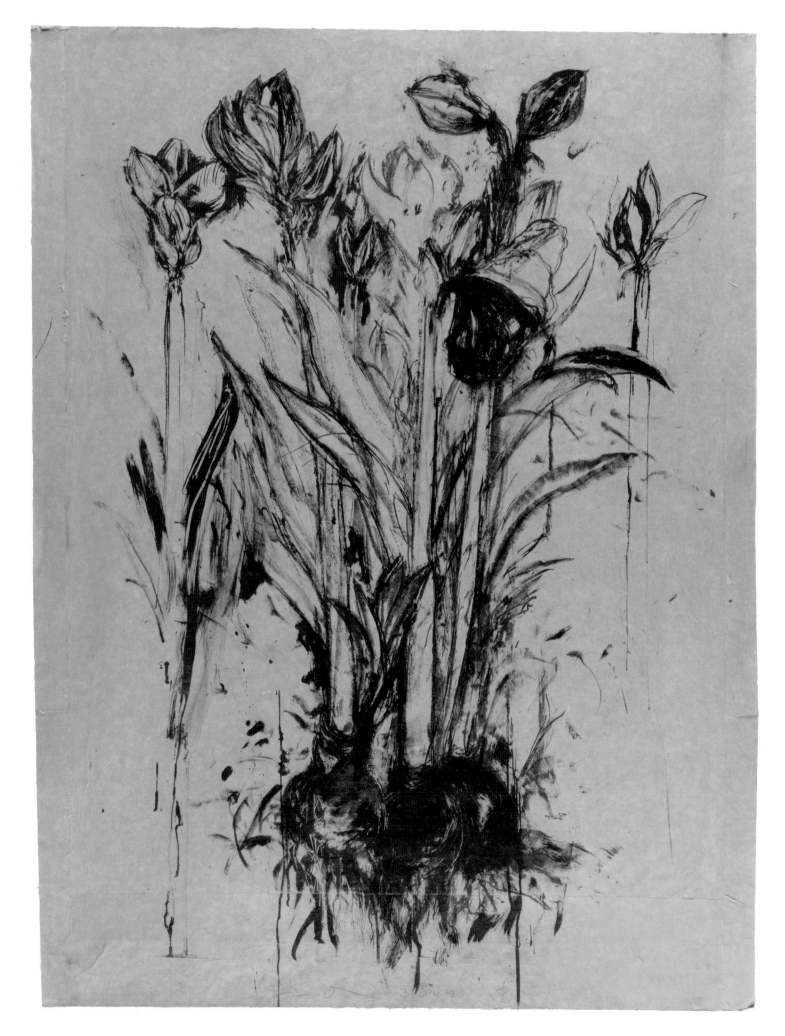

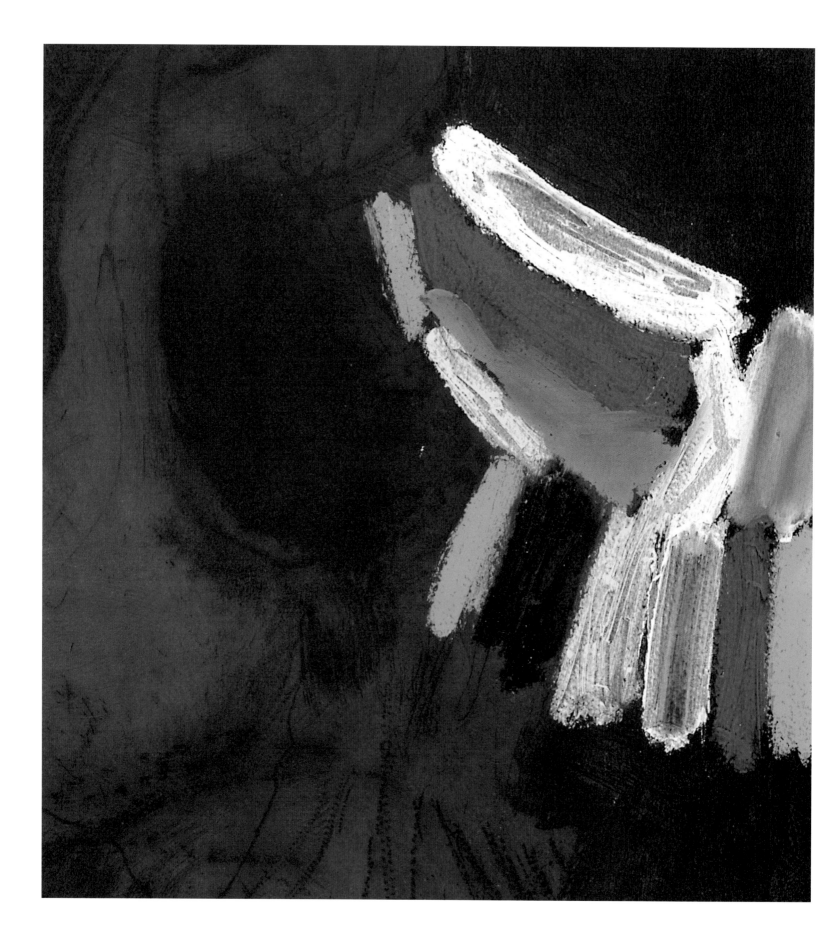

86 "Grease, bone & color"

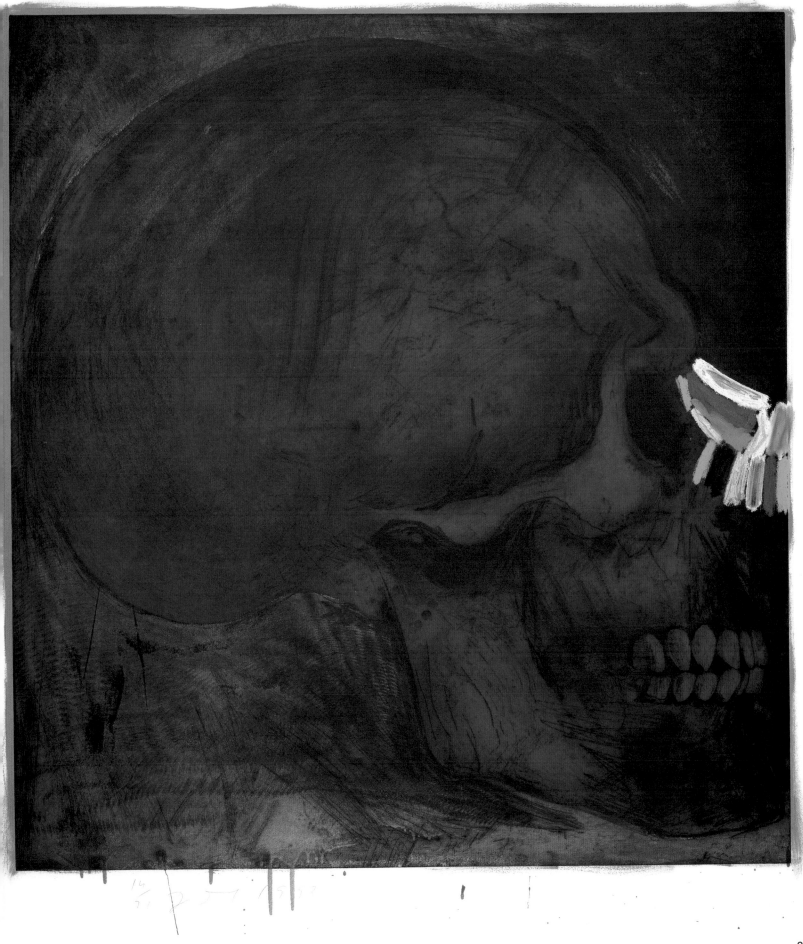

LAKESIDE 1998

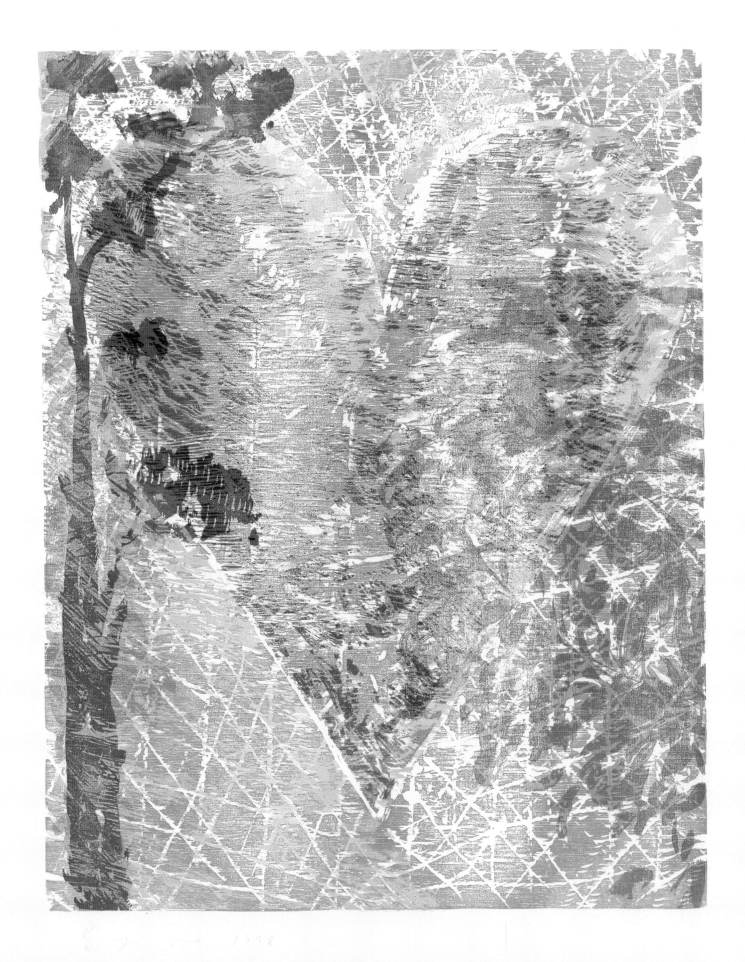

Winter
Breath –

2nd Version

2004

printers: Michael W.
& Dan Clarke

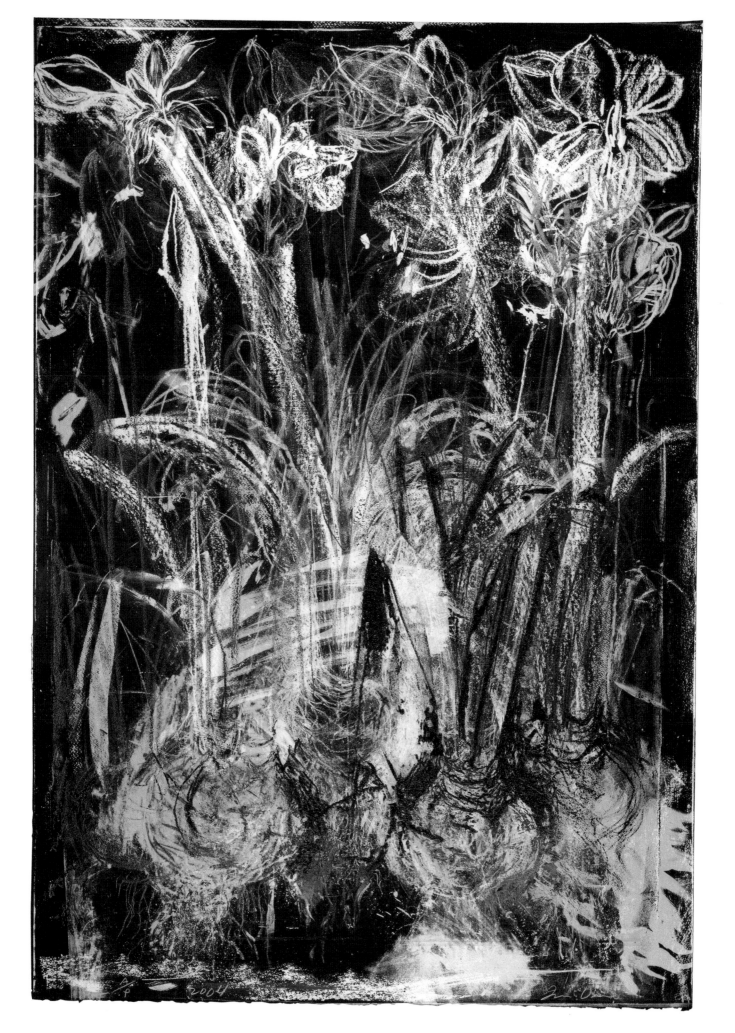

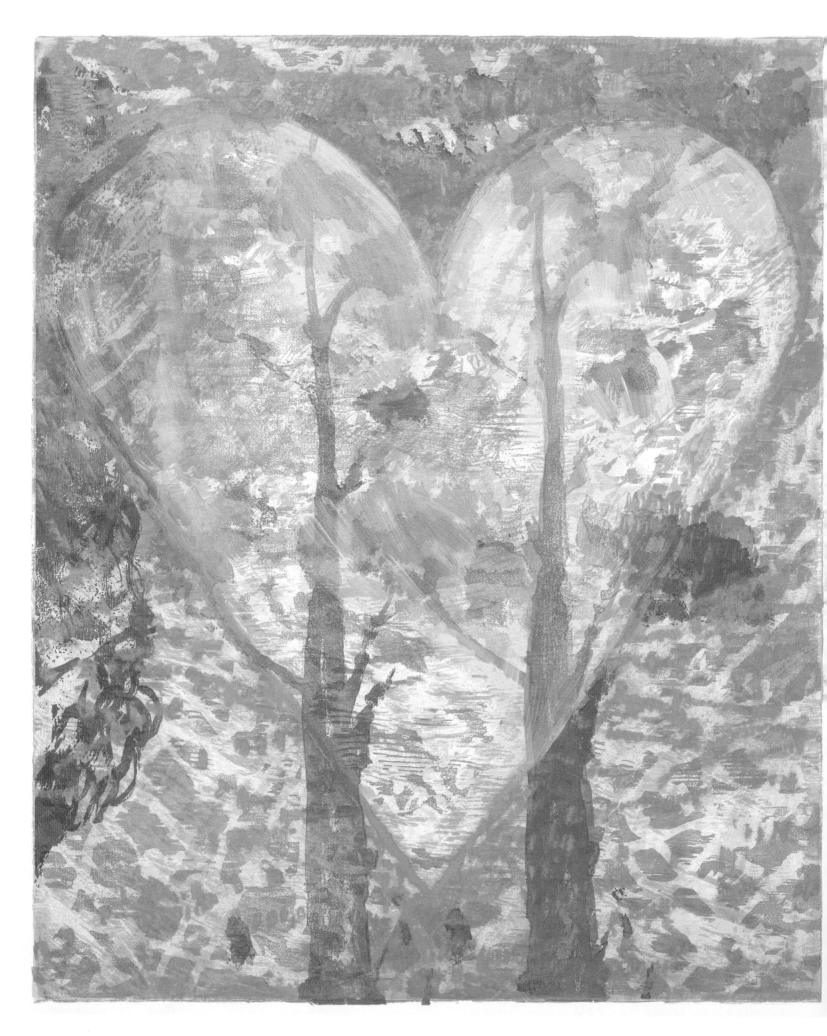

NOON

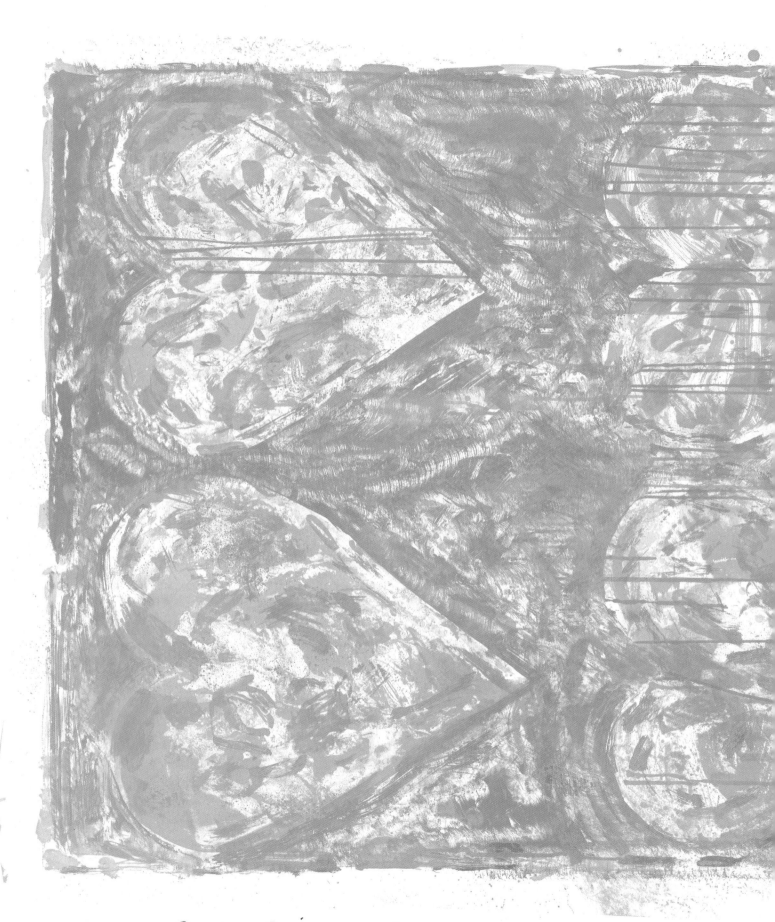

one of the big 4 heart prints from

YELLOW MINTS

Michael Woolworth's Malakoff studio

95

(-) and painted
AFRIKA

The black marks are printed from the filter plate and then every other mark is painted by me. In this case I am the printing machine.

2005

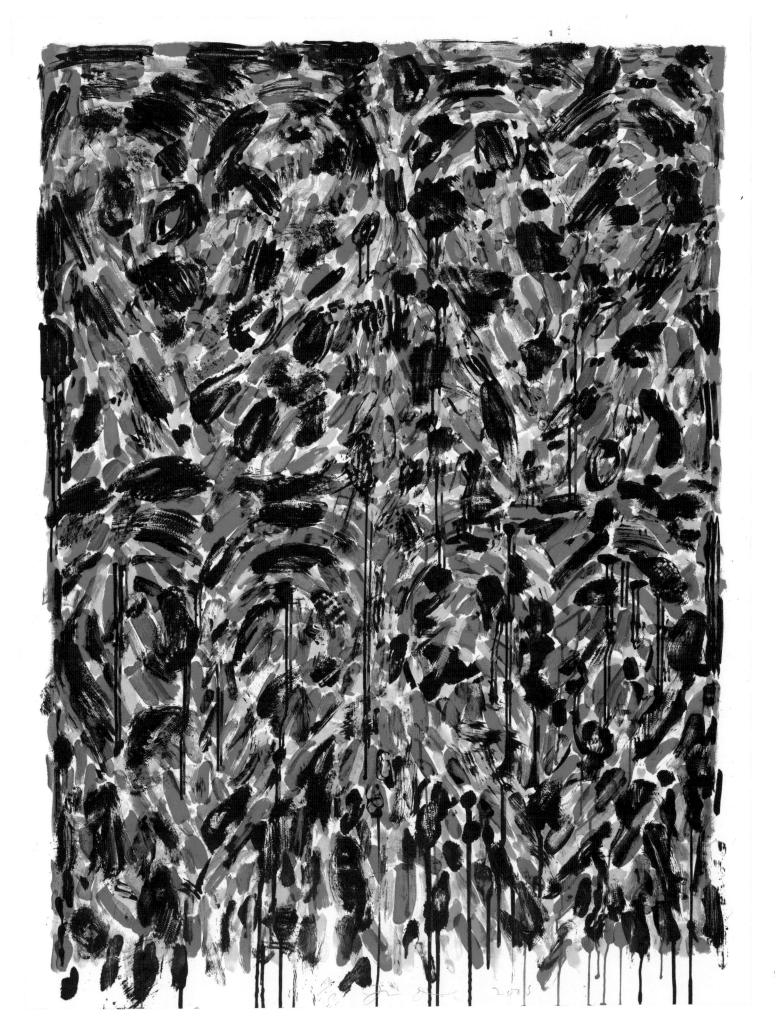

The Garrity
NECKLACE

The softness of the color
in this print was achieved
by a press built by the printer.

The plate was proofed &
editioned by Bob Townsend
in Georgetown Massachusetts
in 1986.

most of the black drawing
for THE GARRITY NECKLACE
was done with a "DREMEL"
Rotary tool on copper.

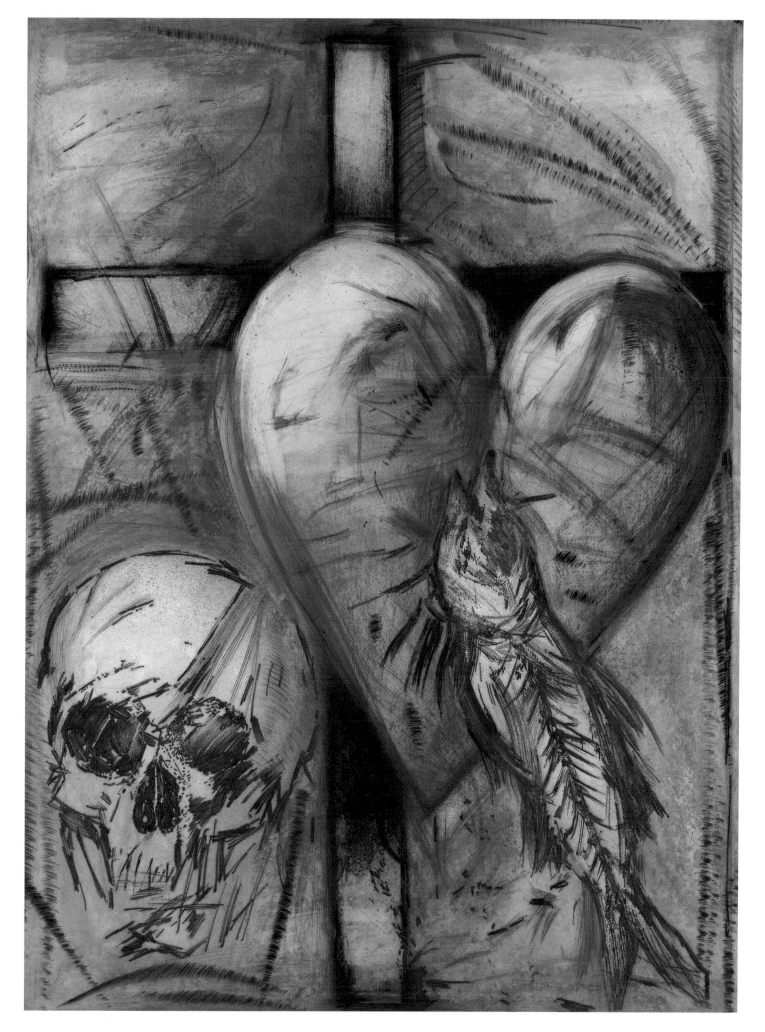

the winter dream

was made at Zein's joint in Vienna. I cut the wood with a small electric chain-saw and various power sanders and a dremel or a Japanese rotary cutter —

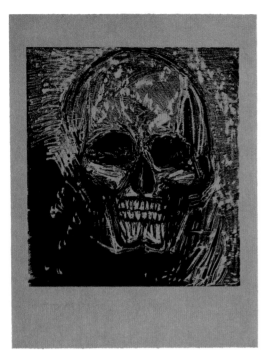
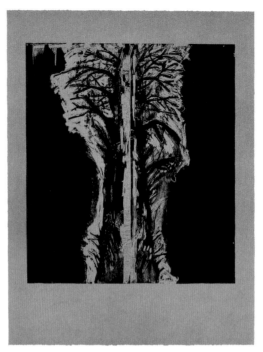
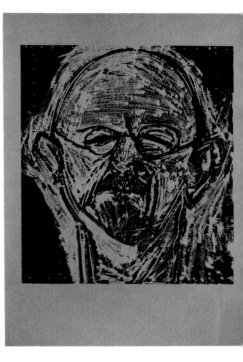
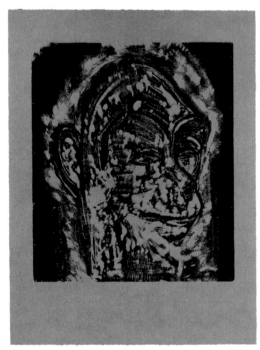
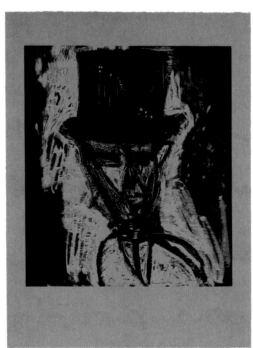
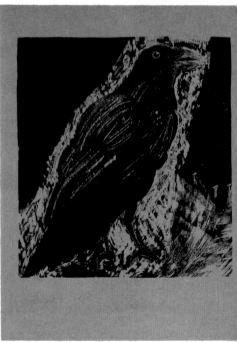

The "Winter Dream" was a dream
I had in Paris in the Winter
of 1994. "V" was the person who

102

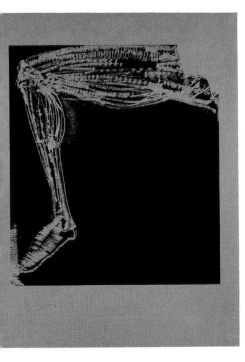
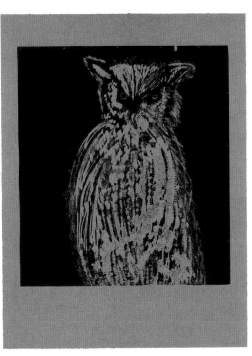
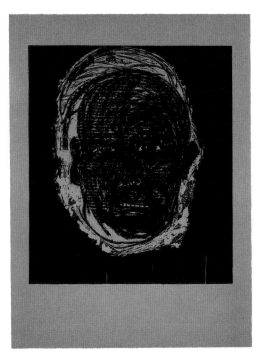
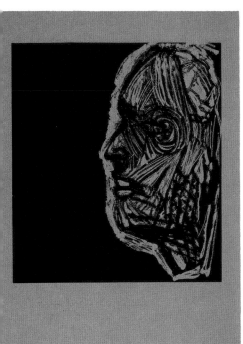
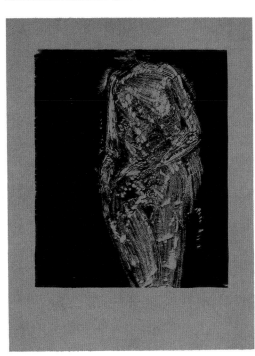
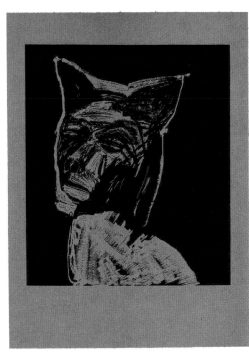

showed me how to access the "dream"
Kurt zain found a way to print the
wood blocks. I had used the top of
wood crates and they were very warped.

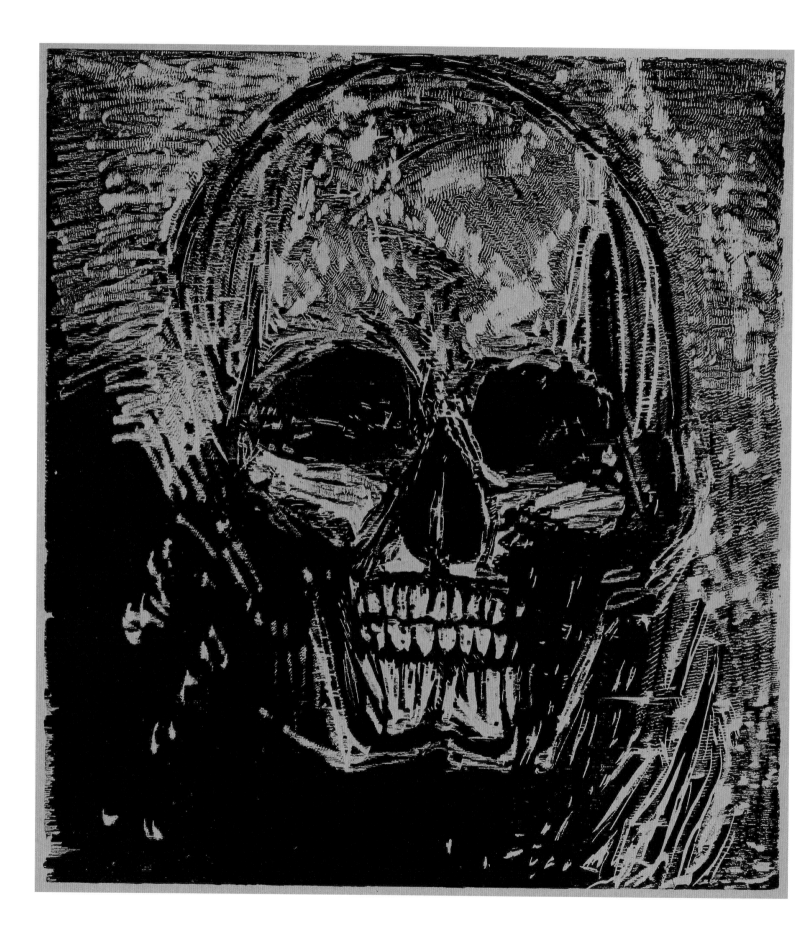

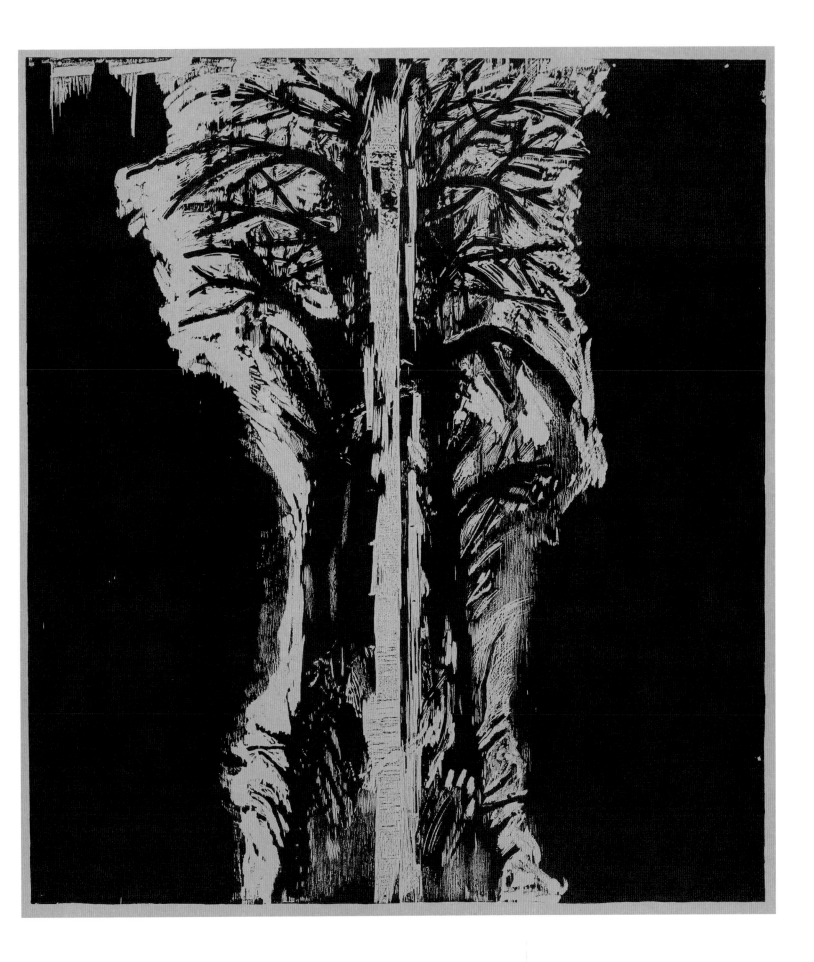

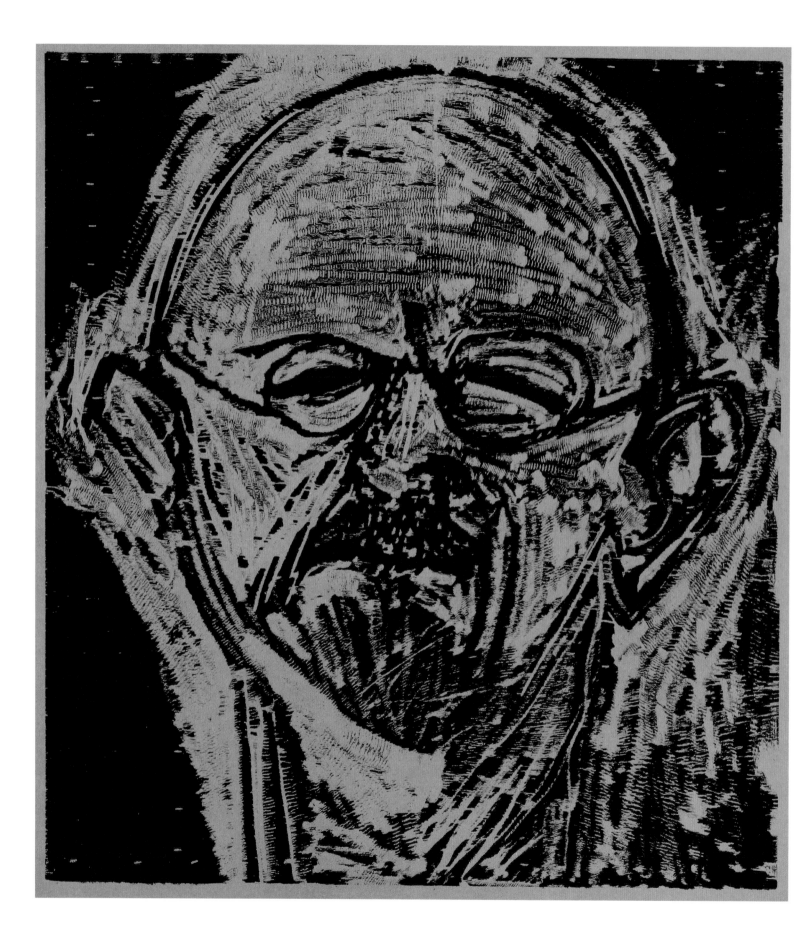

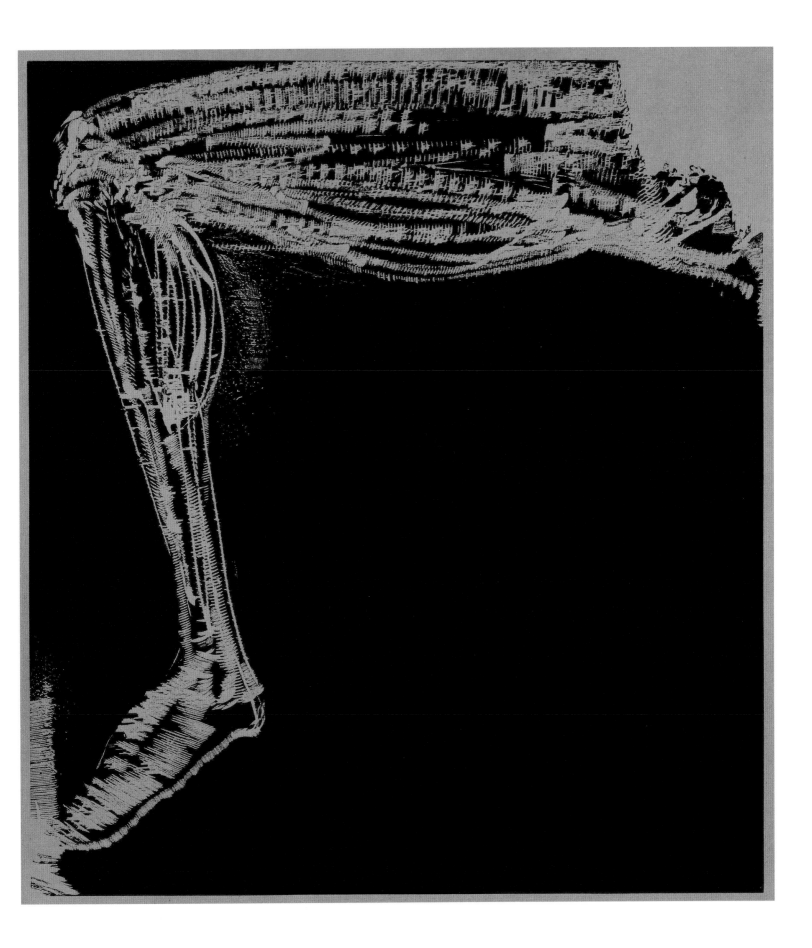

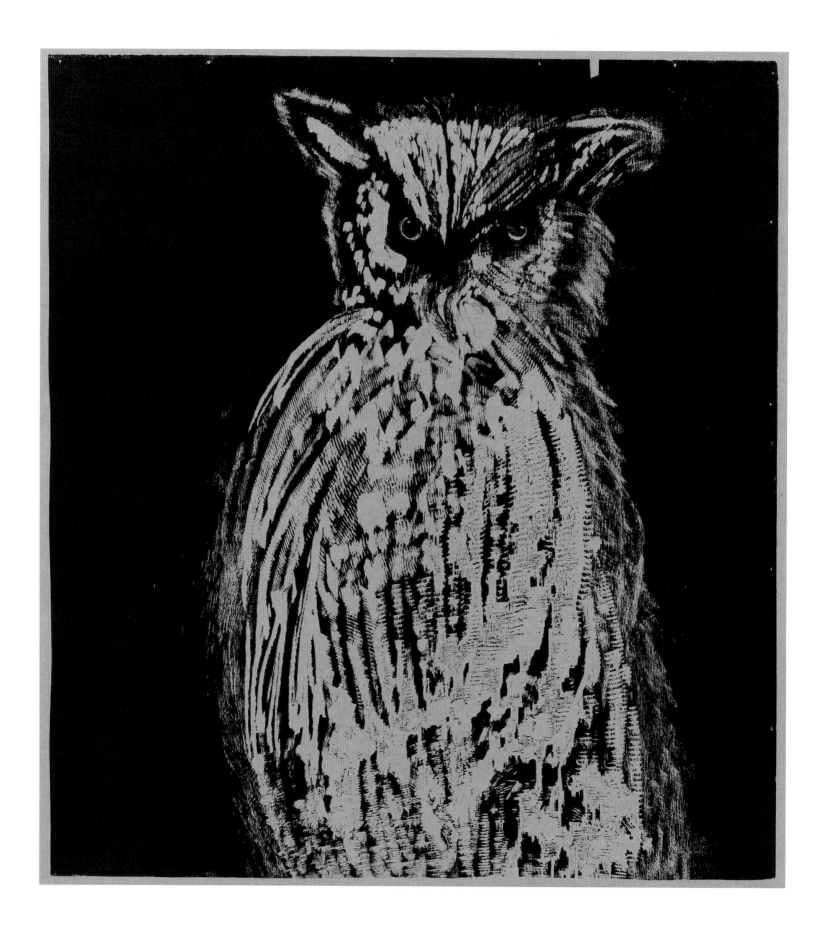

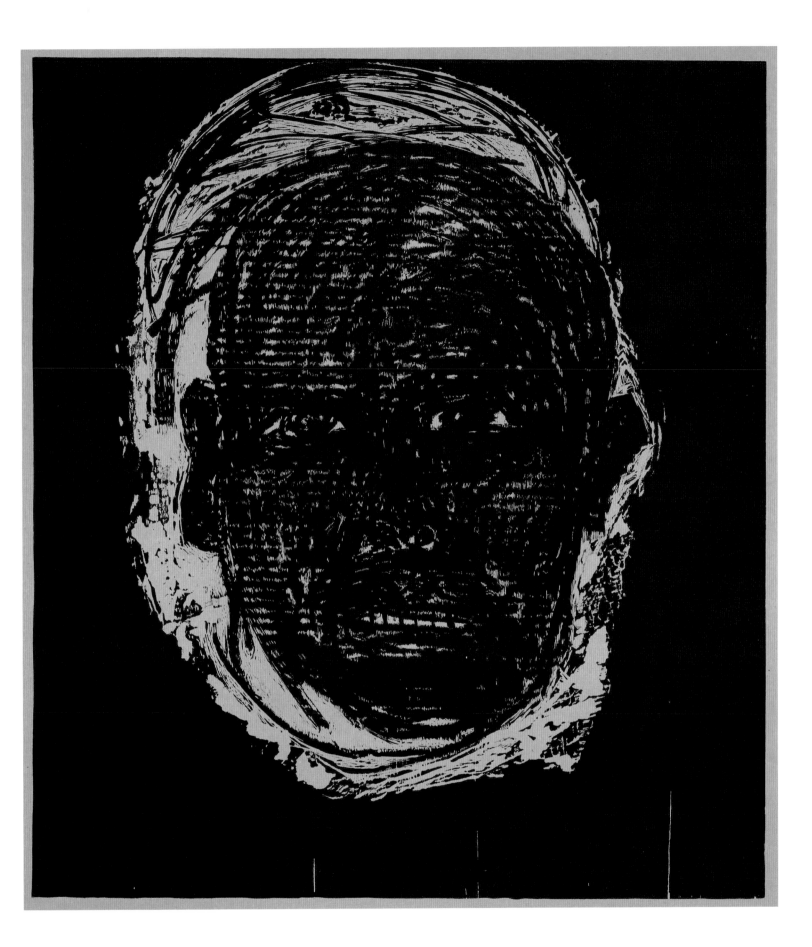

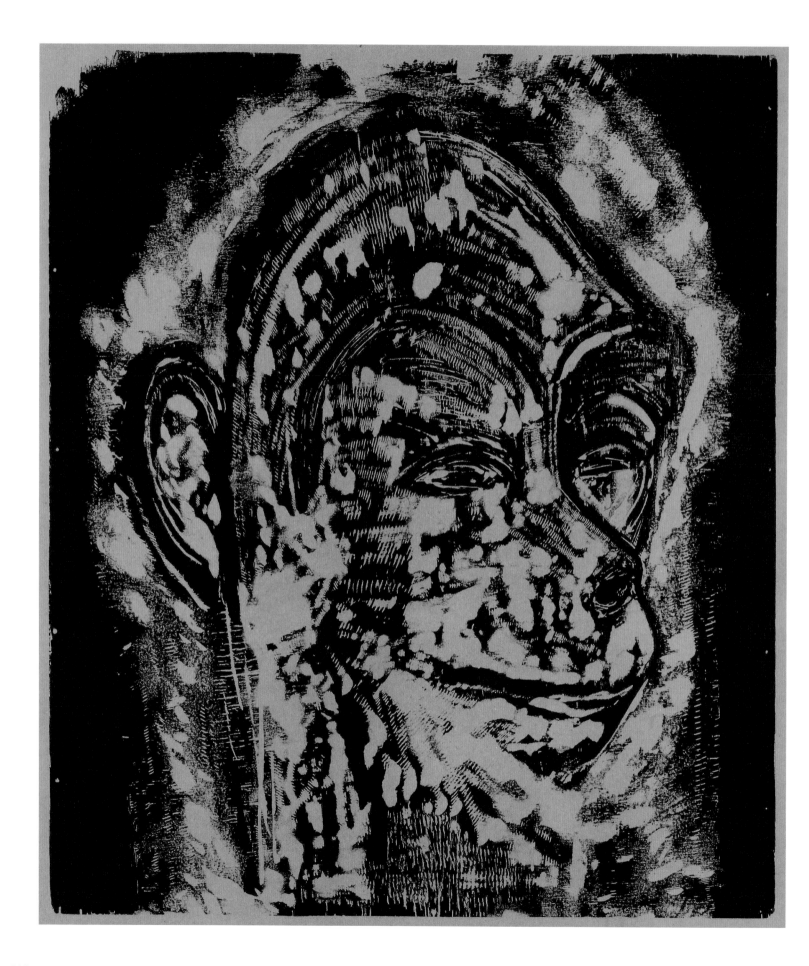

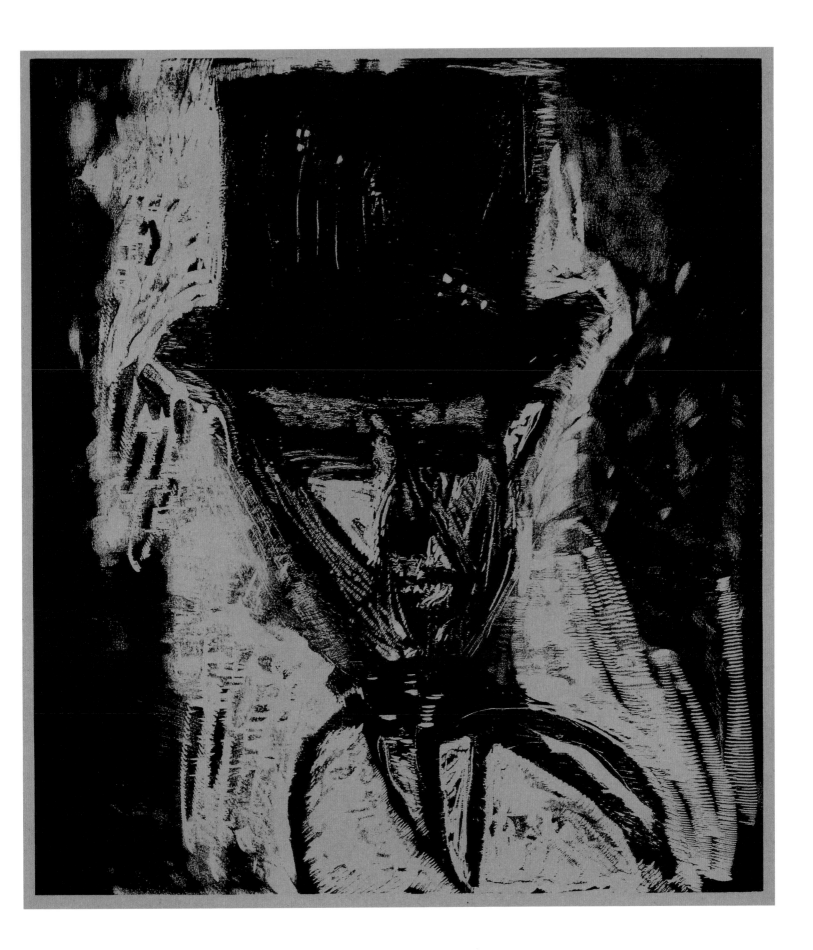

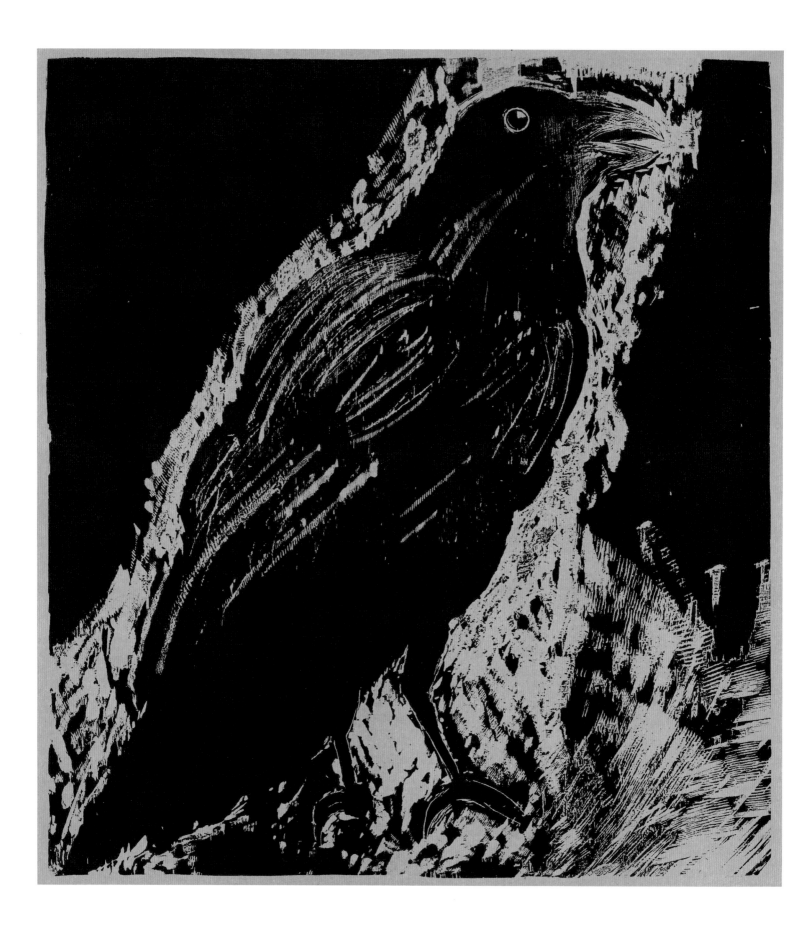

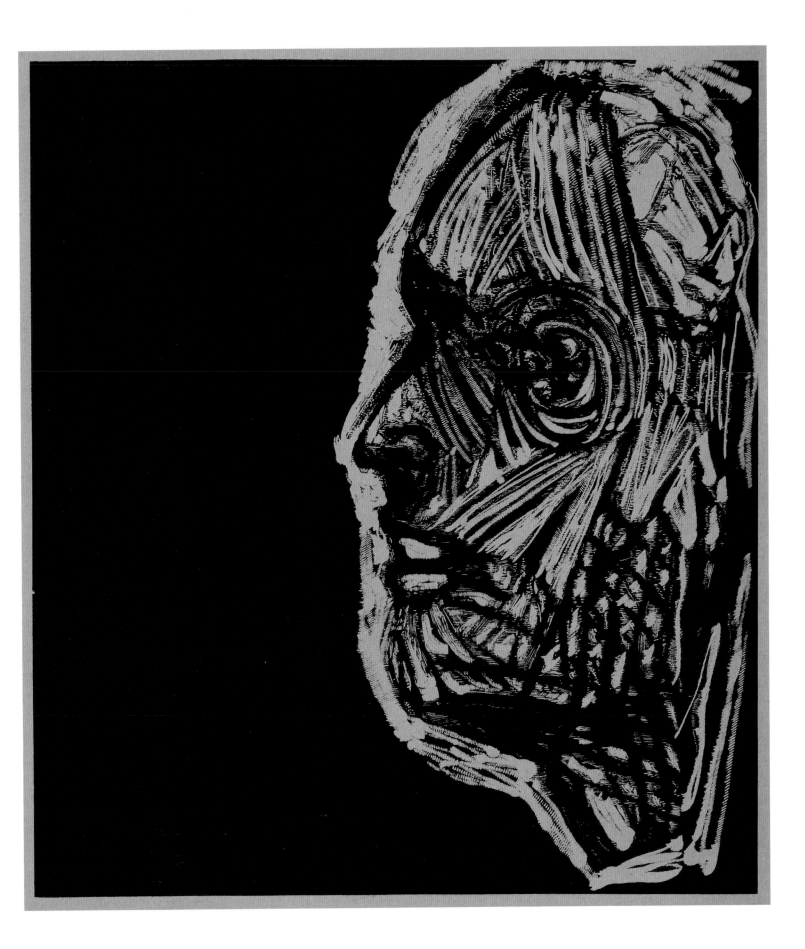

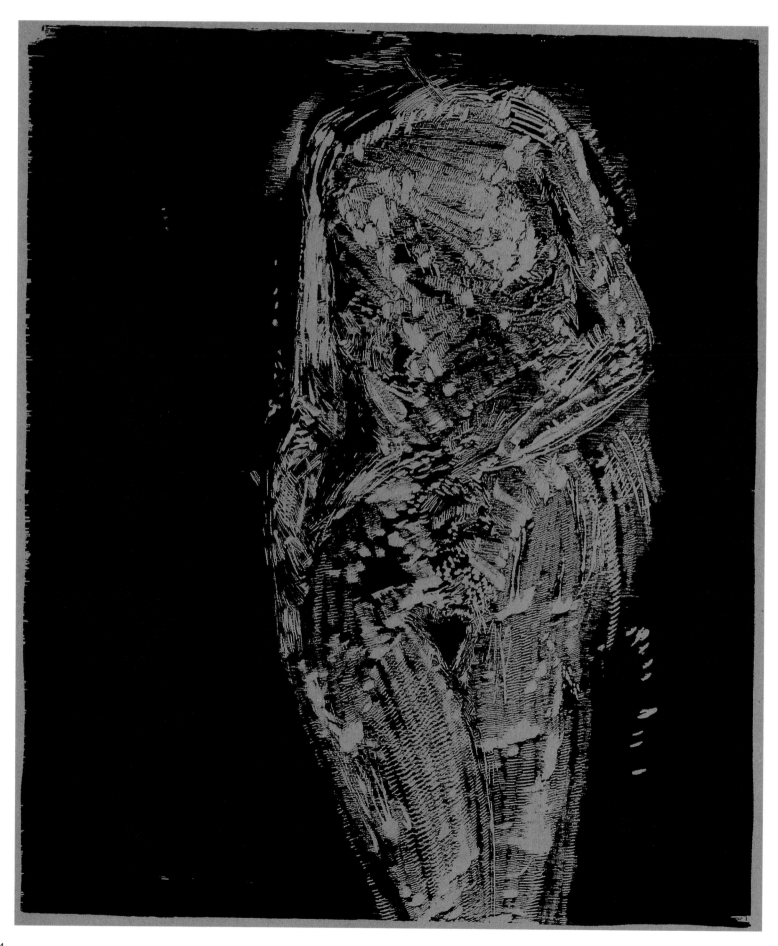

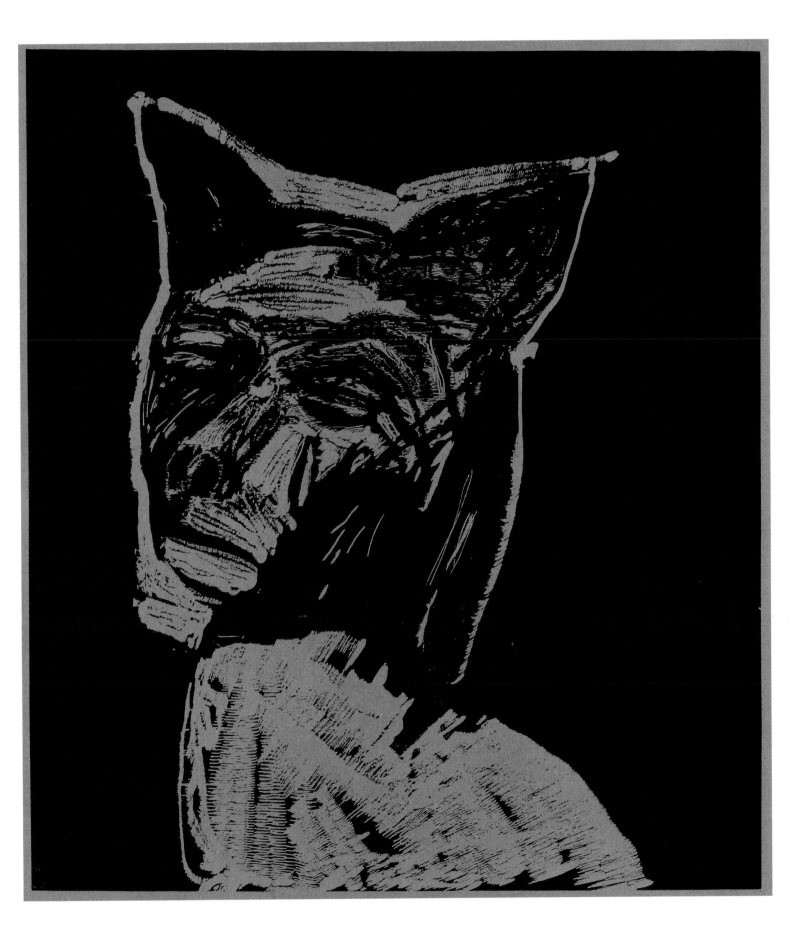

55 portraits

etchings done in
1995 using 10 different
plates printed in various
combinations and grey, white
and black tones. They
became 55 different views
of myself.

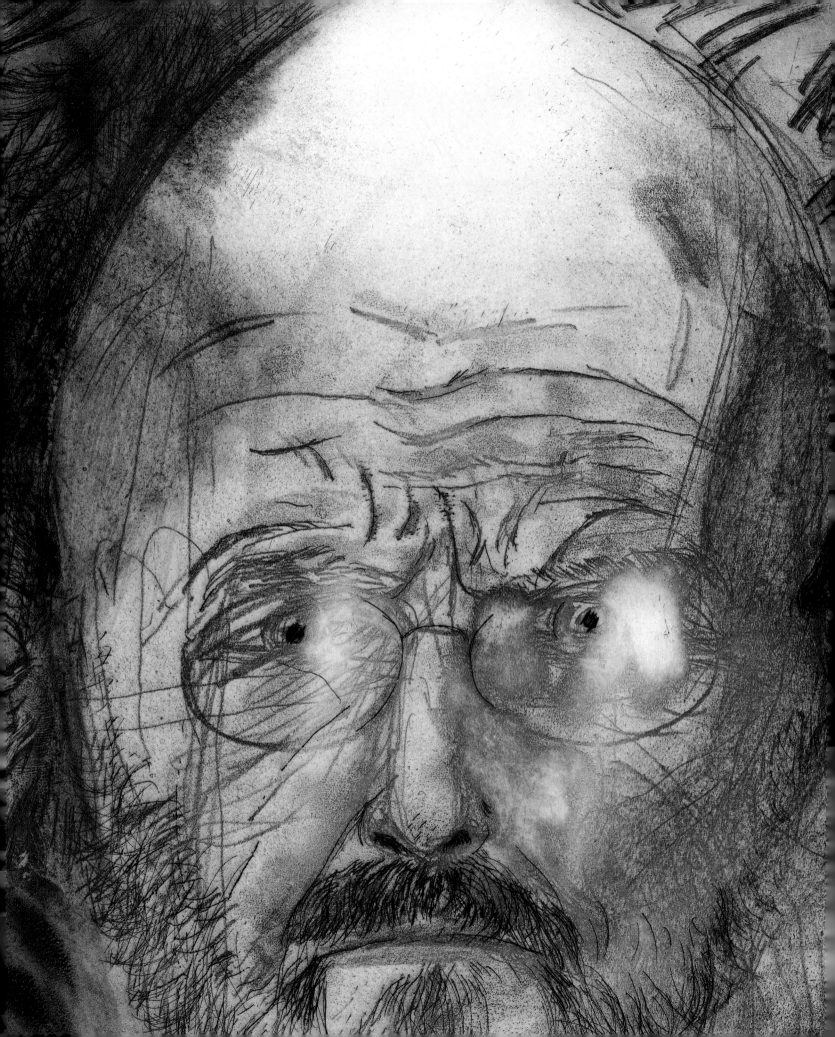

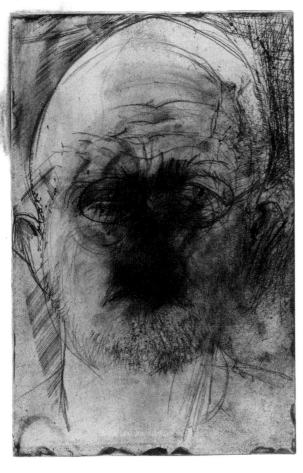

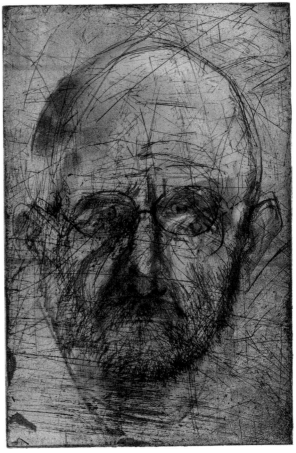

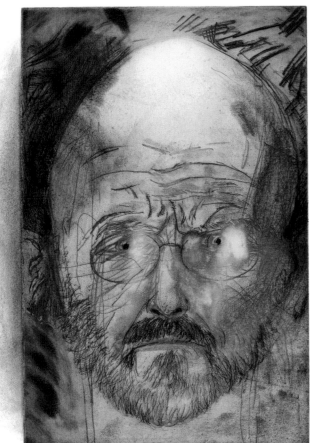

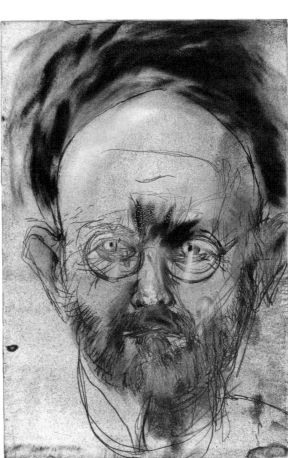

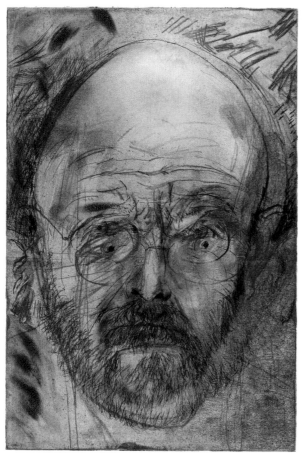
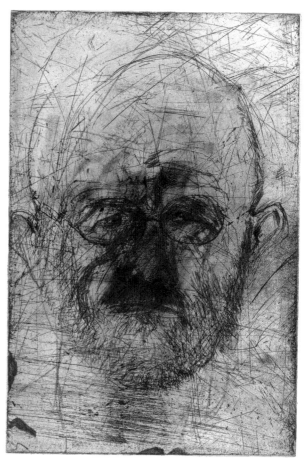
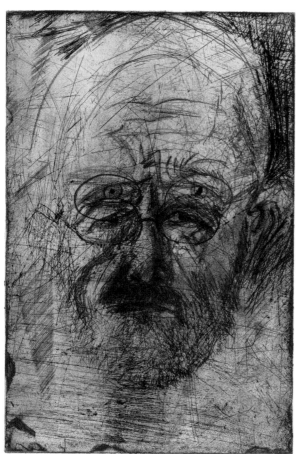
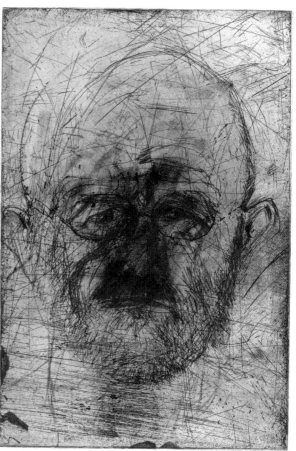

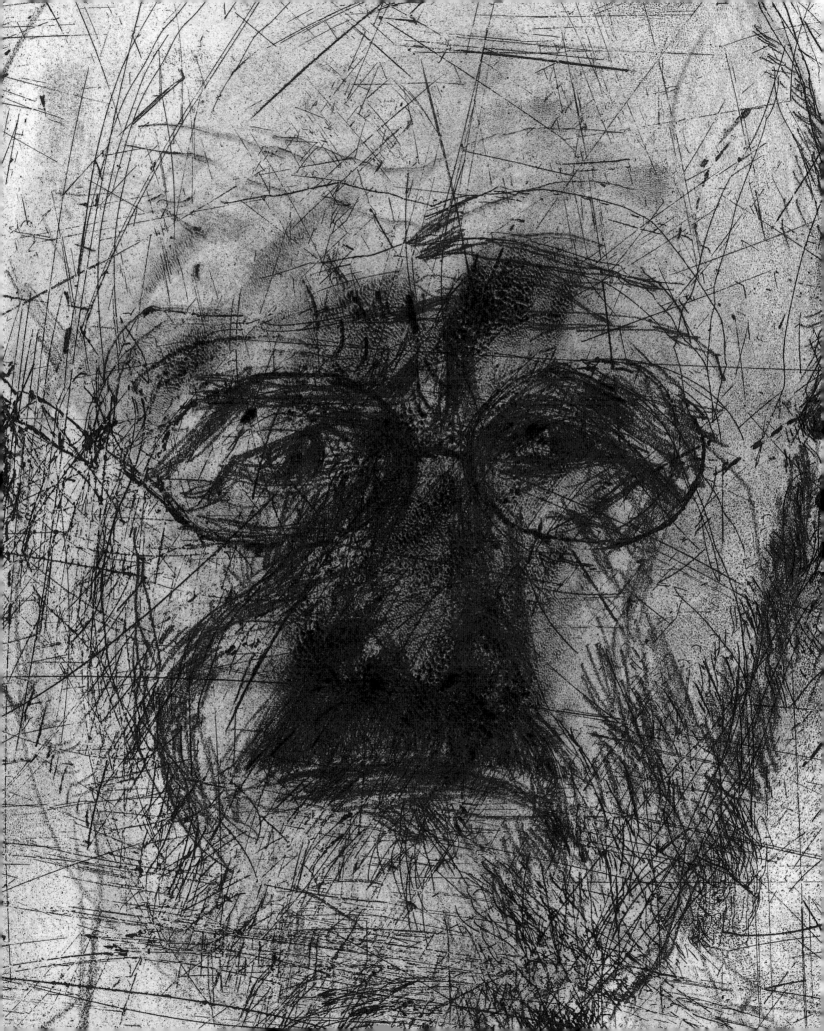

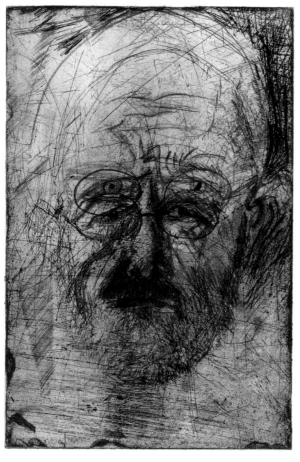

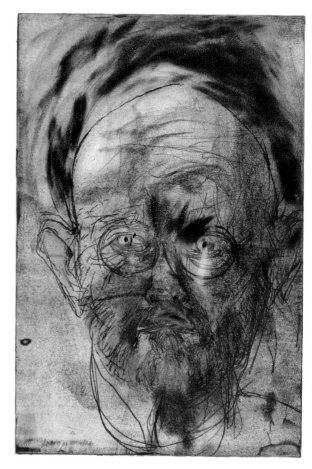

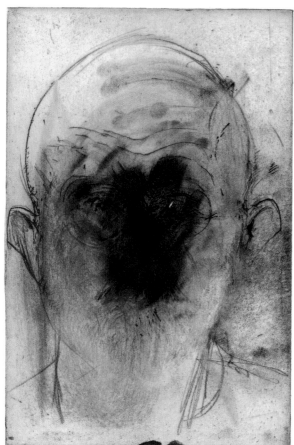

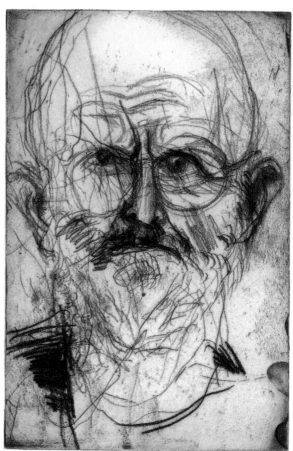

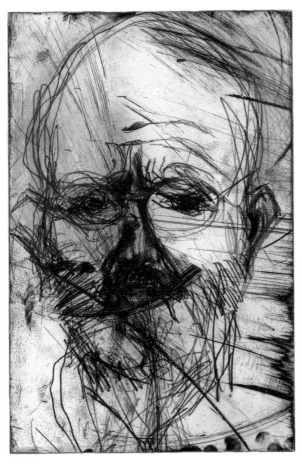
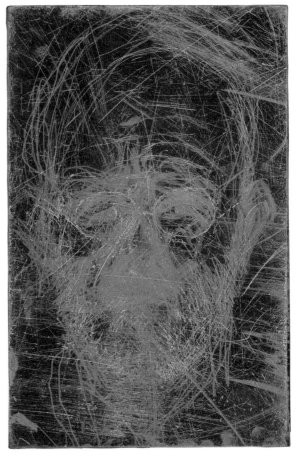
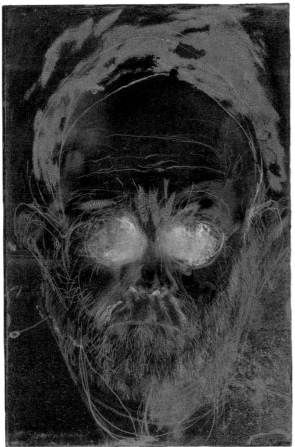
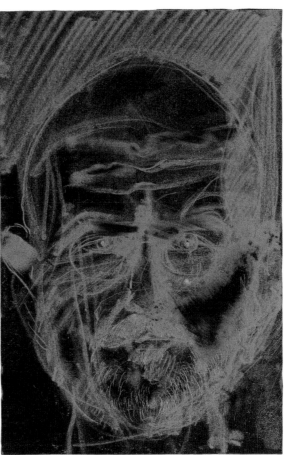

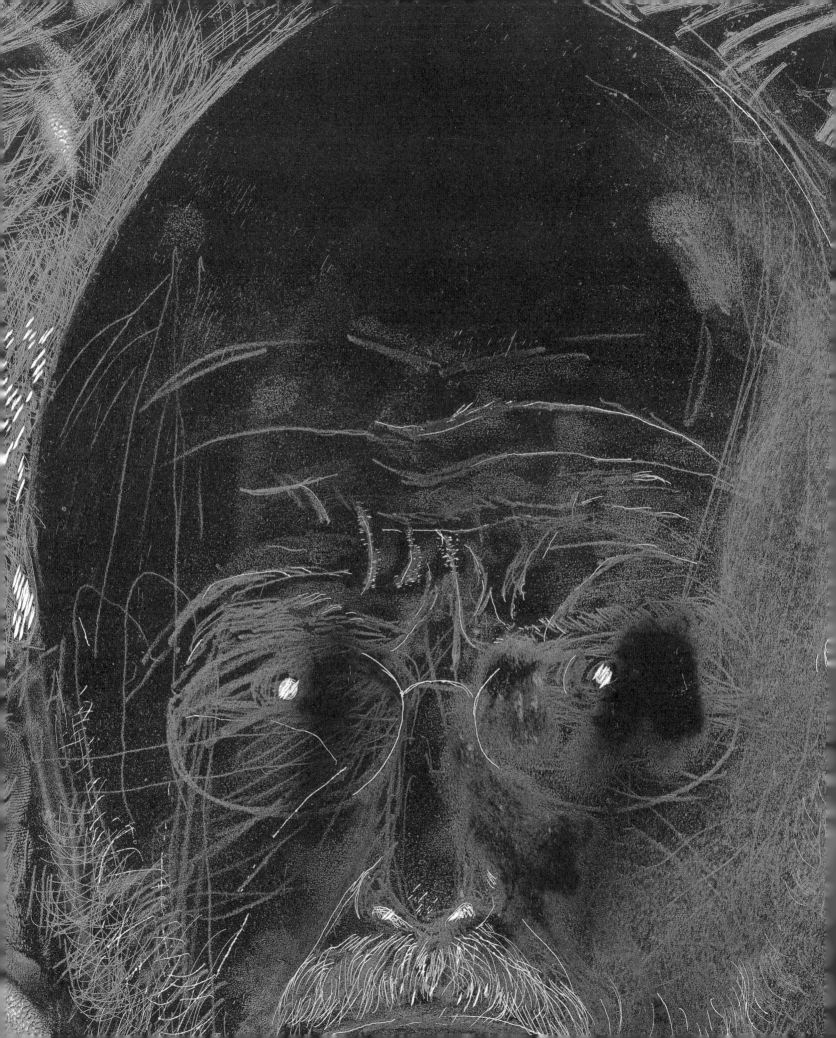

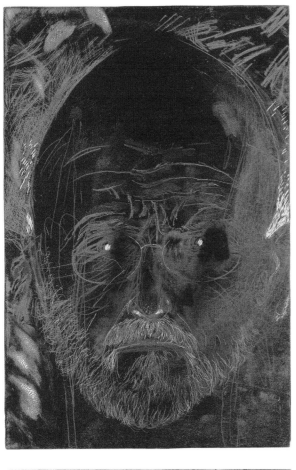
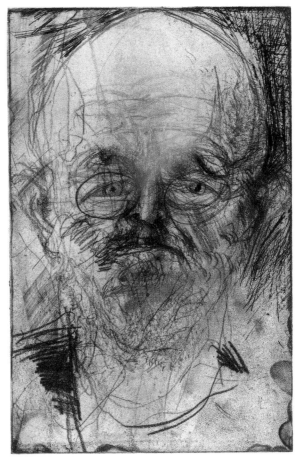
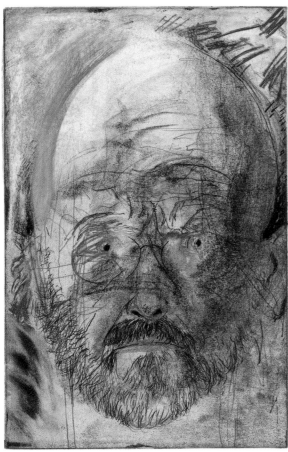
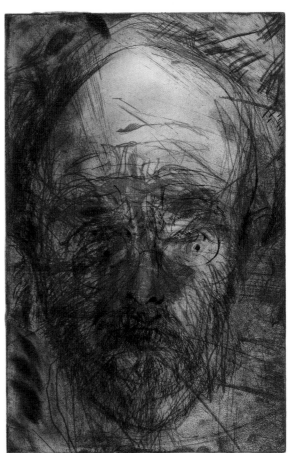

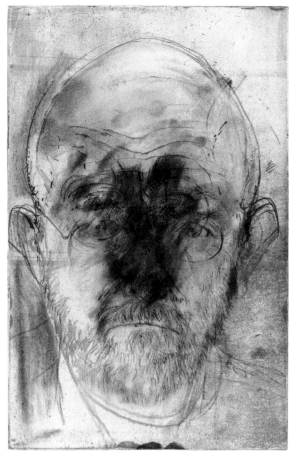
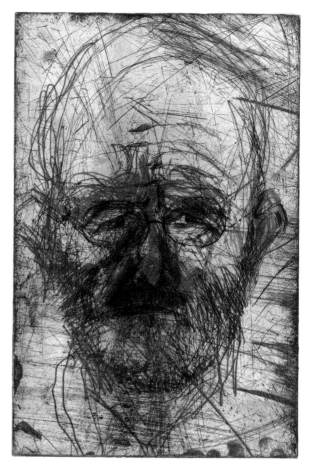
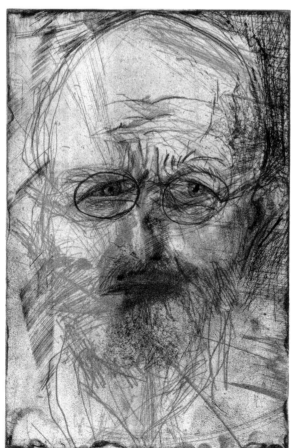
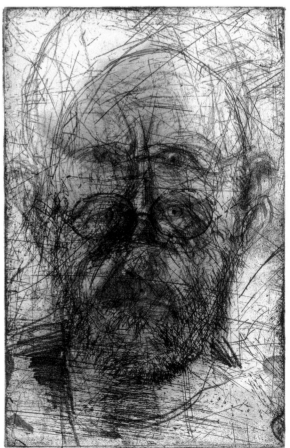

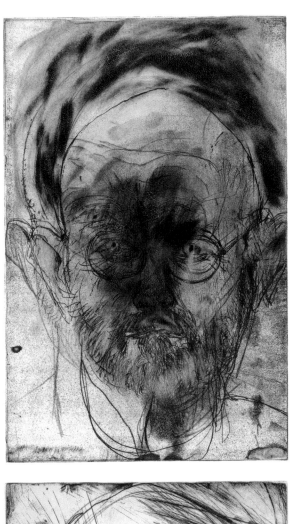
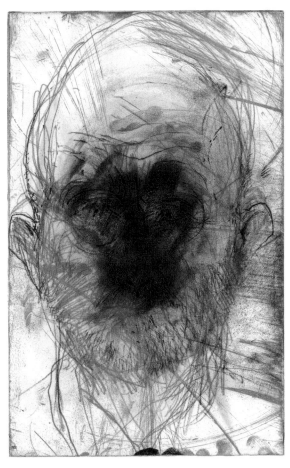
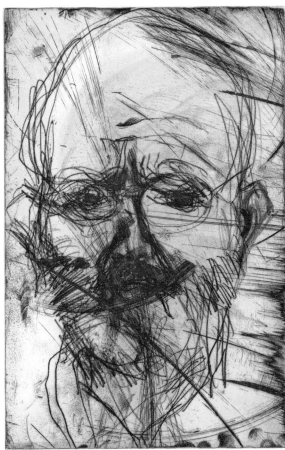
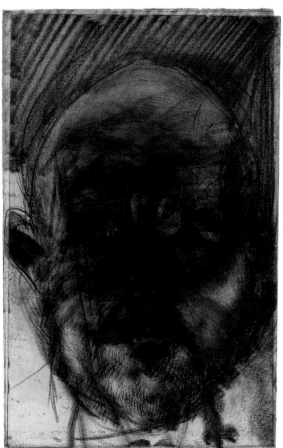

127

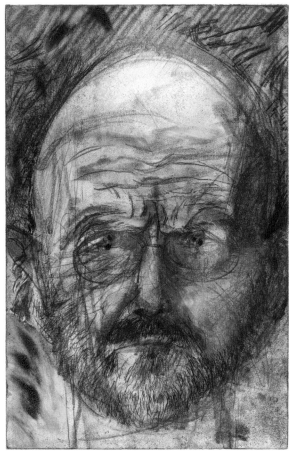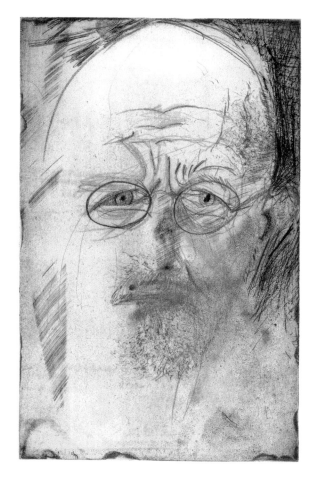
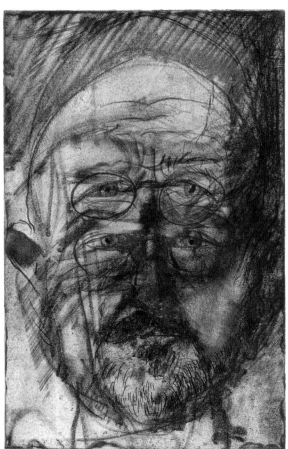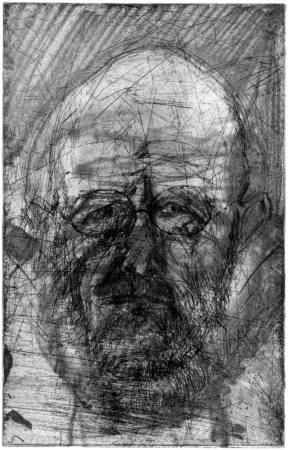

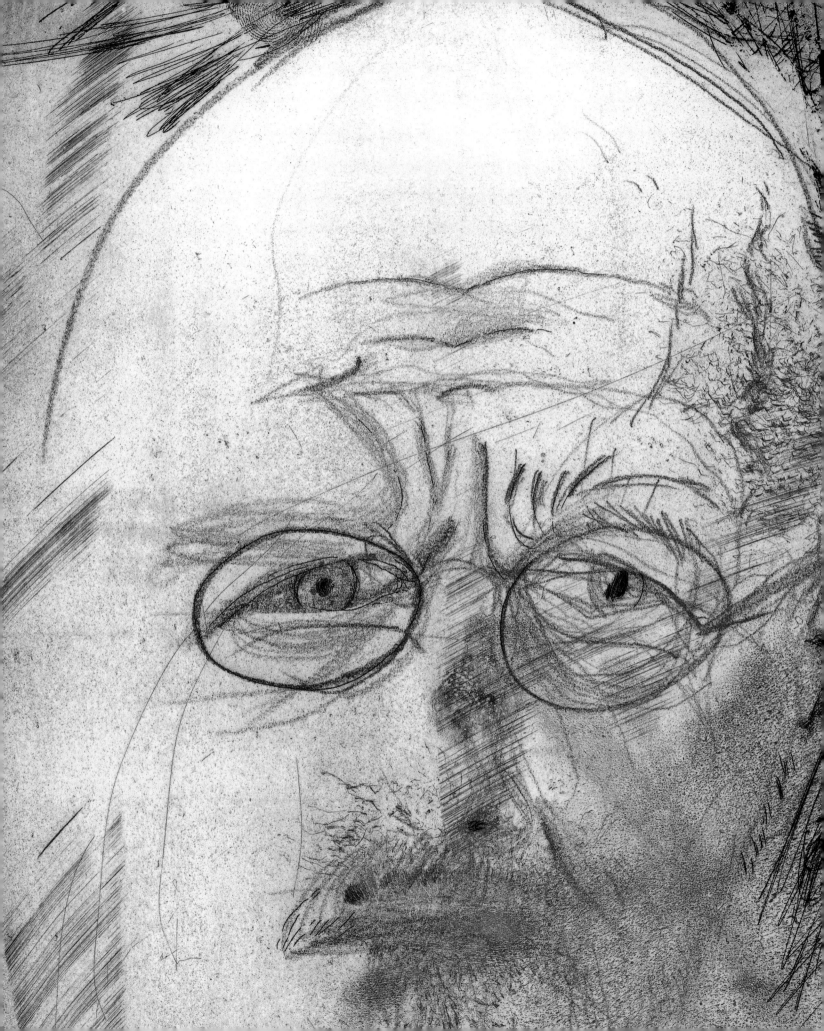

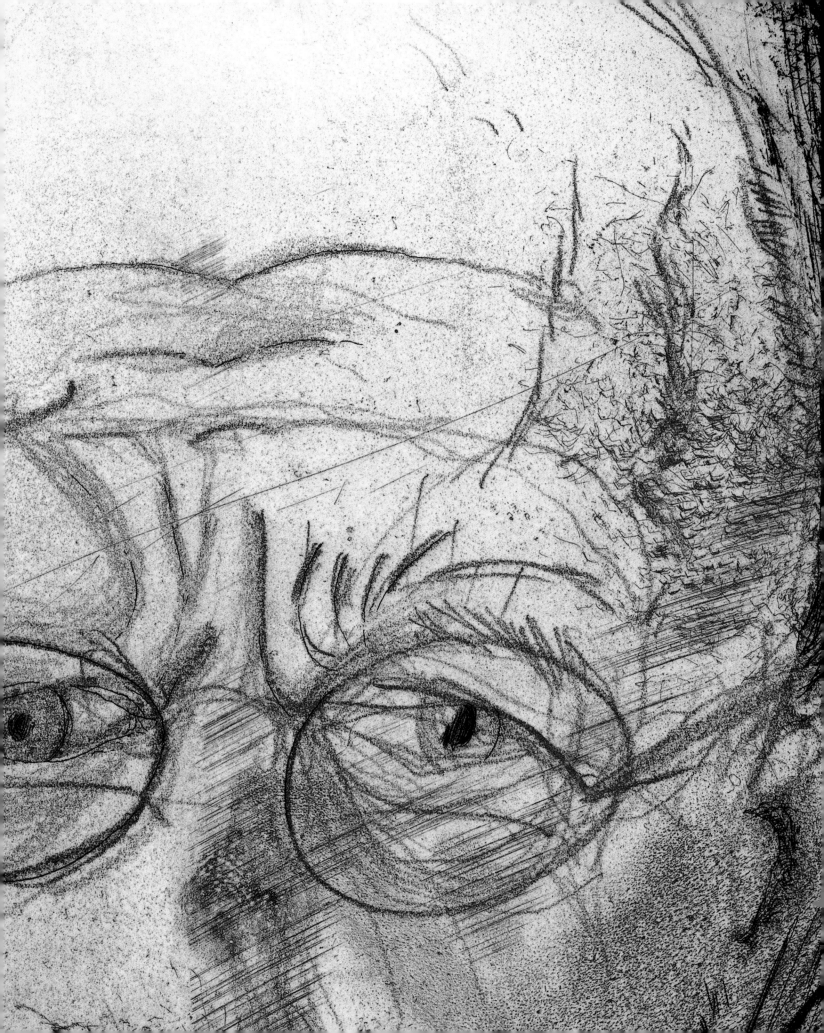

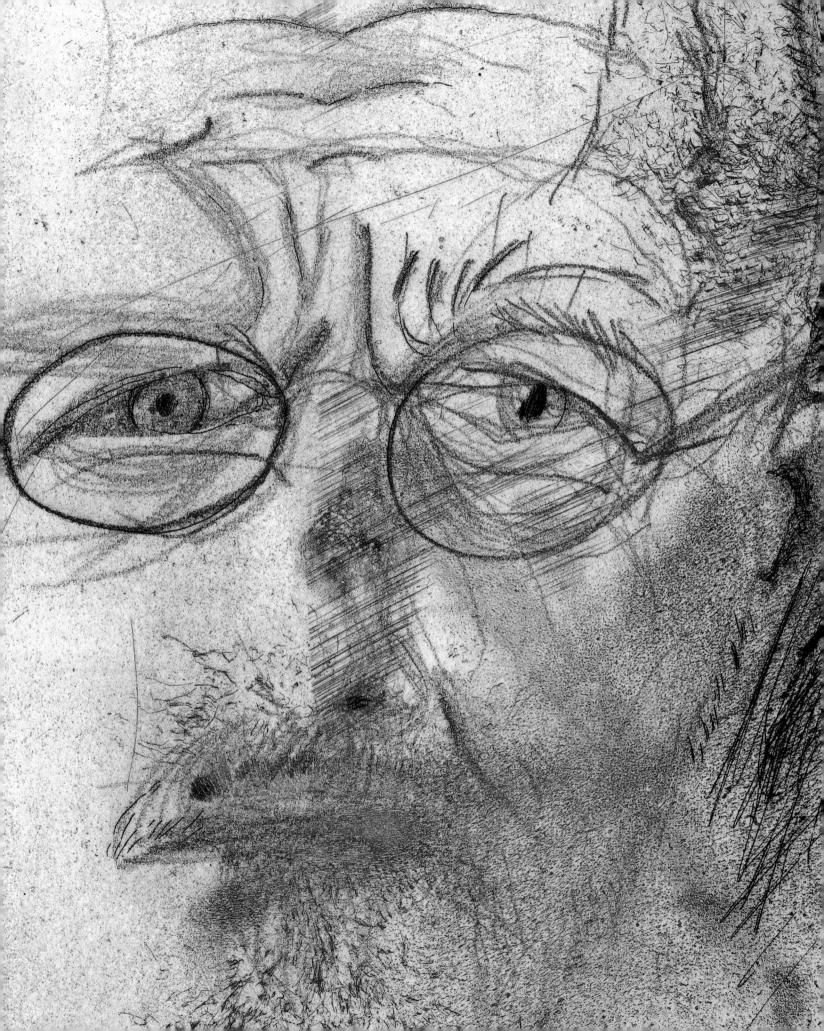

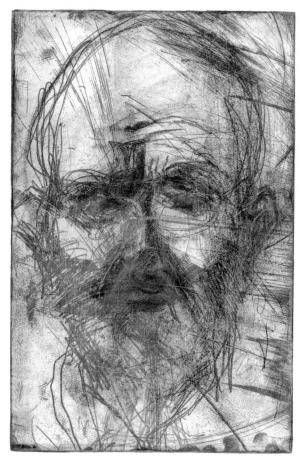
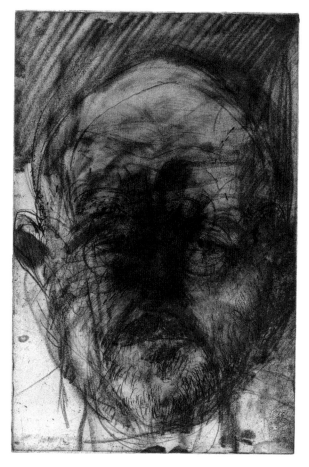
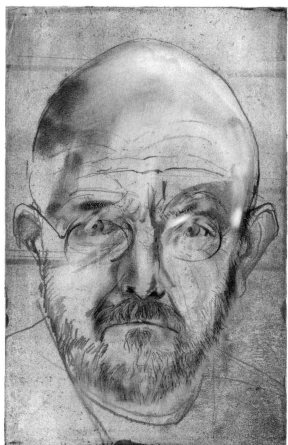
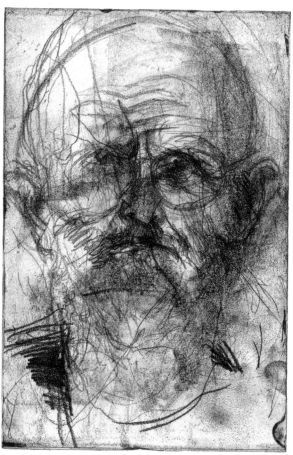

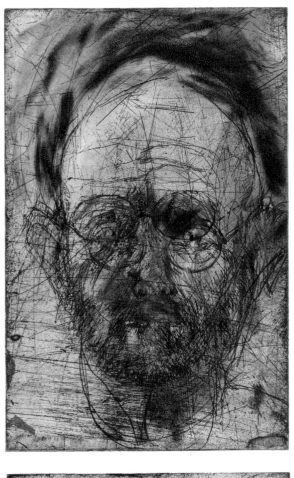
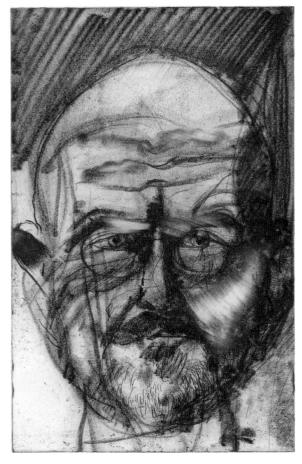
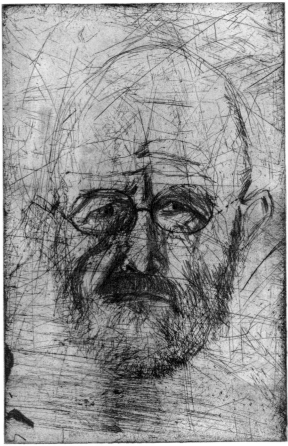
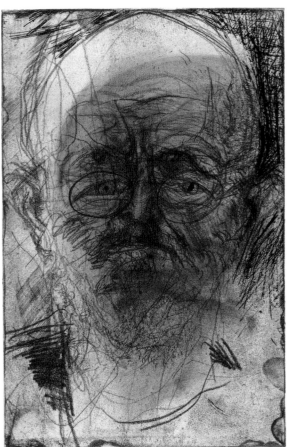

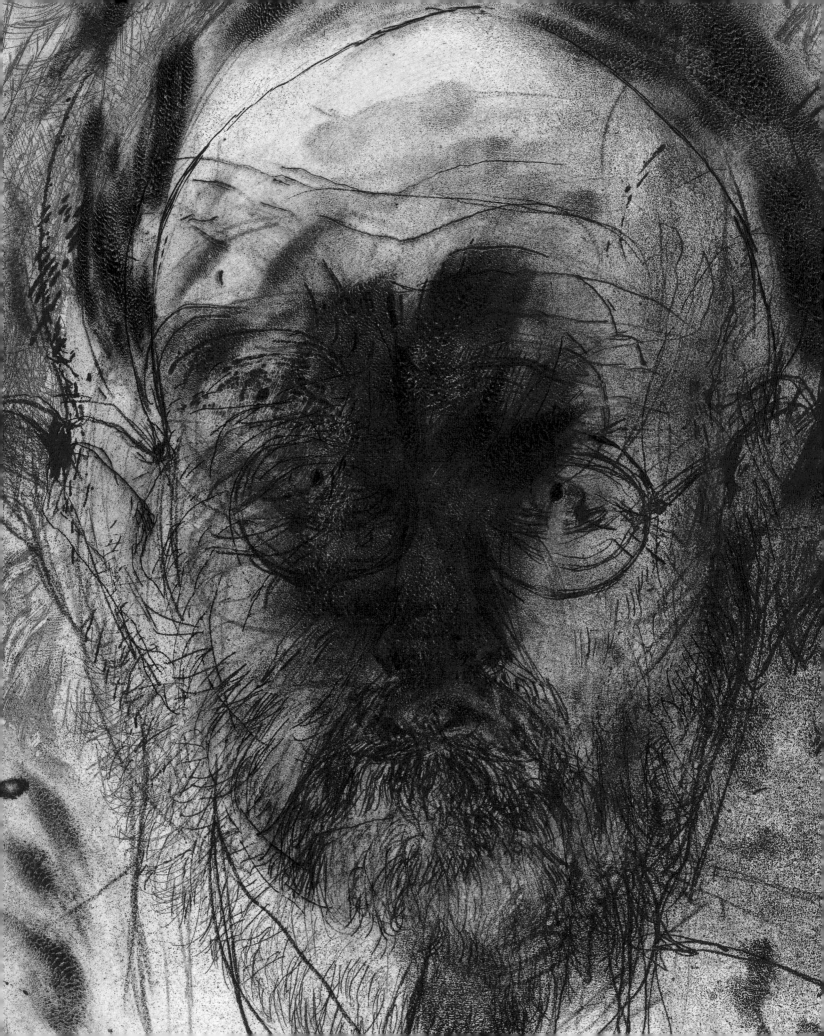

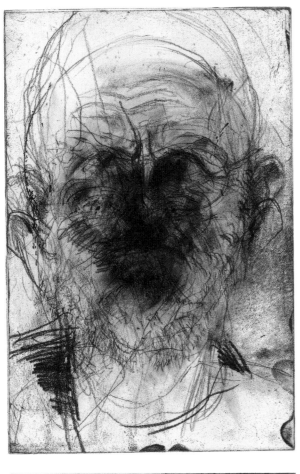

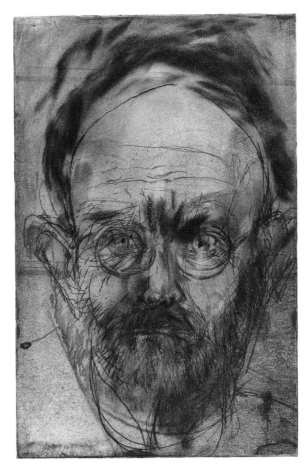

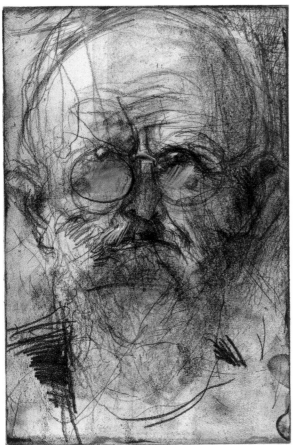

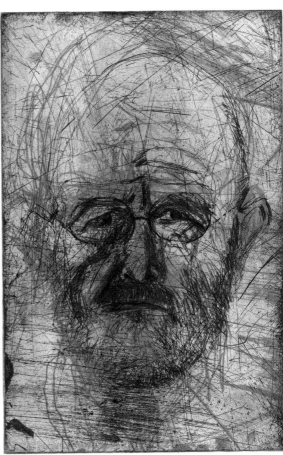

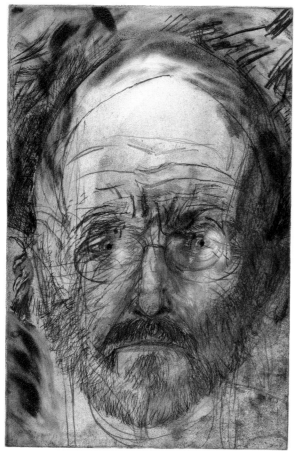
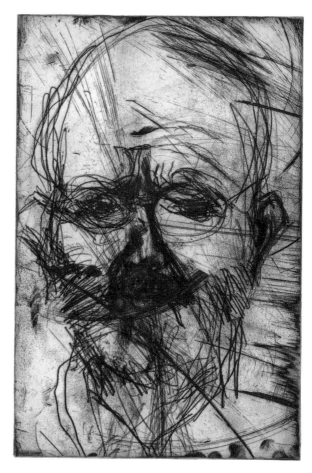
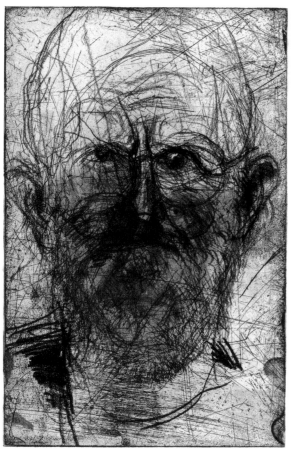
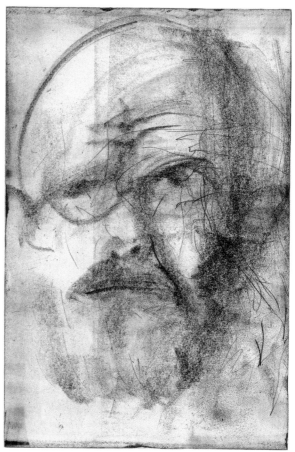

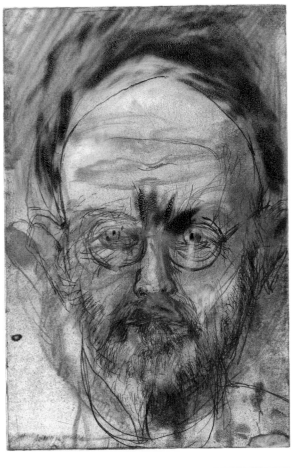
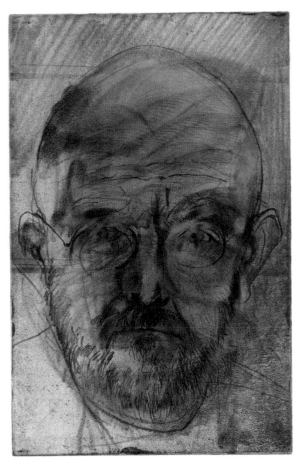
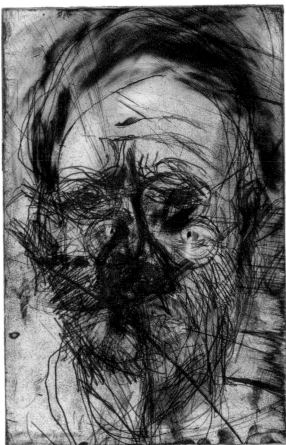
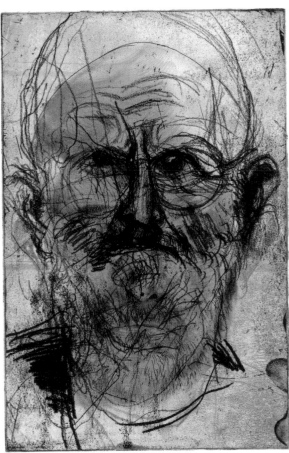

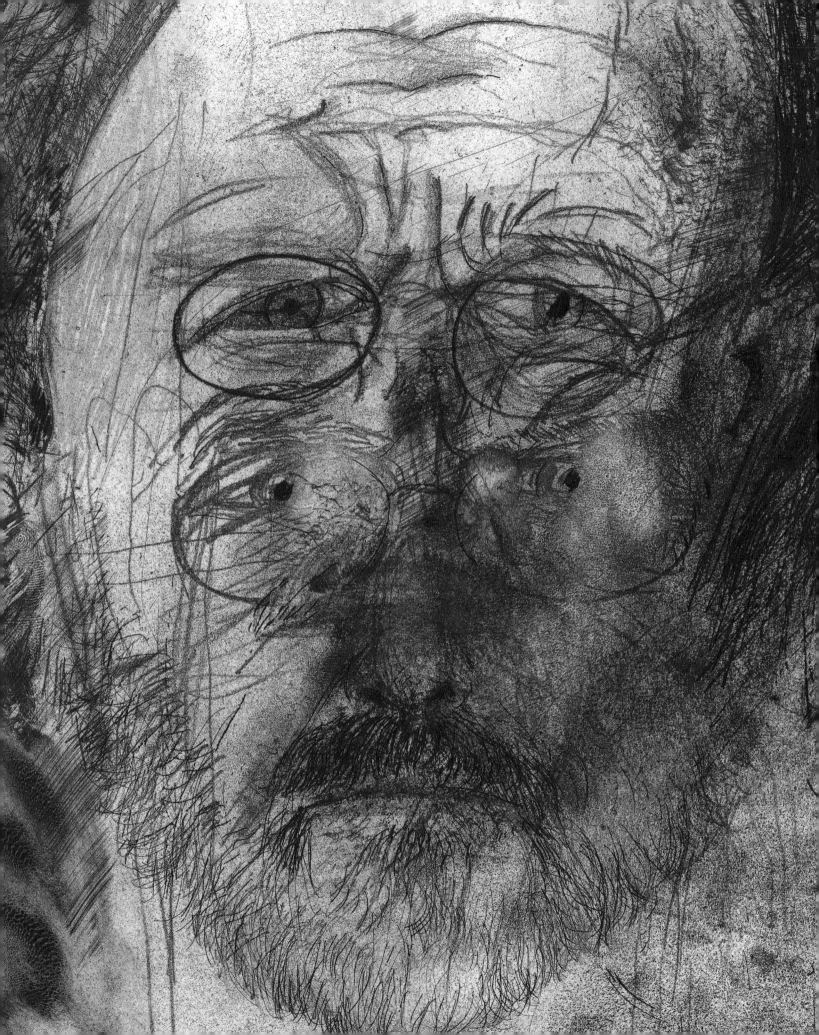

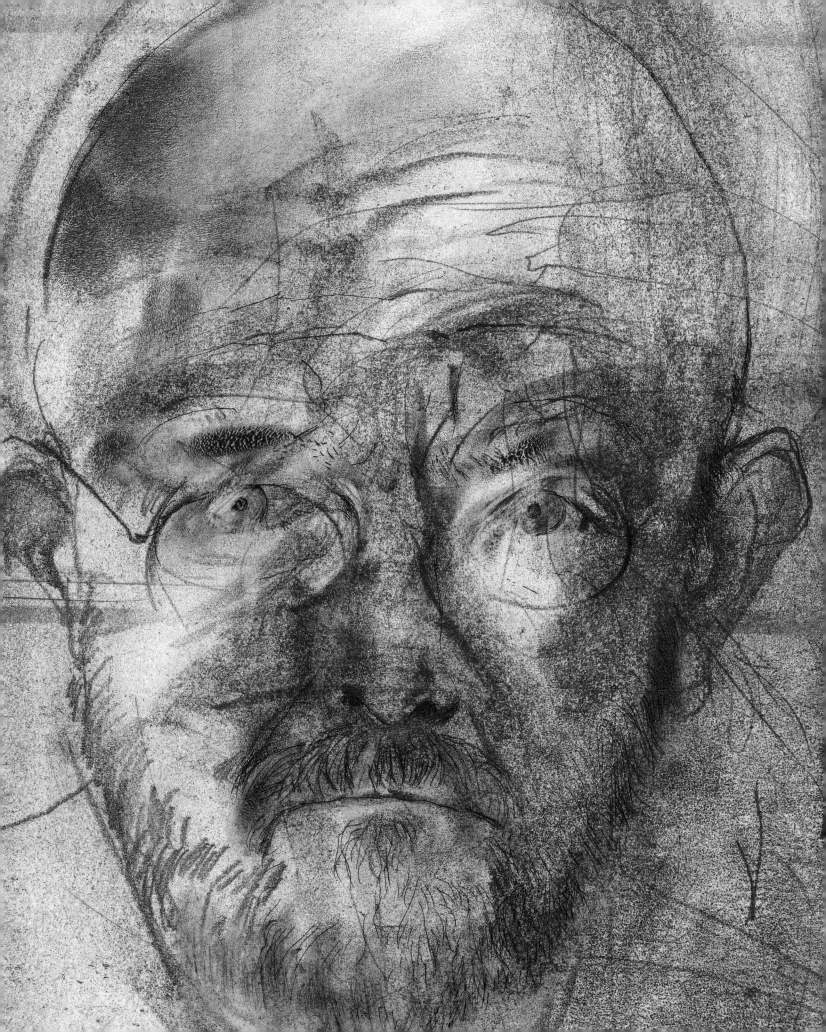

These 36 Lithographs were done at Michael Woodworths print shop over a period of 3 years.. During those years, there wasn't a day when he or I or Dan Clark (the other printer) didn't print on them or I drew or collaged or fine tuned or fiddled with the color etc. It was a very rich time, fraught with problems of registration, time constraints and naturally, money,

the project is done now and
it feels very wonderful to be
in the company of the boy,

pinocchio

jim dine

I truely believe that like
Geppetto in the Story, I have
brought him To life "with the
help of my friends" as they
say.............

jim Dine 2007

A PIECE OF WOOD THAT LAUGHED AND CRIED LIKE A CHILD

found a piece laughed and
of wood cried like a child
wood a child
a child

laughed and
cried
child

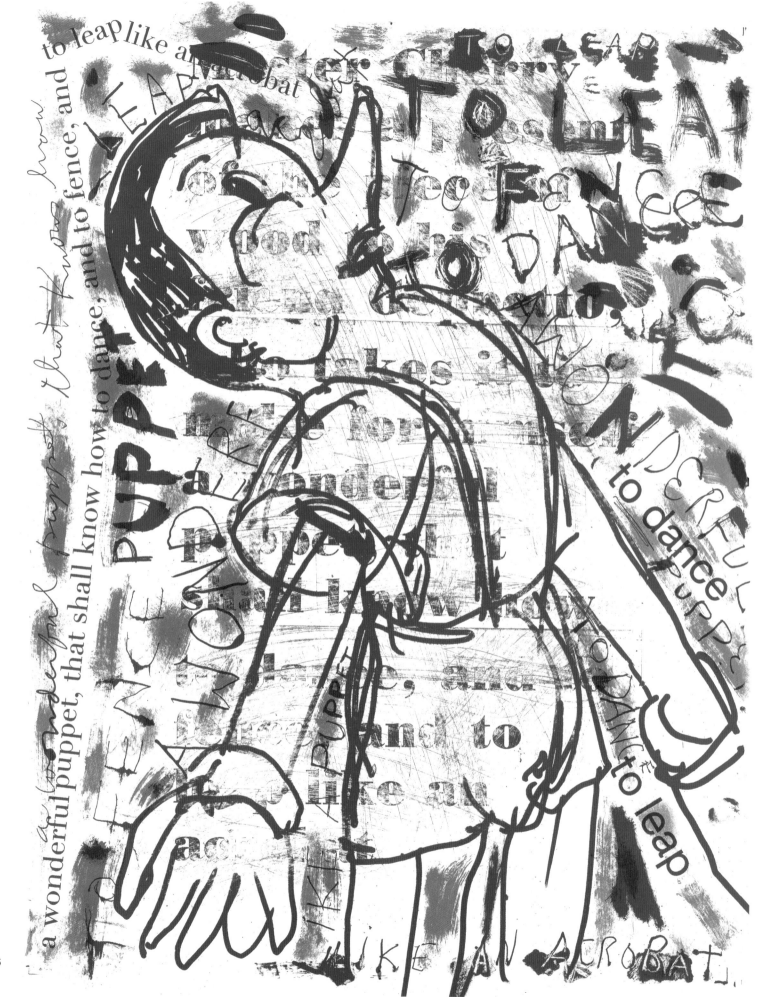

146

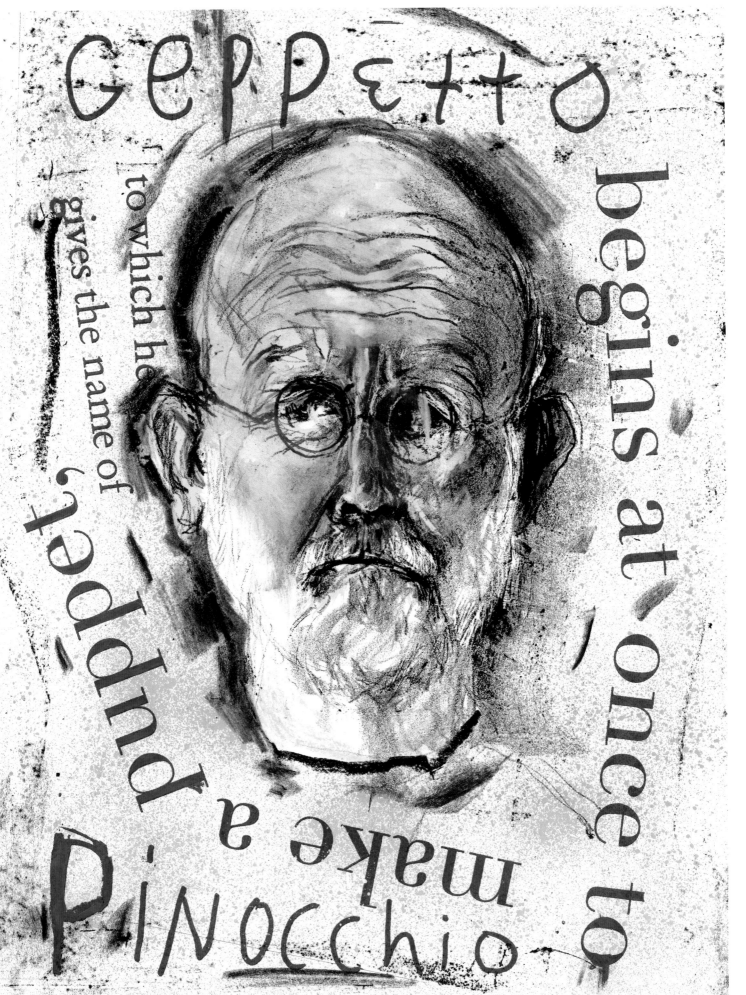

GEPPETTO begins at once to

to which he

gives the name of

puppet,

make a

PINOCCHIO.

who know more than they do boys

The story of Pinocchio and the Talking Cricket, and from which we see that naughty boys cannot endure

The story of Pinocchio and the Talking Cricket, from which we see that naughty boys cannot endure to be corrected by those who know more than they do. The story of Pinocchio and the Talking Cricket from which we see naughty boys cannot endure corrected by the know more

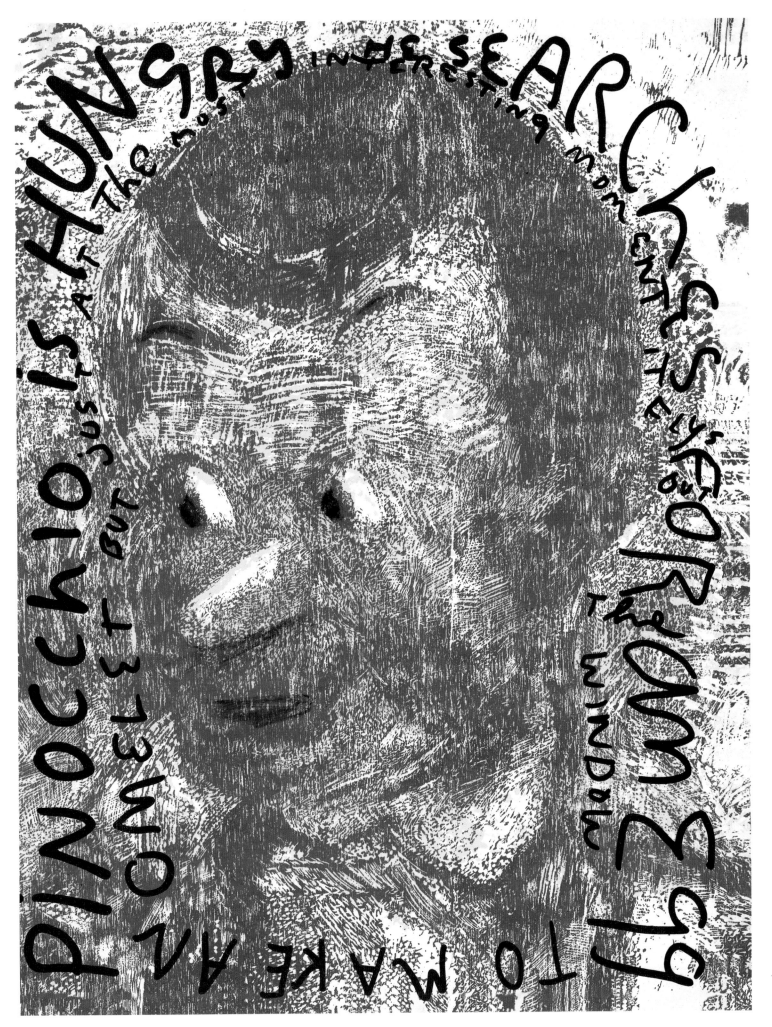

HUNGRY RESEARCH is at the most interesting moment entirely for the window to make an egg, but the most modest. PINOCCHIO is just

149

Pinocchio falls asleep **feet on the brazier and** wakes in the morning to find

to find them **them burnt off** and wakes

150

Geppetto returns home and gives Pinocchio the breakfast

Geppetto returns home and gives Pinocchio the breakfast that the poor man had brought for himself

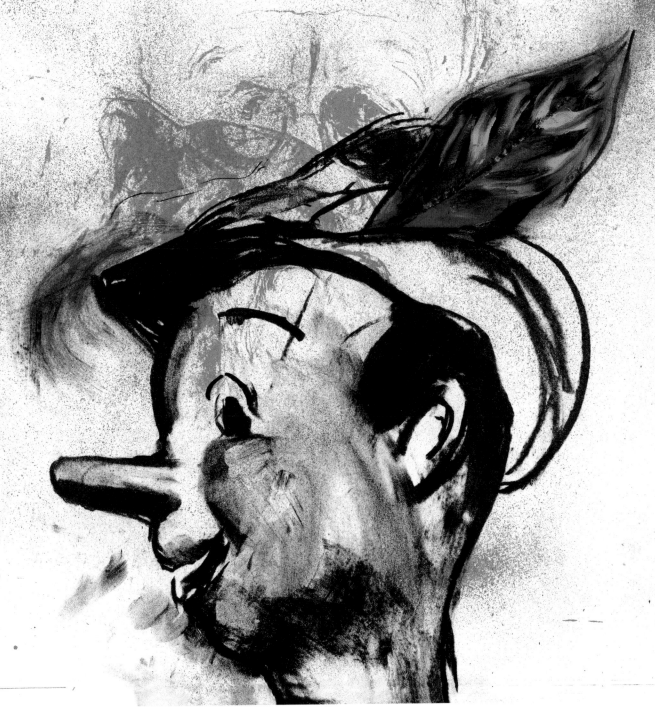

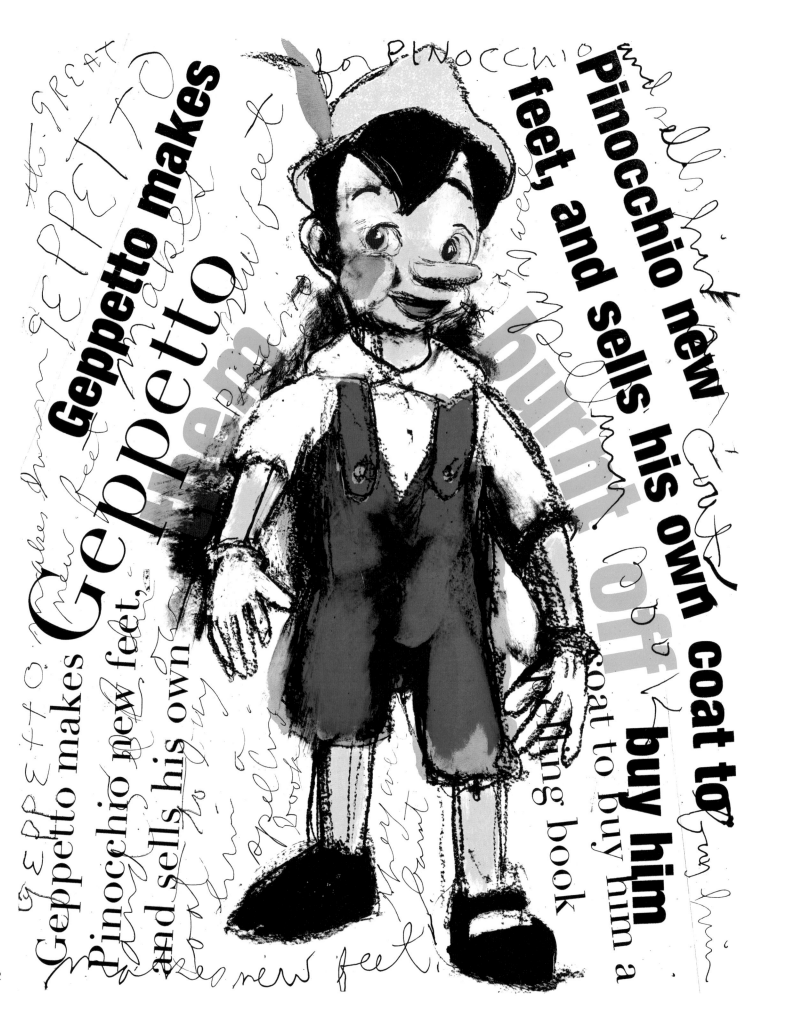

Geppetto makes

Geppetto

Geppetto makes

Pinocchio new feet, and sells his own coat to buy him a

burn off

Pinocchio new feet, and sells his own coat to buy him

152

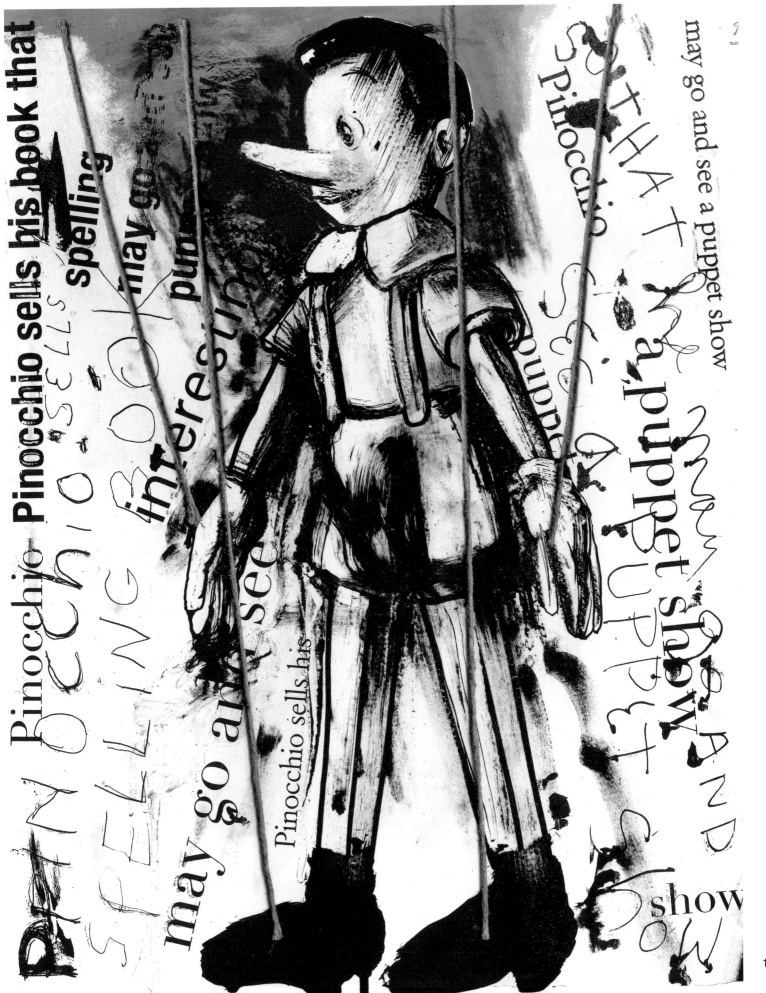

153

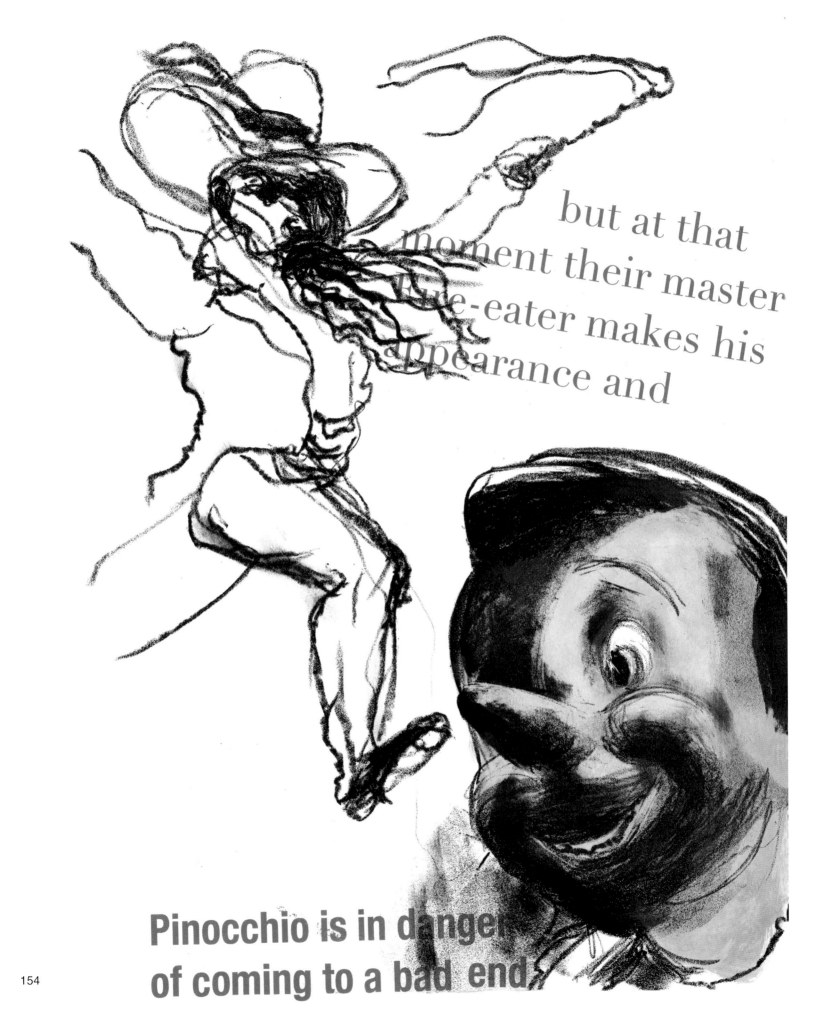

but at that moment their master Fire-eater makes his appearance and

Pinocchio is in danger of coming to a bad end

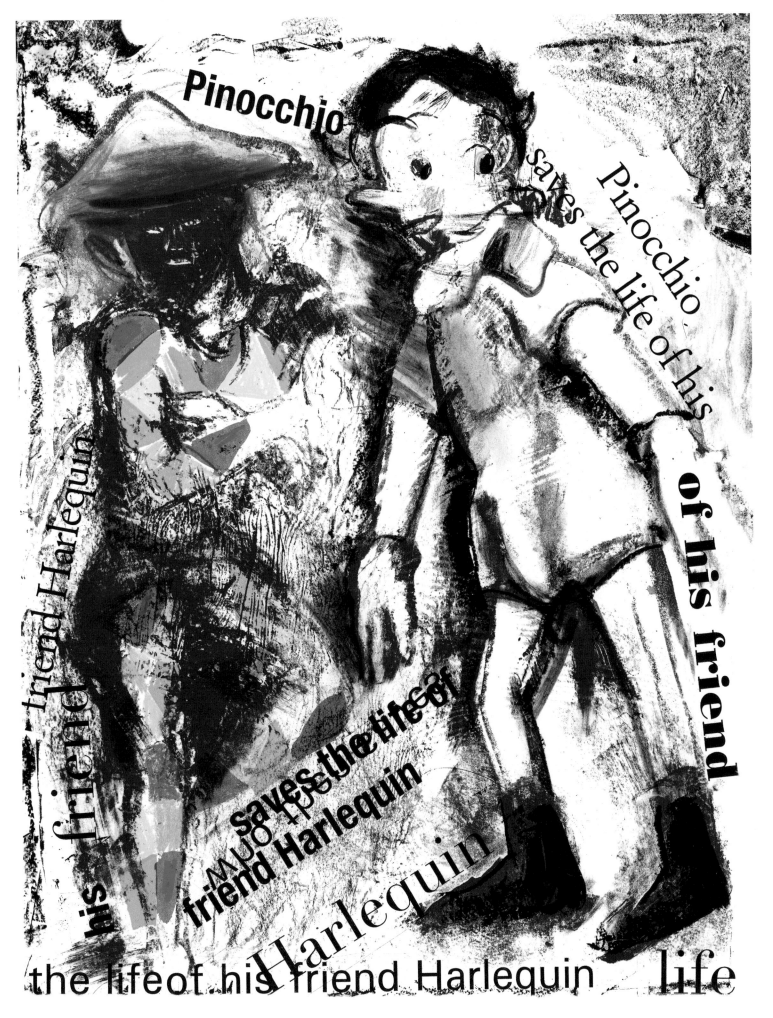

Pinocchio

Pinocchio

saves the life of his · of his friend

friend Harlequin

his friend

saves the life of

friend Harlequin

Harlequin

the lifeof his friend Harlequin life

155

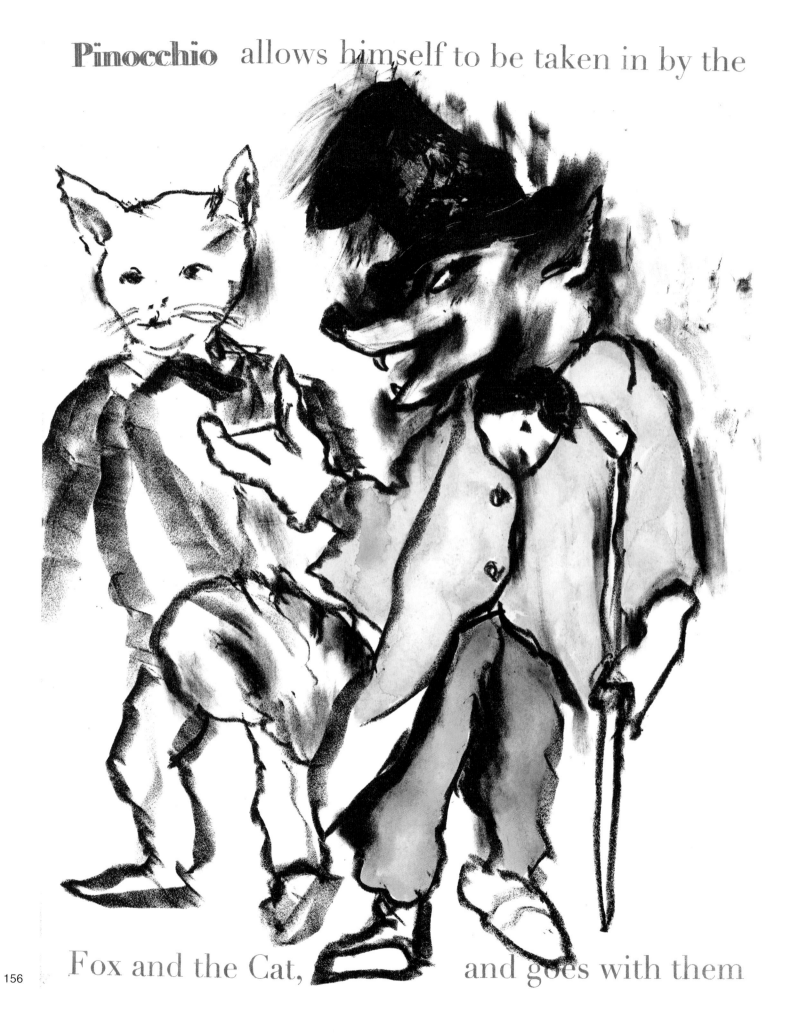

Fox and the Cat, and goes with them

THE INN
OF THE
of the
RED Red
Red
Crawfish
CRAWFISH
Crawfish

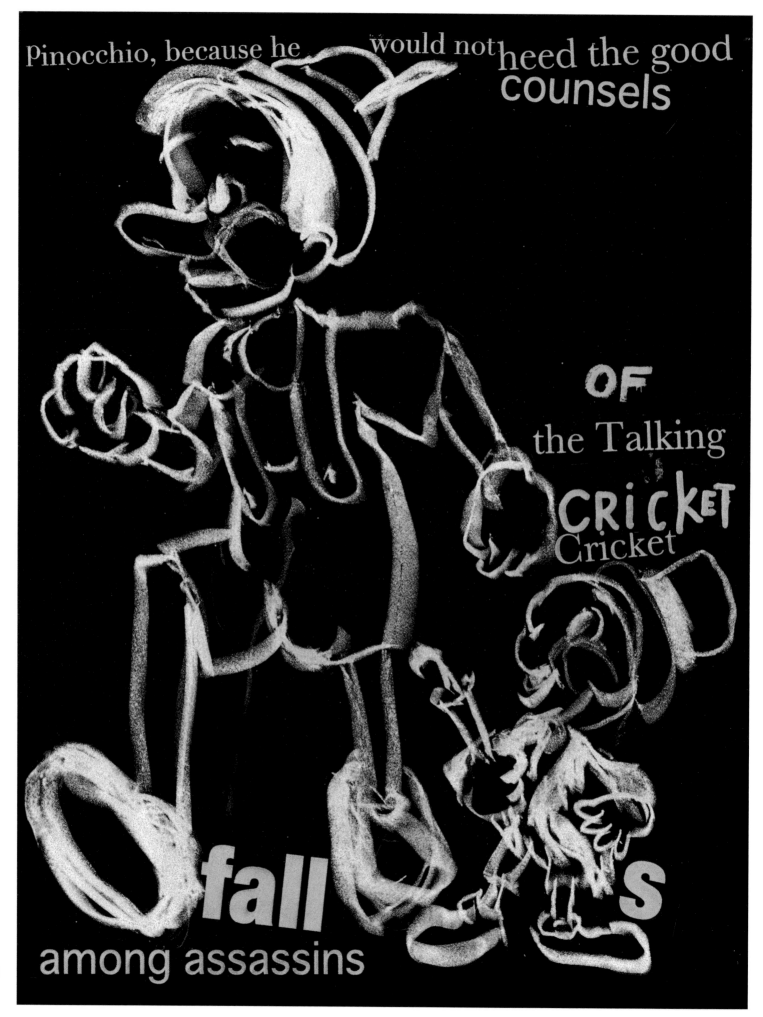

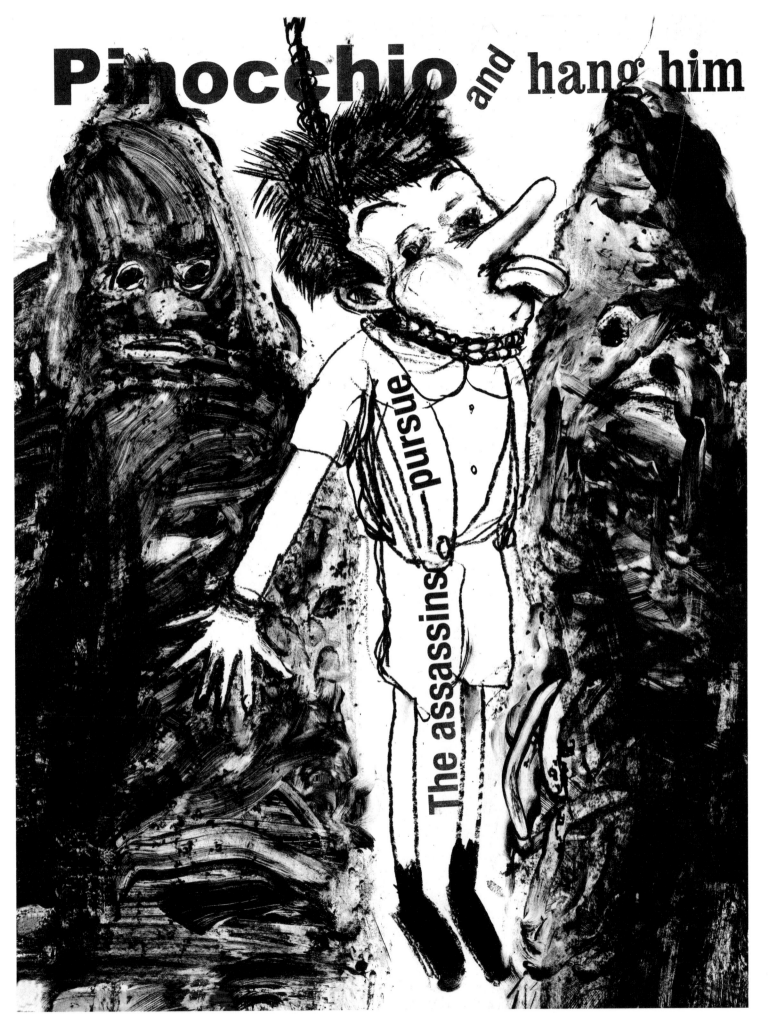

Pinocchio and hang him

pursue

The assassins

159

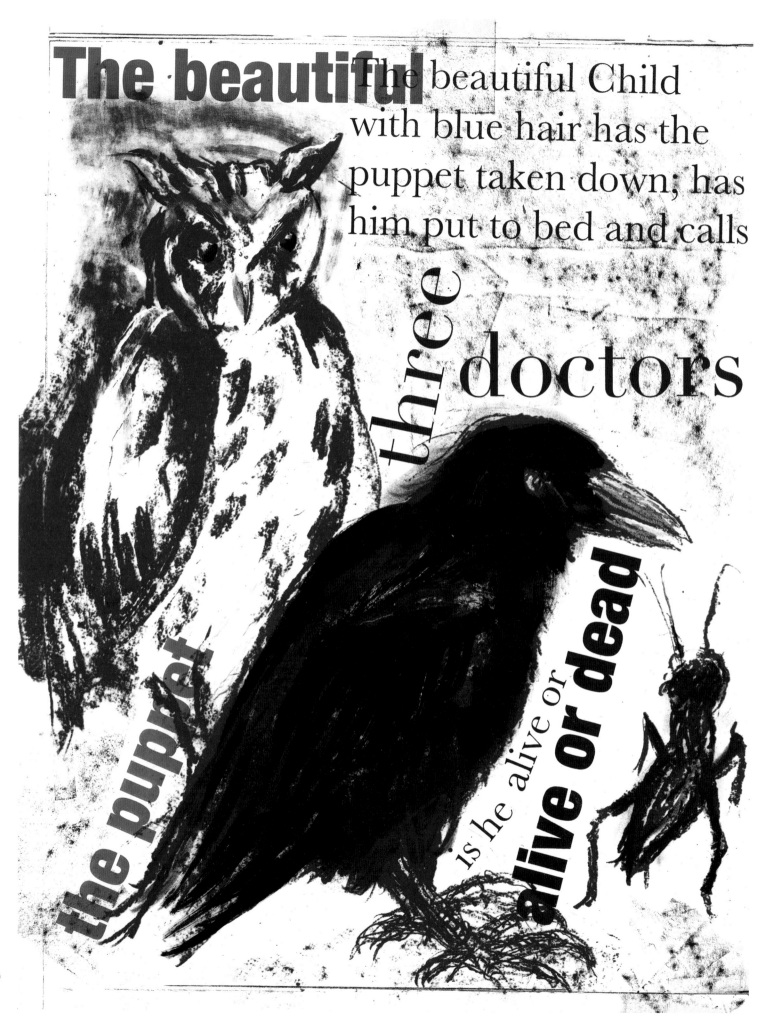

The beautiful The beautiful Child with blue hair has the puppet taken down; has him put to bed and calls

three **doctors**

the puppet

is he alive or **alive or dead**

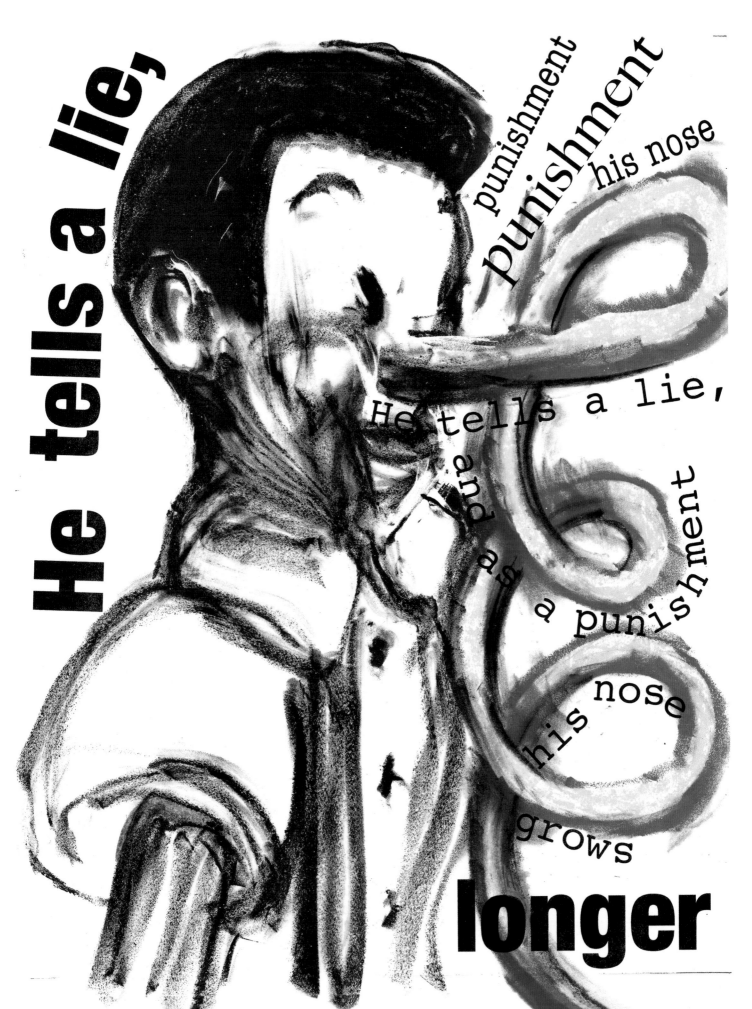

He tells a lie,

punishment
punishment
punishment
his nose

He tells a lie,
and as a punishment
his nose
grows

longer

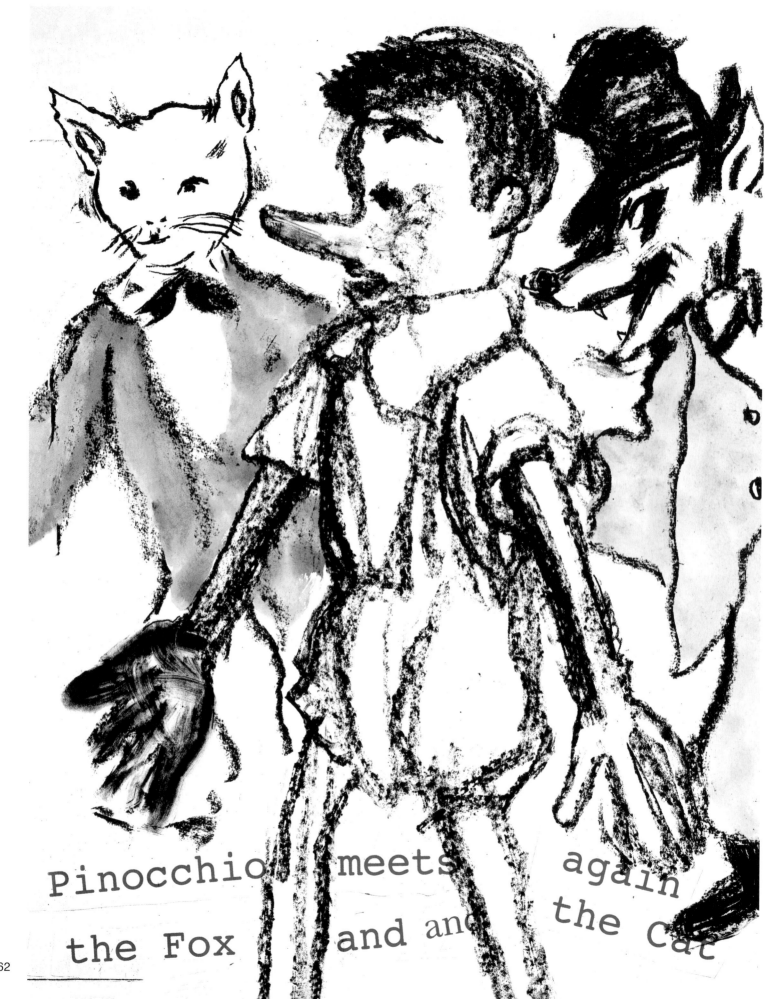

Pinocchio meets again the Fox and and the Cat

Pinecchio is robbed of his money, and as a punishment

prison

4 4

months

Pinocchio is robbed of his money, and as a

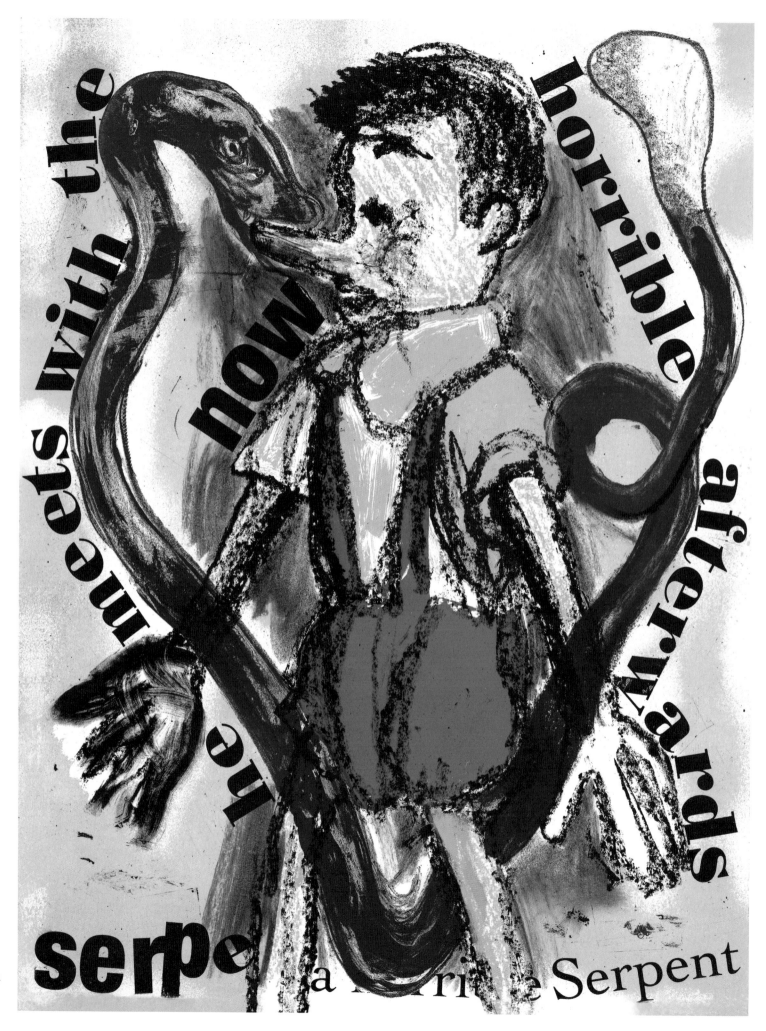

with the

meets

now

he

serpe

horrible

afterwards

a horrible Serpent

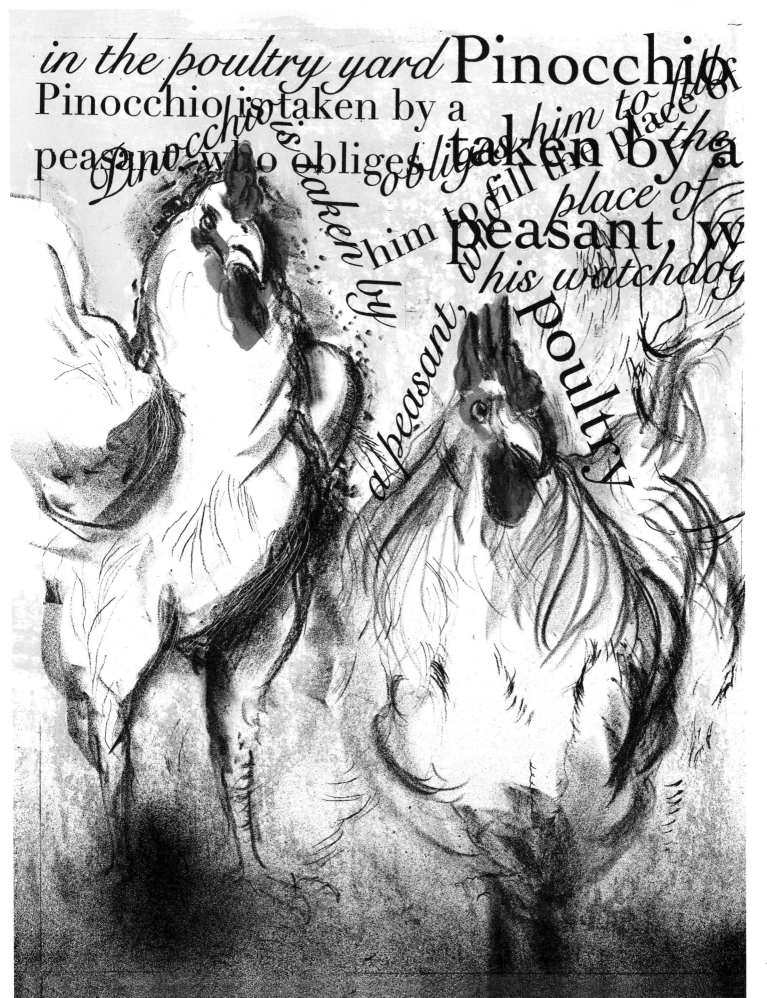

in the poultry yard Pinocchio

Pinocchio is taken by a

peasant who obliges taken by a

place of

peasant, w

his watchdog

poultry

Pinocchio discovers
the robbers
a reward for his fidelity is set
FREE

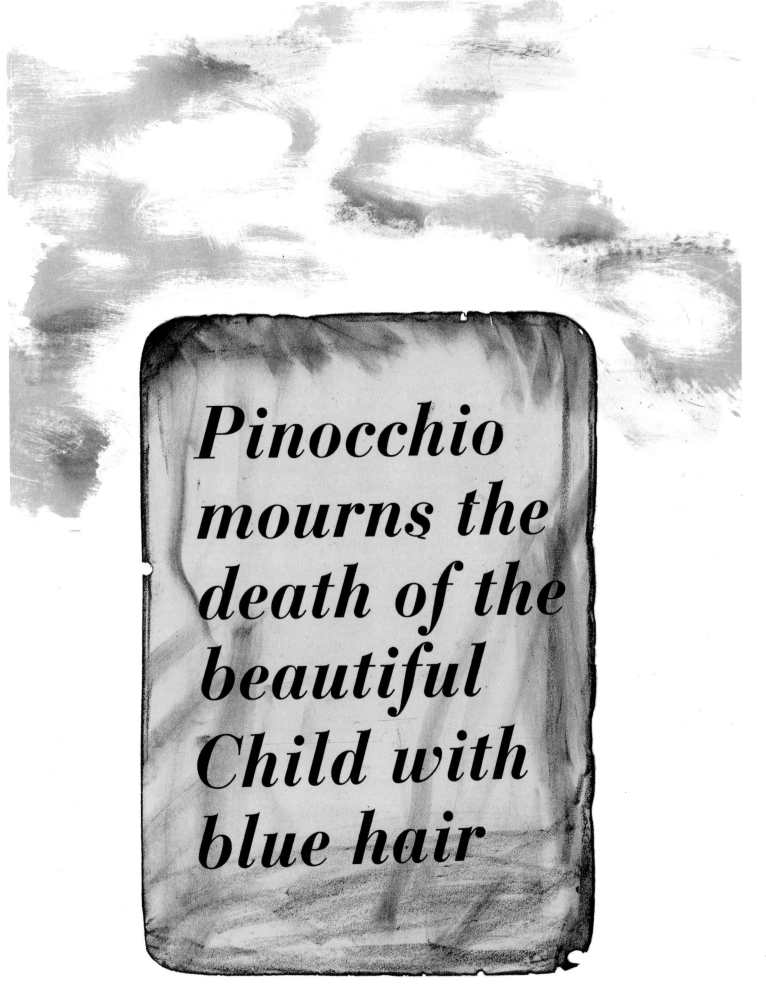

Pinocchio mourns the death of the beautiful Child with blue hair

ISLAND Pinocchio Pinocchio
Pinocchio and
THE Pinocchio and
and Pinocchio arrives
Industrious Pinocc
The to find and
Bees and finds and
fairy again is a Pinocchio
and finds having
a and finds the Pinocch
his
the Industrious Bees
Island of the Industrious and
finds the fairy again the Isl
Pinocchio the Field of
chio the Bees the Isl
arrives Pinocchio and the
Pinocchio and the
the of the fairy again
THE FAIRY AGAIN

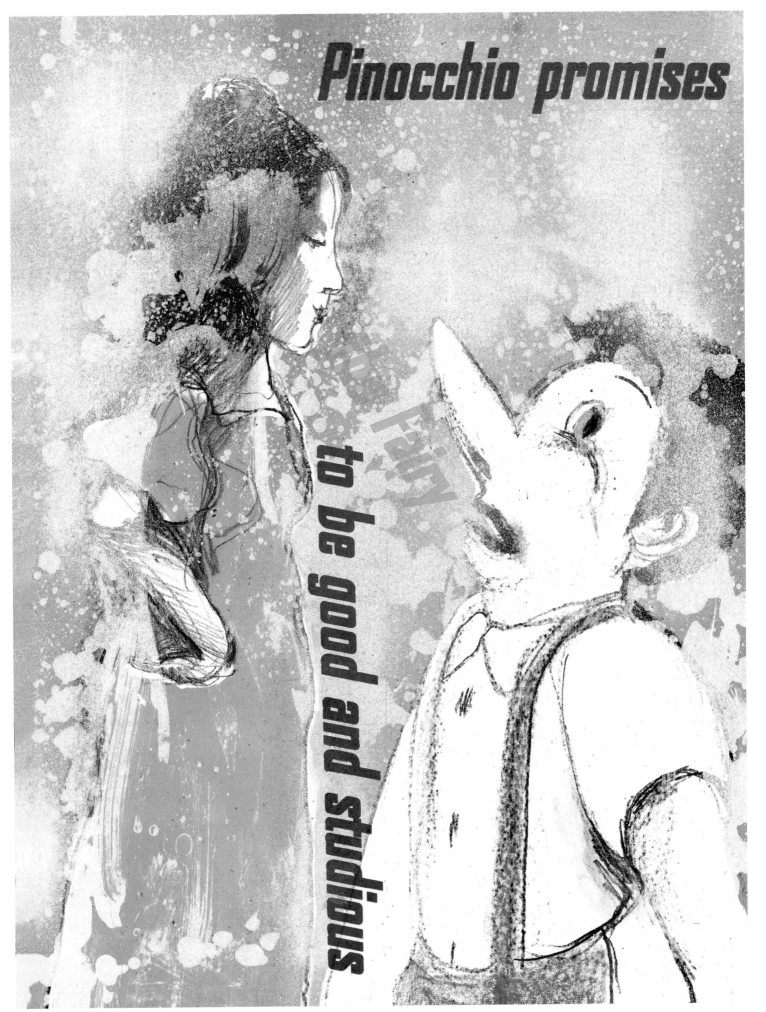

Pinocchio promises to be good and studious

169

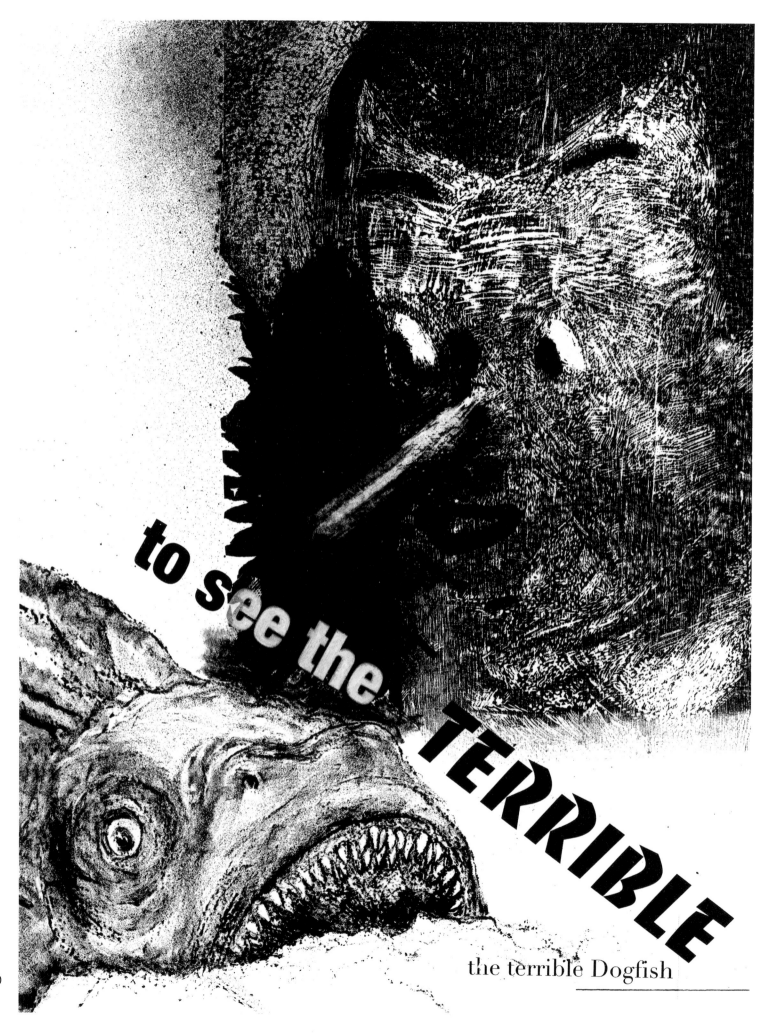

to see the TERRIBLE

the terrible Dogfish

Great fight
between
Pinocchio

Great fight
between
Pinocchio

Great fight
betweenPinocchio
and his
companions.

Great fight
between
Pinocchio
and his companions
One of them is
wounded
police

Pinocchio

Pinocchio is in danger

is in

danger of

being

fried

fried in a

of being

frying pan like

in a frying

pan like a fish

a fish

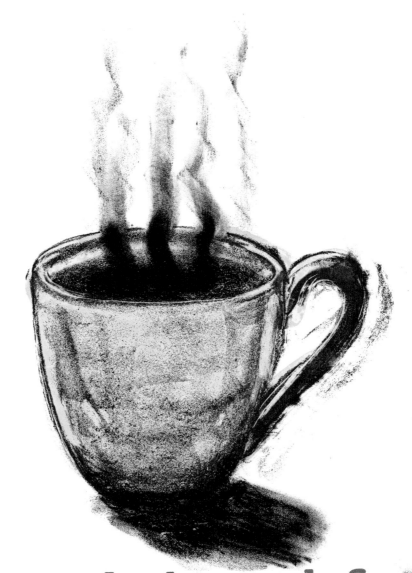

a grand breakfast
of coffee and milk

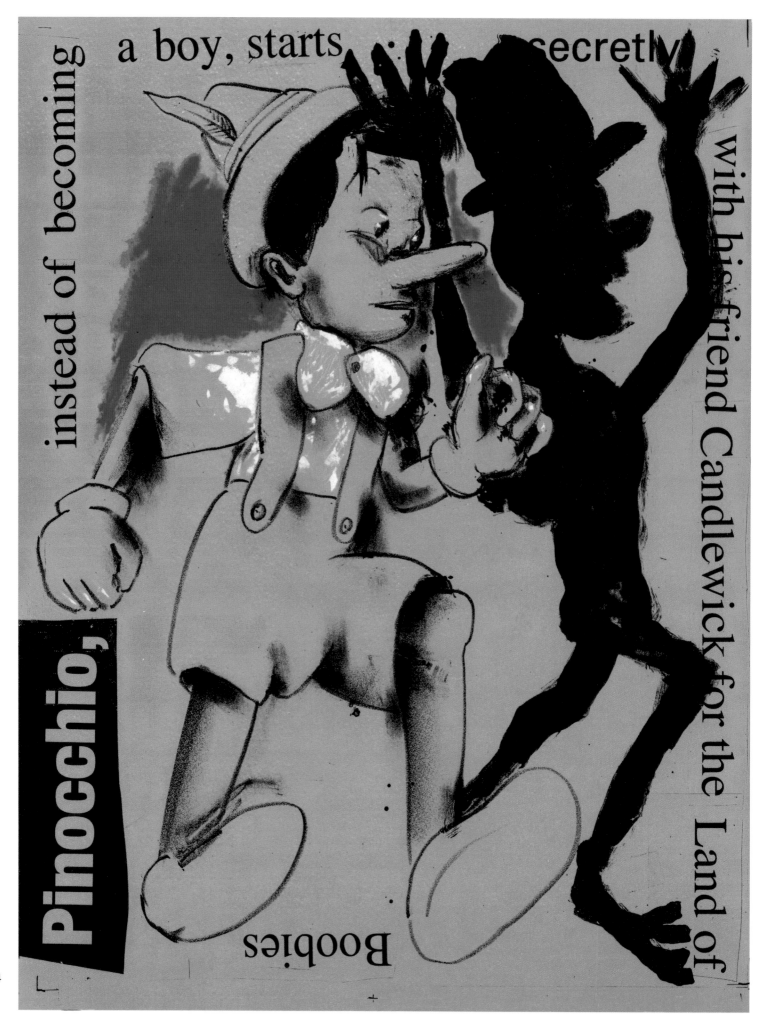

Pinocchio, instead of becoming a boy, starts secretly with his friend Candlewick for the Land of Boobies

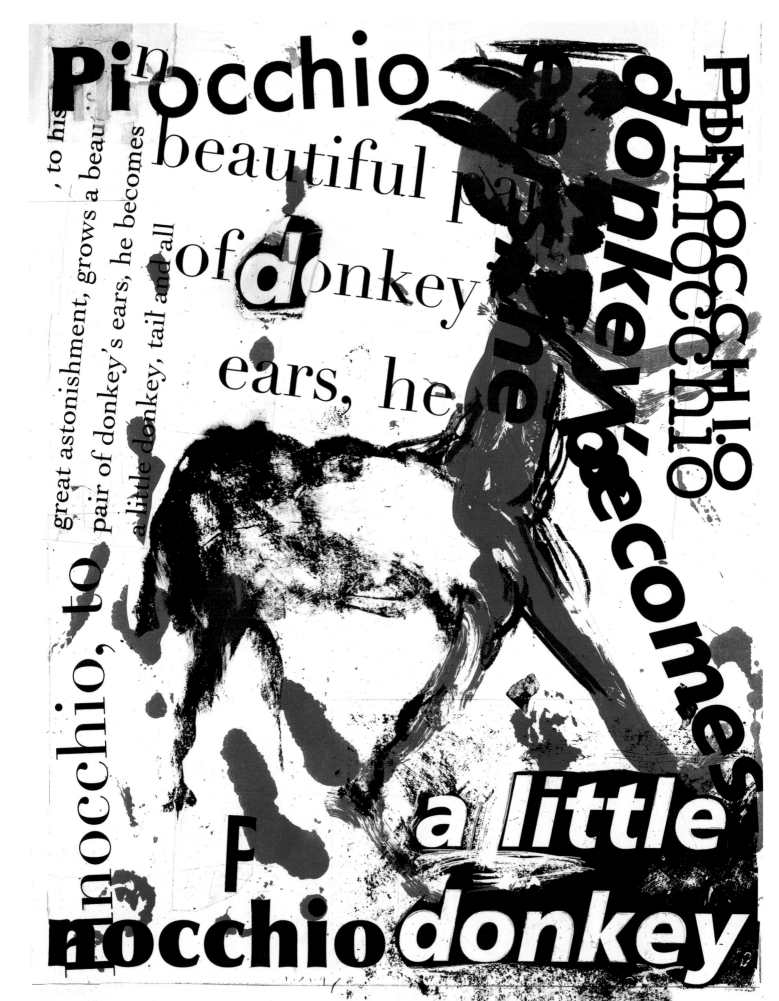

Pinocchio beautiful pair of donkey ears, he becomes a little donkey

, to his great astonishment, grows a beautiful pair of donkey's ears, he becomes a little donkey, tail and all

Pinocchio, to

Pinocchio

Pinocchio

donkey

donkey

becomes

Pinocchio

Pinocchio

a little

donkey

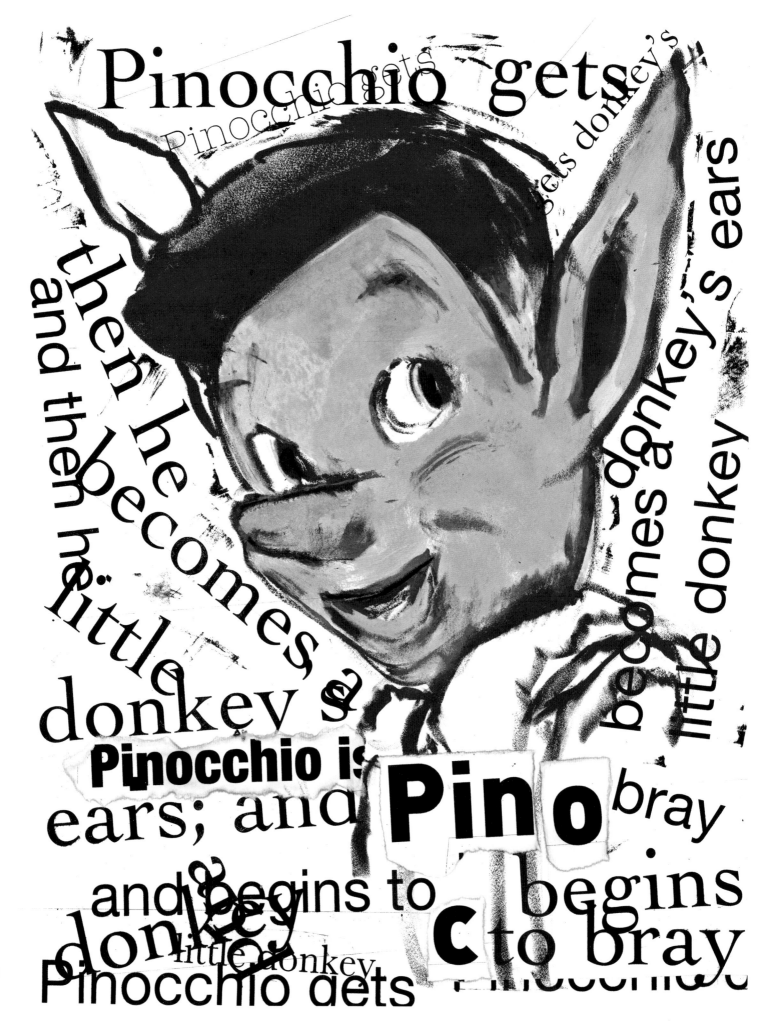

Pinocchio gets

then he becomes a little donkey's ears; and

and then he becomes little donkey

Pinocchio is

Pino

bray

and begins to

begins

c to bray

donkey

little donkey

Pinocchio gets

to dance hot take, but be
and to jump sold and gi
through he bought by
man who
the director ge
wishes to
buffoons lit
make it
to be taught do
by genuine
himself dance
the taken to be
donkey sold and is
bought by
he hurts having ake

donkey

donkey

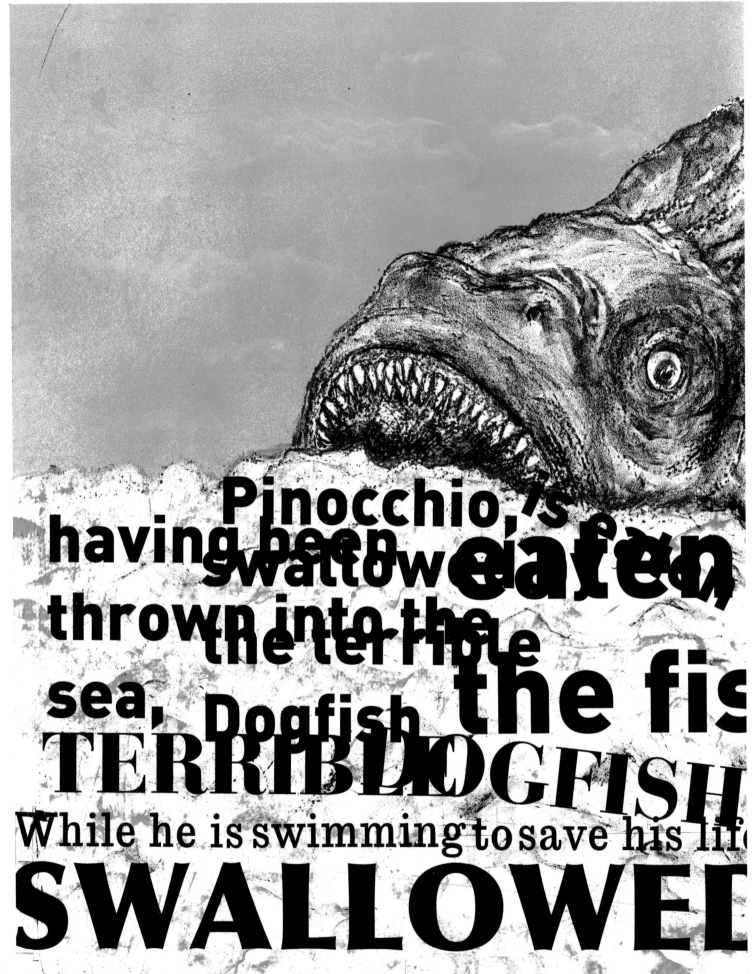

Pinocchio's having been eaten swallowed thrown into the the terrible sea, Dogfish the fis TERRIBLE DOGFISH While he is swimming to save his lif SWALLOWED

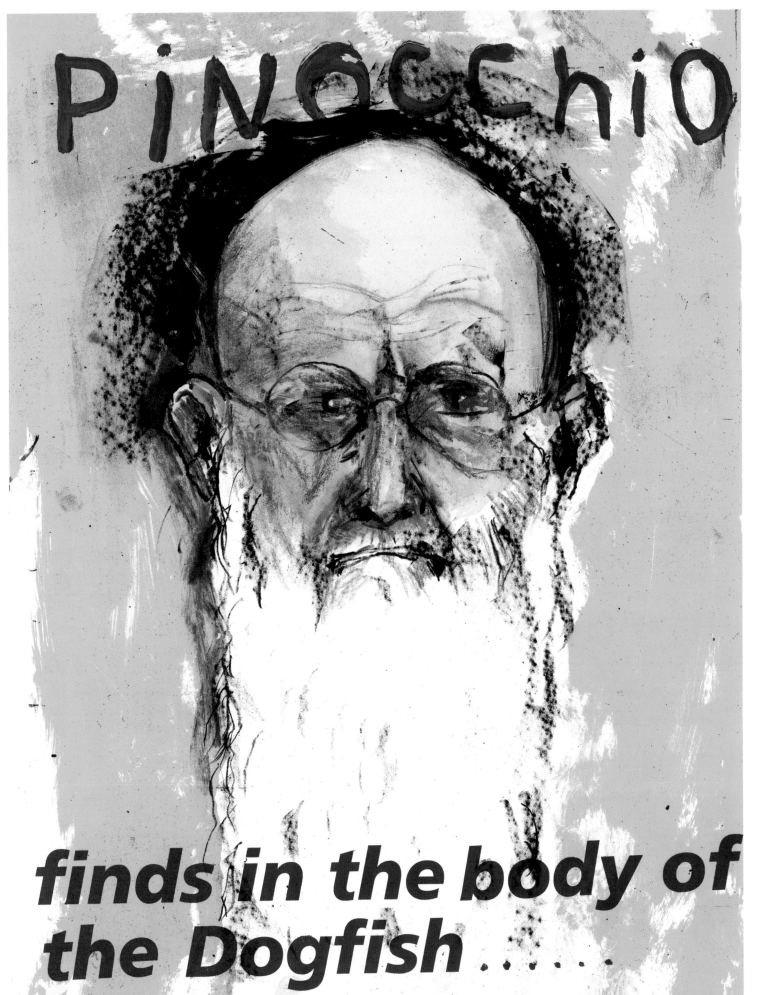

PINOCCHIO

finds in the body of
the Dogfish

179

Pinocchio

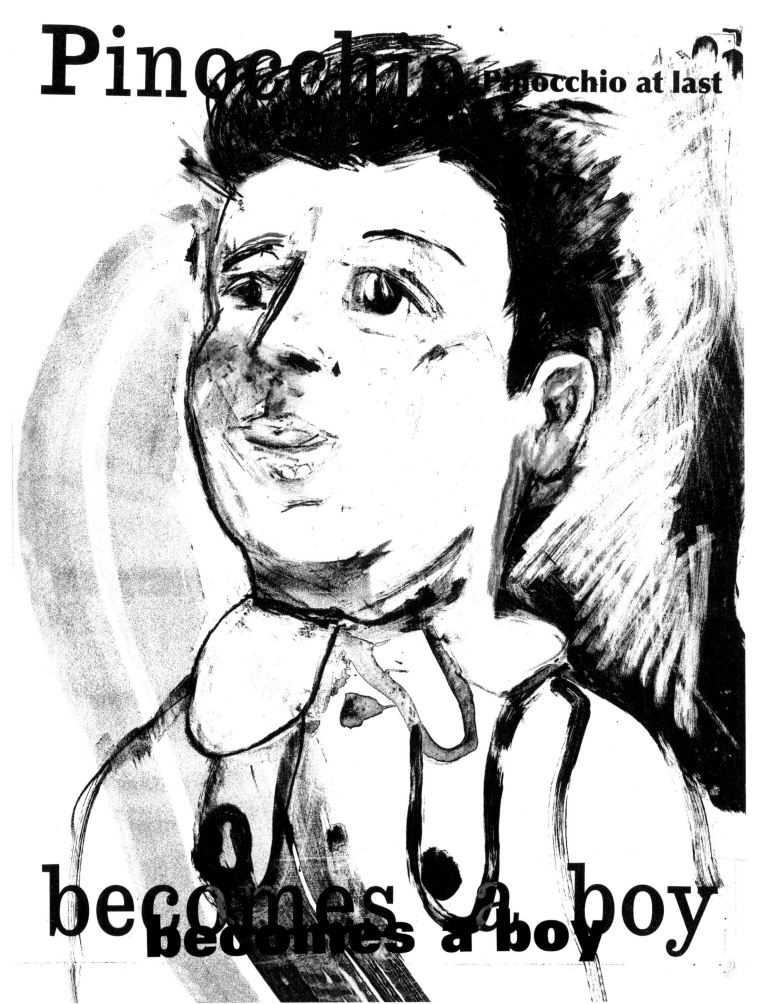

becomes a boy

becomes a boy

1935 Born June 16 in Cincinnati, Ohio

1957 Receives B.F.A. from Ohio University, Athens

Marries Nancy Minto

1958 Moves to New York City

1959–65 Participates in "Happenings," primarily at the Judson and Reuben Galleries, New York

1960 First solo exhibition at the Reuben Gallery, New York

1961–62 Solo exhibition at the Martha Jackson Gallery, New York

1962 Meets Ileana Sonnabend and begins 14-year association with the Sonnabend Gallery, New York

1964 Participates in the Venice Biennale

First solo exhibition at the Sidney Janis Gallery, New York

1965 Guest lecturer, Yale University, New Haven, Connecticut

Artist-in-residence, Oberlin College, Oberlin, Ohio; first solo museum show at the Allen Memorial Art Museum

Set and costume design for *A Midsummer Night's Dream* commissioned by Actor's Workshop, San Francisco, California

1966 Travels to London to work on prints with Editions Alecto

Visiting critic, College of Architecture, Cornell University, Ithaca, New York

1967 Moves to London

1970 Retrospective at the Whitney Museum of American Art, New York

1971 Returns to the United States, settles in Putney, Vermont and begins to draw intensively

1975 Visiting printmaker, Dartmouth College, Hanover, New Hampshire

1976 Artist-in-residence, Williams College, Williamstown, Massachusetts, at the invitation of Thomas Krens

Begins association with The Pace Gallery, New York

1977 First solo exhibition, *Jim Dine: Paintings, Drawings, Etchings, 1976,* at The Pace Gallery, New York

1979 Show at Museum of Modern Art, New York, *Jim Dine's Etchings*

1982 *Lessons in Nuclear Peace,* commissioned for the library of the Louisiana Museum of Modern Art, Humlebaek, Denmark

1984 *2 Big Black Hearts,* commissioned for Pappas Companies' building, White Plains, New York

1984–85 Retrospective, *Jim Dine: Five Themes,* Walker Art Center, Minneapolis. The exhibition traveled to Phoenix, Arizona; Saint Louis, Missouri; Akron, Ohio; Buffalo, New York; and Washington, D.C.

1985 Moves from Vermont to New York

1986 Designs sets and costumes for Houston Grand Opera's 1986–1987 season presentation of Richard Strauss's *Salome*

1935 Naît le 16 juin à Cincinnati, Ohio.

1957 Est diplômé (B.F.A.) de l'Ohio University, Athens.

Épouse Nancy Minto.

1958 S'installe à New York City.

1959–65 Prend part à des « Happenings », principalement à la Judson Gallery et à la Reuben Gallery, New York.

1960 Première exposition personnelle à la Reuben Gallery, New York.

1961–62 Exposition personnelle à la Martha Jackson Gallery, New York.

1962 Rencontre Ileana Sonnabend et commence une collaboration de 14 ans avec la Sonnabend Gallery, New York.

1964 Participe à la Biennale de Venise.

Première exposition personnelle à la Sidney Janis Gallery, New York.

1965 Conférencier, Yale University, New Haven, Connecticut.

Artiste en résidence, Oberlin College, Oberlin, Ohio; première exposition personnelle dans un musée à l'Allen Memorial Art Museum.

Dessine le décor et les costumes pour *A Midsummer Night's Dream*, une commande de l'Actor's Workshop, San Francisco, Californie.

1966 Voyage à Londres pour produire des estampes avec les Éditions Alecto.

Critique invité, College of Architecture, Cornell University, Ithaca, New York.

1967 S'installe à Londres.

1970 Rétrospective au Whitney Museum of American Art, New York.

1971 Retourne aux États-Unis et s'installe à Putney dans le Vermont; il commence à dessiner de manière intensive.

1975 Artiste-graveur invité, Dartmouth College, Hanover, New Hampshire.

1976 Artiste en résidence, Williams College, Williamstown, Massachusetts, à l'invitation de Thomas Krens.

Commence sa collaboration avec la Pace Gallery, New York.

1977 Première exposition personnelle, *Jim Dine: Paintings, Drawings, Etchings, 1976,* à la Pace Gallery, New York.

1979 Exposition *Jim Dine's Etchings* au Museum of Modern Art, New York.

1982 *Lessons in Nuclear Peace,* commande pour la bibliothèque du Louisiana Museum of Modern Art, Humlebaek, Danemark.

1984 *2 Big Black Hearts,* commande pour l'immeuble de Pappas Companies, White Plains, New York.

1984–85 Rétrospective, *Jim Dine: Five Themes,* Walker Art Center, Minneapolis. Exposition présentée à Phoenix, Arizona, à Saint Louis, Missouri, à Akron, Ohio, à Buffalo, New York, et à Washington, D.C.

1985 Quitte le Vermont pour New York.

1986 Réalise les décors et les costumes pour *Salome* de Richard Strauss au Grand Opéra de Houston.

1988 *Jim Dine: Paintings, Sculpture, Drawings, Prints, 1959–1987* at Galleria d'Arte Moderna Ca'Pesaro, Venice

1988–90 *Drawings, Jim Dine, 1973–1987* at The Contemporary Arts Center, Cincinnati, Ohio. The exhibition traveled to Fort Lauderdale, Florida; Santa Barbara, California; Seattle, Washington; Fort Worth, Texas; Minneapolis, Minnesota; Chicago, Illinois; Omaha, Nebraska; and San Francisco, California.

1989 *Looking Toward the Avenue,* commissioned by Tishman Speyer Trammell Crow Limited Partnership and installed outside 1301 Avenue of the Americas, New York

1990 Exhibition of drawings, *In der Glyptothek,* Staatliche Antikensammlungen und Glyptothek, Munich

1990–91 Retrospective exhibition at the Isetan Museum of Art, Tokyo and the Museum of Art, Osaka

1993 *Black Venus* exhibited in *Copier créer de Turner à Picasso, 300 oeuvres inspirées par les maîtres du Louvre,* Musée du Louvre, Paris

1993–94 *Jim Dine: Drawing from the Glyptothek* organized by the Madison Art Center, Madison, Wisconsin. The exhibition traveled to Salzburg, Cincinnati, Honolulu, Montreal, and Miami.

Jim Dine: Paintings, Drawings and Sculpture 1973–1993, Borås Konstmuseum, Borås, Sweden. The exhibition traveled to Budapest and Nice.

1995 *Jim Dine: A Self-Portrait on the Walls,* a 30-minute film documenting the artist's exhibition of temporary wall drawings, Kunstverein Ludwigsburg, Germany, produced by Outside in July, Inc.

1996 *Ape & Cat,* commissioned by the Battery Park City Authority for Robert Wagner Park in Battery Park, New York, Inc.

All About Looking: Jim Dine Teaches at the International Sommerakademie Salzburg, a 30-minute film about the artist's methods for teaching life drawing, filmed in Salzburg, Austria in 1994 and produced by Outside in July, Inc.

1997 Receives honorary doctorate from California College of Arts and Crafts

Three Red Spanish Venuses commissioned by the Guggenheim Museum Bilbao, Bilbao, Spain

1999 *Jim Dine: Walking Memory 1959–1969,* exhibition at the Solomon R. Guggenheim Museum, New York

2000 Invited by the Mayor of Siena, Italy, to design banner for the Palio, July 2, 2000

2003 Named Commandeur de l'ordre des Arts et des Lettres, June 25, 2003, Paris, France (awarded for artistic or literary contributions in France and around the world)

1988 *Jim Dine: Paintings, Sculpture, Drawings, Prints, 1959–1987* à la Galleria d'Arte Moderna Ca'Pesaro, Venise.

1988–90 *Drawings, Jim Dine, 1973–1987* au Contemporary Arts Center, Cincinnati, Ohio. Exposition présentée à Fort Lauderdale, Floride, à Santa Barbara, Californie, à Seattle, Washington, à Fort Worth, Texas, à Minneapolis, Minnesota, à Chicago, Illinois, à Omaha, Nebraska et à San Francisco, Californie.

1989 *Looking Toward the Avenue,* commandé par Tishman Speyer Trammell Crow Limited Partnership et installé au 1301 Avenue of the Americas, New York.

1990 Exposition itinérante de dessins, *In der Glyptothek,* Staatliche Antikensammlungen und Glyptothek, Munich.

1990–91 Exposition rétrospective à l'Isetan Museum of Art, Tokyo, et au Museum of Art, Osaka.

1993 *Black Venus* est présentée à l'exposition *Copier créer de Turner à Picasso, 300 œuvres inspirées par les maîtres du Louvre,* Musée du Louvre, Paris.

1993–94 *Jim Dine: Drawing from the Glyptothek* organisé par le Madison Art Center, Madison, Wisconsin. Exposition présentée à Salzbourg, à Cincinnati, à Honolulu, à Montréal et à Miami.

Jim Dine: Paintings, Drawings and Sculpture 1973–1993, Borås Konstmuseum, Borås, Suède. Exposition présentée à Budapest et à Nice.

1995 *Jim Dine: A Self-Portrait on the Walls,* un film de 30 minutes sur l'exposition de dessins muraux présentée au Kunstverein Ludwigsburg, Allemagne, produit par Outside in July, Inc.

1996 *Ape & Cat,* commandé par le Battery Park City Authority pour Robert Wagner Park dans Battery Park, New York, Inc.

All About Looking: Jim Dine Teaches at the International Sommerakademie Salzburg, un film de 30 minutes sur l'enseignement par l'artiste du dessin d'après nature, filmé en 1994 à Salzbourg, Autriche, et produit par Outside in July, Inc.

1997 Reçoit un doctorat honoraire du California College of Arts and Crafts.

Three Red Spanish Venuses, commandé par le Guggenheim Museum de Bilbao, Espagne.

1999 *Jim Dine: Walking Memory 1959–1969,* exposition au Solomon R. Guggenheim Museum, New York.

2000 Invité par le maire de Sienne, Italie, pour dessiner la bannière du Palio du 2 juillet 2000.

2003 Nommé Commandeur de l'ordre des Arts et des Lettres, le 25 juin 2003, Paris, France (en récompense de ses contributions littéraires et artistiques en France et dans le monde).

The exhibition, *Jim Dine, the Photographs, so far,* organized by the Davison Art Center, Wesleyan University, Middletown, Connecticut and the Maison Européenne de la Photographie, Paris, traveled to Sweden and Germany.

2004 Retrospective exhibition, *Jim Dine Drawings,* organized by the National Gallery of Art, Washington, D.C.

2005 Marries Diana Michener

Jim Dine's some drawings, curated by Stephanie Wiles. Exhibited at Allen Memorial Art Museum, Oberlin College, and traveled to Neuberger Museum of Art, Purchase College, State University of New York; Mary and Leigh Block Museum of Art, Northwestern University; and Frederick R. Weisman Museum of Art, Pepperdine University, Malibu, California

2006 New York Public Library, New York launch of a new edition of Carlo Collodi's novel *Pinocchio,* images by Jim Dine

2007 *L'Odyssée de Jim Dine: Survey of Prints, 1985–2006,* curated by Caroline Joubert. Exhibited at Musée des Beaux-Arts de Caen, France

Aldo et Moi, the complete etchings of Jim Dine made with Aldo Crommelynck. Exhibited at Bibliothèque nationale de France, Paris

Exposition itinérante, *Jim Dine, the Photographs, so far,* organisée par le Davison Art Center, Wesleyan University, Middletown, Connecticut et la Maison Européenne de la Photographie, Paris. Exposition présentée en Suède et en Allemagne.

2004 Exposition rétrospective, *Jim Dine Drawings,* organisée par la National Gallery of Art, Washington, D.C.

2005 Épouse Diana Michener.

Jim Dine's some drawings, exposition organisée par Stephanie Wiles à l'Allen Memorial Art Museum, Oberlin College, et présentée ensuite au Neuberger Museum of Art, Purchase College, State University of New York, au Mary and Leigh Block Museum of Art, Northwestern University, et au Frederik Weisman Museum of Art, Pepperdine University, Malibu, Californie.

2006 Lancement à la New York Public Library, New York, d'une nouvelle édition du *Pinocchio* de Carlo Collodi illustrée par Jim Dine.

2007 *L'Odyssée de Jim Dine: Survey of Prints, 1985–2006,* exposition organisée par Caroline Joubert au Musée des Beaux-Arts de Caen, France.

Aldo et Moi: the complete etchings of Jim Dine made with Aldo Crommelynck, exposition à la Bibliothèque nationale de France, Paris.

selected bibliography

1970 *Jim Dine: Complete Graphics.* Berlin, Galerie Mikro, 1970; Hannover, Kestner-Gesellschaft; London, Petersburg Press. Includes catalogue raisonné and essays by John Russell, Tony Towle, and Wieland Schmied.

1977 Krens, Thomas. *Jim Dine Prints: 1970-1977.* New York, Harper & Row, in association with the Williams College Artist-in-Residence Program, 1977. Includes catalogue raisonné, conversation between the artist and Thomas Krens, and essay by Riva Castleman.

1986 D'Oench, Ellen G., and Feinberg, Jean E. *Jim Dine Prints 1977-1985.* New York, Harper & Row, in association with the Davison Art Center and the Ezra and Cecile Zilkha Gallery, Wesleyan University, Middletown, Connecticut, 1986. Includes catalogue raisonné and two essays by Ellen G. D'Oench and Jean E. Feinberg.

Jim Dine: Rise Up, Solitude! Prints 1985-86. London, Waddington Graphics, 1986. Text by Marco Livingstone, and interview with the artist.

1987 *Jim Dine chez Aldo Crommelynck: Gravures.* Paris, American Center, 1987. Text by Madeleine Deschamps.

Aldo Crommelynck in collaboration with Georges Braque, Pablo Picasso, Richard Hamilton, Jim Dine. London, Waddington Graphics, 1987. Texts by Alan Cristea and Pat Gilmour.

1988 *Jim Dine: Youth and the Maiden.* London, Waddington Graphics, 1988. Texts by Konrad Oberhuber and Donald Saff.

1990 *Jim Dine: The Hand-Coloured Viennese Hearts, 1987-90.* London, Waddington Graphics; New York, Pace Prints, 1990.

1993 *Jim Dine: The Four Continents.* New York, Pace Prints, 1993. Text by Marco Livingstone.

1994 *Jim Dine: Untersberg 1993-1994.* Salzburg, Residenzgalerie, 1994. Texts by Jim Dine, Roswitha Juffinger, Wieland Schmied, and Barbara Wally.

1995 *Jim Dine: Winter Dream.* New York, Pace Prints, 1995. Text by Marco Livingstone.

1998 Livingstone, Marco. *Jim Dine: The Alchemy of Image.* New York, The Monacelli Press, 1998. Monograph by Marco Livingstone with commentary by Jim Dine, particularly "Me and Aldo", p. 149.

2000 *Jim Dine: Subjects.* London, Alan Cristea Gallery, 2000. Text by Marco Livingstone.

2002 Carpenter, Elizabeth. *Jim Dine Prints 1985-2000: A Catalogue Raisonné.* Minneapolis, The Minneapolis Institute of Arts, 2002. Texts by Joseph Ruzicka and Elizabeth Carpenter, and catalogue raisonné of prints, livres d'artiste and portfolios by Elizabeth Carpenter.

Jim Dine: Painted Monoprints. London, Alan Cristea Gallery, 2002. Text by Alan Cristea.

2005 *Jim Dine: Tools and Plants.* London, Alan Cristea Gallery, 2005. Text by Jim Dine.

2006 *Pinocchio: Collodi/Dine.* Göttingen, Steidl, 2006. Text by Carlo Collodi translated into English by M. A. Murray, and illustrations by Jim Dine.

2007 *L'Odyssée de Jim Dine: A Survey of Printed Works 1985-2006.* Musée des Beaux-Arts de Caen, France. Göttingen, Steidl, 2007. Essay and interview with the artist by Caroline Joubert.

ALDO ET MOI. Bibliothèque nationale de France, Paris. Göttingen, Steidl, 2007. The complete etchings of Jim Dine made in collaboration with the printer Aldo Crommelynck 1976-97.

Excluding the portfolio *Pinocchio/Jim Dine*, published in 2006 by Gerhard Steidl, Göttingen, Jim Dine's prints were published, from 1985 to 1994, by Pace Editions, Inc., New York, and Waddington Graphics, London; after 1995 by Pace Editions, Inc., New York, and Alan Cristea Gallery, London.

Titles have been provided by Jim Dine. The date given is the year of publication. The printing process is given first, followed by the brand name (when available) and the type of paper or other support. Dimensions are expressed in inches, with centimeters in parentheses. Sheet dimensions are always listed, followed by plate mark dimensions if the work was printed intaglio. Height precedes width. The number of published prints constitutes the edition. The names of the printer (or printers) are followed by the name of the workshop where the edition was printed.

Double Pacific Gift 1985 Lithograph and linoleum cut on Arches Cover White paper. Two sheets: 60 x 45 $^3/_8$ (152.4 x 115.3) and 59 $^3/_4$ x 47 (151.8 x 119.4); overall, 60 x 90 $^3/_4$ (152.4 x 230.5). Edition of 6. Printer: Toby Michel at Angeles Press, Los Angeles

The Garrity Necklace 1986 Direct gravure, aquatint and power-tool drypoint on Arches Cover White paper. Sheet: 53 $^1/_4$ x 40 $^3/_4$ (135.3 x 103.5) Plate: 47 $^3/_4$ x 35 $^3/_4$ (121.3 x 90.8). Edition of 30. Printer: Robert Townsend, Georgetown, Massachusetts

The Side View 1986 Etching, soft-ground etching and power-tool drypoint on Heritage White paper. Sheet: 47 x 44 $^3/_4$ (119.4 x 113.7). Plate: 41 $^1/_2$ x 38 $^7/_8$ (105.4 x 98.7). Edition of 20. Printer: Niels Borch Jensen at Vaerksted for Kobbertryk, Copenhagen

The Foreign Plowman 1988 Heliorelief, woodcut and spit-bite etching with hand coloring and sanding on Arches Cover White paper. Five sheets: 70 $^7/_8$ x 24 $^1/_4$ (180 x 61.5); 70 $^7/_8$ x 25 $^1/_2$ (180 x 64.8); 70 $^7/_8$ x 24 $^1/_2$ (180 x 62.2); 70 $^7/_8$ x 23 $^5/_8$ (180 x 60); 70 $^7/_8$ x 24 $^1/_2$ (180 x 62.2). Edition of 10. Printer: Donald Saff, Graphicstudio, University of South Florida, Tampa

Self in Ocean 1991 Soft-ground etching, aquatint and spit-bite aquatint with hand coloring on Hahnemühle White paper. Sheet: 54 $^1/_2$ x 39 $^5/_8$ (138.4 x 100.6). Plate: 49 x 39 (124.5 x 99.1). Edition of 30. Printer: Niels Borch Jensen, Copenhagen

Ghost Robe 1992 Woodcut on Arches Cover White paper. Sheet: 64 x 41 $^1/_2$ (162.6 x 105.4). Edition of 12. Printers: Joe Wilfer, Ruth Lingen, Kathy Kuehn at Pace Editions Inc., New York

The Blue Carborundum Robe 1992 Woodcut and carborundum on Arches Cover White paper. Sheet: 62 $^7/_8$ x 42 $^1/_4$ (159.7 x 107.3). Plate: 60 $^5/_8$ x 40 $^3/_4$ (154 x 103.5). Edition of 30. Printers: Joe Wilfer, Ruth Lingen, Kathy Kuehn, Bill Hall, Julia D'Amario, at Pace Editions Inc., New York

Woman on Fire in Vienna 1993 Etching with hand coloring on Arches Aquarelle Cream paper. Sheet: 55 $^5/_8$ x 41 (141.3 x 104.1). Plate: 47 $^1/_2$ x 34 $^3/_4$ (120.7 x 88.3). Edition of 21. Printer: Kurt Zein at Werkstatt für Handgedruckte Original-Graphik, Vienna

Two Old Bathers 1993 Etching, drypoint and power-tool drypoint with hand coloring on Somerset White paper. Sheet: 54 x 52 (137.2 x 132.1.) Plates: overall, 50 x 48 (127 x 121.9). Edition of 22. Printer: Kurt Zein at Werkstatt für Handgedruckte Original-Graphik, Vienna

Grease, Bone, and Color 1993 Etching, soft-ground etching, drypoint and power-tool drypoint with hand coloring on Arches Aquarelle Cream paper. Sheet: 45 $^1/_2$ x 41 (115.6 x 104.1). Plate: 41 $^1/_2$ x 38 $^7/_8$ (105.4 x 98.7). Edition of 21. Printer: Kurt Zein at Werkstatt für Handgedruckte Original-Graphik, Vienna

The Historical Untersberg 1994 Cardboard intaglio, etching, drypoint, roulette, power-tool drypoint, sandpaper abrasion and carborundum on T. H. Saunders Waterford Aquarelle Ivory paper. Three sheets: 58 $^1/_2$ x 43 (148.6 x 109.2) each. Plates: 52 $^3/_4$ x 39 (134 x 99.1) each. Edition of 15. Printer: Kurt Zein at Werkstatt für Handgedruckte Original-Graphik, Vienna

Raven on Cloth 1994 Etching, drypoint, roulette and sandpaper abrasion on cotton canvas. Sheet: 45 x 39 (114.3 x 99.1.) Plate: 37 $^7/_8$ x 31 $^1/_2$ (96.2 x 80). Edition of 14. Printer: Kurt Zein at Werkstatt für Handgedruckte Original-Graphik, Vienna

Felt Skull 1994 Woodcut on brown papermaking felt. Sheet: 45 x 39 (114.3 x 99.1). Plate: 37 $^7/_8$ x 31 $^1/_2$ (96.2 x 80). Edition of 7. Printers: Julia D'Amario and Ruth Lingen at Pace Editions Inc., New York

White Owl (for Alan) 1995 Cardboard intaglio on Arches Cover White paper. Sheet: 58 3/4 x 30 5/8 (149.2 x 77.8). Plate: 56 1/2 x 29 1/4 (143.5 x 74.3). Edition of 20. Printers: Bill Hall and Julia D'Amario at Pace Editions Inc., New York

Winter Dream (for V.) 1995 Series of 12 prints. Woodcut on recycled gray blotter. Sheet: 67 x 51 (170.2 x 129.5). Edition of 12. Printer: Kurt Zein at Werkstatt für Handgedruckte Original·Graphik, Vienna

Winter Dream (for V.) [Skull], Winter Dream (for V.) [Tree], Winter Dream (for V.) [Black Head], Winter Dream (for V.) [Owl], Winter Dream (for V.) [Self-Portrait], Winter Dream (for V.) [Nude], Winter Dream (for V.) [Ape], Winter Dream (for V.) [Crow], Winter Dream (for V.) [Cat], Winter Dream (for V.) [Leg], Winter Dream (for V.) [Monsieur], Winter Dream (for V.) [Head]

55 Portraits 1995 Portfolio of 55 etchings, plus title sheet and colophon, in linen box. Box: 20 3/4 x 15 1/4 x 2 (52.7 x 38.7 x 5.1). Sheet: 19 x 14 (48.3 x 35.6) each. Plate: 11 1/4 x 7 5/8 (28.6 x 19.4) each. Edition of 10. Printers: Bill Hall and Julia D'Amario (intaglio), and Ruth Lingen (letterpress) at Pace Editions Inc., New York

The Pro Consul 1996 Cardboard intaglio on Arches Cover Buff paper. Sheet: 55 x 42 1/4 (139.7 x 107.3). Plate: 46 1/2 x 40 (118.1 x 101.6). Edition of 25. Printers: Bill Hall and Julia D'Amario at Pace Editions Inc., New York

Red Sitting with Me 1996 Cardboard intaglio on Arches Cover White paper. Sheet: 58 1/2 x 42 (148.6 x 106.7). Plate: 53 1/4 x 39 1/4 (135.3 x 99.7). Edition of 30. Printers: Bill Hall and Julia D'Amario at Pace Editions Inc., New York

Lakeside 1998 Woodcut on Arches Cover Buff paper. Sheet: 47 1/2 x 38 (120.7 x 96.5). Plate: 41 1/2 x 33 (105.4 x 83.8). Edition of 30. Printers: Ruth Lingen and Anne Polashenski at Pace Editions Inc., New York

Noon 1998 Woodcut and cardboard intaglio with hand coloring on Arches Cover White paper. Sheet: 47 1/2 x 38 (120.7 x 96.5). Plate: 41 1/2 x 33 (105.4 x 83.8). Edition of 18. Printers: Ruth Lingen, Anne Polashenski, Julia D'Amario and Bill Hall at Pace Editions Inc., New York

To the Lake 1998 Woodcut on Arches Cover White paper. Sheet: 47 1/2 x 38 (120.7 x 96.5). Plate: 41 1/2 x 33 (105.4 x 83.8). Edition of 30. Printers: Ruth Lingen, Anne Polashenski at Pace Editions Inc., New York

Pure Woodcut 1999 Woodcut on Okawarashi Off White paper. Sheet: 62 1/4 x 37 1/4 (158.1 x 94.6). Edition of 18. Printers: Ruth Lingen, Julia D'Amario and Caroline Carlisle at Pace Editions Inc., New York

Sun's Night Glow 2000 Lithograph on Rives BFK White paper. Sheet: 40 x 55 (101.6 x 139.7). Edition of 30. Printers: Jack Lemon, Barbara Spies Labus, Steve Campbell, Tom Reed and Brian Taylor at Landfall Press, Chicago

White Fingers 2002 Intaglio with hand coloring Arches Cover White paper. Sheet: 56 5/8 x 33 7/8 (143.8 x 84.6). Plate: 51 1/2 x 29 3/4 (130.8 x 75.5). Edition of 10. Printer: Pace Editions Inc., New York

Dexter & Gus 2002 Woodcut from jig saw woodblock and etching on Somerset paper. Sheet: 39 x 59 1/2 (99 x 151.1). Plate: 39 x 59 1/2 (99 x 151.1). Edition of 21. Printer: Pace Editions Inc., New York

Sakusa (3rd Version) 2004 Lithograph on Sakusa paper. Sheet: 38 9/16 x 26 3/16 (97.9 x 66.4). Edition of 10. Printers: Michael Woolworth and Daniel Clarke, Paris

Winter Breath (2nd Version) 2004 Lithograph on black hand painted Hahnemühle paper. Sheet: 39 3/8 x 27 9/16 (100 x 70). Edition of 10. Printers: Michael Woolworth and Daniel Clarke, Paris

Big Winter Breathing 2004 Lithograph in white ink on Hahnemühle paper. Sheet: 63 x 46 7/8 (160 x 119). Edition of 10. Printers: Michael Woolworth and Daniel Clarke, Paris

Sepia with Coconut 2004 Lithograph on Thai paper. Sheet: 59 x 44 1/8 (149.8 x 112). Edition of 6. Printers: Michael Woolworth and Daniel Clarke, Paris

Paris IX 2004 Lithographic monoprint with hand coloring in various media on Hahnemühle paper. Sheet: 59 x 43 1/2 (149.7 x 109.6). Printers: Michael Woolworth and Daniel Clarke, Paris

Hand Painted Afrika 2005 Lithograph with hand painting on Hahnemühle paper. Sheet: 57 x 44 (144.7 x 111.7). Edition of 13. Printers: Michael Woolworth and Daniel Clarke, Paris

7 Color Pass Dream 2006 Lithograph on Hahnemühle paper. Sheet: 62 ¹/₂ x 49 ¹/₂ (158.7 x 125.7). Edition of 12. Printers: Michael Woolworth and Daniel Clarke, Paris

Yellow Nights 2006 Lithograph on Hahnemühle paper. Sheet: 62 ¹/₂ x 49 ¹/₂ (158.7 x 125.7). Edition of 12. Printers: Michael Woolworth and Daniel Clarke, Paris

Pinocchio in a Caul 2006 Lithograph, woodcut and hand painting on Hahnemühle paper. Sheet: 79 ¹/₈ x 47 ¹/₄ (200 x 120). Edition of 14. Printers: Michael Woolworth and Daniel Clarke, Paris

The Red One 2006 Lithograph on Okawara paper. Sheet: 73 x 38 ⁹/₁₆ (185.5 x 98.4). Edition of 6. Printers: Michael Woolworth and Daniel Clarke, Paris

Pinocchio/Jim Dine 2006 Portfolio of 36 lithographs, plus five numbered and signed plates on Hahnemühle Vellum 300 gr. Reproductions from the Pinocchio series come from a unique, hand-colored set. Wooden box designed by Daniel Clarke and Jim Dine and made at Atelier Michael Woolworth. Sheet: 22 x 16.9 (56 x 44). Edition of 35. Printers: Michael Woolworth, Daniel Clarke, Aurélie Pagés and Ismael Orgambídez, Paris

glossary of printmaking terms

Aquatint An etching technique that permits tonal gradations from pale gray to deep black. The metal printing plate is dusted with a powdered acid-resistant material, such as rosin or asphaltum, and then heated to make the particles adhere. The dusted plate is placed in an acid bath, which eats away the metal around each particle. The resulting pitted surface can produce either a smooth or coarse appearance, depending on the type and size of the particles and the length of time the plate is immersed.

Carborundum Trade name for a powdered compound of silicon and carbon, used as an abrasive. Fixed to a plate (or other printing element) with a binder such as polymer medium, particles of Carborundum give the appearance of aquatint to the printed image.

Cardboard intaglio An intaglio method in which Upson board is substituted for the usual metal plate. The board can be left bare or sealed with coat of polymer. The artist uses handheld scraping tools, power tools, or sandpaper, or peels away areas of the board's surface by hand. The board can be built up with modelling paste and the resulting surface refined with sandpaper. Matte or gloss medium may be applied to the surface to heighten plate tone. The plate is printed like any other intaglio plate.

Direct gravure A variation of traditional photogravure. Instead of a continuous-tone photographic film positive, a drawing on a sheet of translucent material is used. The drawing is transferred photographically to a plate coated with the light-sensitive and acid-resistant ground. The plate is printed on an intaglio press.

Drypoint An intaglio method in which lines are scratched into a bare metal plate with a needle. Depending on the angle of cut, one or both sides of the line will have a rough edge, or burr, which produces the blurry black line characteristic of drypoint. In the course of printing, the burr wears down, limiting the number of prints possible in a given edition.

Etching An intaglio process in which the artist draws with various sharp-edged tools on a metal plate that has been coated with an acid-resistant ground. The plate is placed in an acid bath, which bites the exposed metal; areas still covered by the ground remain unaffected. After the plate is taken from the acid bath, the ground is removed and the plate is inked, wiped, and printed.

glossaire des termes techniques de l'estampe

Aquatinte Une variante de l'eau-forte qui permet des dégradés de ton, du gris pâle au noir profond. La plaque de métal est recouverte d'une poudre de colophane ou de bitume résistante à l'action de l'acide, puis elle est chauffée pour que les particules adhèrent au métal. La plaque est ensuite plongée dans un bain d'acide, la solution acidulée rongeant le métal autour de chaque particule. La surface semée de petits trous peut produire un effet soit régulier, soit grossier, selon la taille des particules et le temps d'immersion de la plaque.

Carborundum Nom commercial donné à un composé en poudre à base de silicone et de carbone, utilisé comme abrasif. Fixées sur la plaque (ou tout autre élément d'impression) avec un liant tel qu'un médium polymère, les particules de Carborundum donnent l'apparence d'une aquatinte à l'image imprimée.

Gravure sur carton Un procédé de gravure qui substitue à la plaque de métal habituelle un carton Upson. Le carton peut être laissé nu ou rendu étanche grâce à une couche de polymère. L'artiste utilise pour graver des outils manuels, des outils électriques et du papier de verre, ou détache des couches superficielles du carton dans certaines zones. Le carton peut être remodelé avec une pâte, la surface ainsi obtenue étant polie avec du papier de verre. Un vernis brillant ou mat peut être appliqué à la surface selon le fond de plaque souhaité. Le carton est imprimé comme n'importe quelle plaque de métal.

Photogravure directe Une variante de la photogravure traditionnelle. Au lieu d'un film photographique positif, on utilise un dessin exécuté sur une feuille translucide. Le dessin est transféré comme une photographie sur une plaque couverte d'une substance sensible à la lumière et résistante à l'acide. La plaque est imprimée sur une presse à taille-douce.

Pointe sèche Une technique de gravure où les lignes sont creusées dans le métal nu avec une pointe. Selon l'angle d'attaque de la pointe, l'un ou les deux côtés de l'entaille auront des bords rugueux, des barbes, qui produisent la ligne floue caractéristique de la pointe sèche. Les barbes s'usent en cours d'impression, limitant le nombre d'épreuves possibles dans une édition donnée.

Eau-forte Un procédé de gravure où l'artiste dessine avec différents outils aiguisés sur une plaque de métal qui a été préalablement recouverte d'un vernis résistant à l'acide. La plaque est plongée dans un bain d'acide qui mord le métal mis à nu par les outils, laissant intactes les zones encore couvertes de vernis. Après avoir retiré la plaque du bain d'acide et ôté le vernis, la plaque est encrée, essuyée et imprimée.

Heliorelief A woodcut process, developed at Graphicstudio, in which a light-sensitive, water-soluble film emulsion is fixed to large sheets of plywood. A photo negative or an image drawn on a sheet of frosted Mylar is transferred to the film emulsion by exposure to ultraviolet light. The light causes the emulsion to harden, except under dark areas of the negative or drawing. The woodblock is then washed, dissolving unhardened emulsion. Where the emulsion has been removed, the wood is cut away by pressure-blasting with aluminium oxide, leaving the emulsion-covered areas in relief. The woodblock is printed by traditional relief-printing methods, producing images prized for their fine detail.

Intaglio A printmaking process in which the image is incised or etched on a metal plate. The entire plate is inked and then wiped, so that ink remains only in the incised or etched depressions. When a dampened sheet of paper is placed over the plate and run through a press, the ink is pulled onto the paper. Often the plate leaves an embossed mark, called the plate mark, around the edges of the print. Aquatint, drypoint, engraving, and etching are all intaglio process.

Linoleum cut (linocut) A relief technique similar to woodcut. The design is carved into a sheet of linoleum, which is much softer and easier to work than wood. The linoleum is then inked with a brayer and run through a press or printed by hand.

Lithography (lithograph) A planographic printing process in which the artist draws directly on a stone or a grained metal plate, using a greasy fluid called tusche or a lithographic crayon. The stone is then treated with a solution of gum arabic and nitric acid to make the blank areas attract water. The stone is dampened with water, and ink is applied with a roller. The damp areas repel the ink, whereas the greasy image attracts it.

Power-tool abrasion The use of power tools such as the Dremel rotary tool, power gouge, die grinder with grinding wheels and router bits, and dentist's drill to make shallow marks on a copper plate or to polish the plate without cutting it too deeply.

Power-tool drypoint A drypoint technique in which the same tools employed in power-tool abrasion are used to make deep cuts in metal plates.

Héliorelief Un procédé de gravure sur bois, développé au Graphicstudio, où une émulsion sensible à la lumière et soluble à l'eau est appliquée sur de grandes feuilles de contre-plaqué. Un cliché négatif, ou une image dessinée sur une feuille de Mylar, est transféré à l'émulsion par exposition aux radiations ultraviolettes. La lumière durcit l'émulsion sauf dans les zones sombres du négatif ou du dessin. La planche est ensuite lavée, l'eau dissolvant l'émulsion non durcie. Là où l'émulsion a été ôtée, le bois est entaillé avec des projections sous pression d'oxyde d'aluminium, les zones couvertes par l'émulsion restant en relief. L'impression du bois se fait par la méthode traditionnelle, produisant des images parfaites par la finesse du détail.

Gravure en taille-douce Un procédé de gravure où l'image est obtenue par l'incision ou la morsure à l'acide d'une plaque de métal. La plaque est entièrement encrée puis essuyée de manière à ce que l'encre reste seulement dans les creux. Lorsque la feuille de papier humidifiée est placée sur la plaque et passée sous les rouleaux de la presse, l'encre se dépose sur le papier. La plaque laisse souvent une marque dans le papier, appelée cuvette, qui entoure l'image. L'aquatinte, la pointe sèche, la gravure au burin et l'eau-forte sont des procédés de gravure en taille-douce.

Linogravure Une technique en relief similaire à la gravure sur bois. Le dessin est creusé dans la planche de linoléum, plus souple et facile à travailler que le bois. Le linoléum est encré avec un rouleau, puis passé sous une presse ou imprimé à la main.

Lithographie Un procédé d'impression à plat où l'artiste dessine directement sur une pierre ou une plaque de métal grenée avec une encre grasse ou un crayon lithographique. La pierre est ensuite traitée avec une solution de gomme arabique et d'acide nitrique qui rendent les parties non dessinées poreuses. La pierre est lavée avec de l'eau, puis l'encre est appliquée au rouleau. Les parties poreuses absorbent l'eau et rejettent l'encre tandis que les parties dessinées et grasses l'attirent.

Abrasion aux outils électriques L'utilisation d'outils électriques tels que des gouges, des disques, des fraises ou des roulettes permet de produire des marques dans la plaque de cuivre ou de la polir sans l'entamer trop profondément.

Gravure aux outils électriques Une technique de gravure où les outils, semblables à ceux qui ont été employés précédemment, permettent de faire des entailles profondes dans le métal.

Roulette A small, sharp-toothed, revolving cylinder set into a handle. This tool is used in intaglio printmaking to create dotted lines and dotted areas on a copper plate.

Soft-ground etching A technique in which a metal plate is coated with a soft, nonhardening ground. By drawing, pressing with his fingers, or using fabrics or other textured objects, the artist pulls away some of the tacky ground, leaving impressions that will be bitten into the plate by the acid bath.

Spit-bite aquatint The application of acid, saliva, or gum arabic directly to a copper plate that has been given an aquatint ground. This can be done with a brush in a controlled manner or by splashing.

Woodcut The artist draws or transfers a design on a block of wood. Using gouges, chisels, power tools or a jig saw, the artist cuts away everything but the lines and areas of the image. The design which is to be inked and printed thus stands in relief.

Roulette Une petite molette, ou roulette, pourvue de petites dents et montée sur un manche. Cet instrument est utilisé en gravure pour créer sur une plaque de cuivre des lignes et des zones faites uniquement de petits points.

Vernis mou Une technique où la plaque de métal est recouverte d'un vernis mou. En créant une empreinte avec le doigt, du papier, un tissu ou tout autre objet ayant une texture ou un grain, l'artiste enlève un peu de vernis et laisse des traces qui seront mordues lors du bain d'acide.

Lavis d'aquatinte L'application directe d'acide, de salive ou de gomme arabique sur une plaque de cuivre qui a été au préalable recouverte de résine d'aquatinte. On peut faire cette application par projection ou de manière plus contrôlée avec un pinceau.

Gravure sur bois L'artiste dessine ou transfère un dessin sur une planche de bois. Avec des gouges, des ciseaux, des outils électriques ou une tronçonneuse, l'artiste entaille et creuse le bois en épargnant les lignes et les aplats de l'image. Le dessin en relief est encré et imprimé.

acknowledgements

Jim Dine would like to thank the printers of these prints: Dan Clarke, Julia D'Amario,
Bill Hall, Neils Borch Jensen, Kathy Kuehn, Jack Lemon, Ruth Lingen, Toby Michel, Ismael Orgambidez,
Aurèlie Pagès, Bob Townsend, Donald Saff, Michael Woolworth and Kurt Zein.

Also to remember with thanks the late Joe Wilfer. He also gives special thanks to
Donald Traver at Pace Editions, N.Y., Julia Braun at Steidl Verlag, and Laurie Hurwitz in Paris.

First edition 2007

Copyright © 2007 Jim Dine for the images
Copyright © 2007 Caroline Joubert for the texts
Copyright © 2007 Steidl Publishers for this edition

Book design: Jim Dine, Gerhard Steidl and Claas Möller
Scans by Steidl's digital darkroom
Production and printing: Steidl, Göttingen

Steidl
Düstere Str. 4 / D–37073 Göttingen
Phone +49 551-49 60 60 / Fax +49 551-49 60 649
E-mail: mail@steidl.de
www.steidlville.com / www.steidl.de

ISBN 978-3-86521-370-9
Printed in Germany